The Library
University of Sa
WITHD
Fort Wayne, Ind

Issues and Approaches to Art for Students with Special Needs

Andra L. Nyman
Anne M. Jenkins
Editors

1999

The National Art Education Association

About NAEA

Founded in 1947, the National Art Education Association is the largest professional art education association in the world. Membership includes elementary and secondary teachers, artists, administrators, museum educators, arts council staff, and university professors from throughout the United States and abroad. NAEA's mission is to advance art education through professional development, service, advancement of knowledge, and leadership.

ISBN 0-937652-81-4

© 1999 The National Art Education Association, 1916 Association Drive, Reston, Virginia 20191-1590.

TABLE OF CONTENTS

Table of Contents (continued)

Preface

This anthology of readings on the subject of art education for students with special needs was developed in response to a Request for Proposals drafted by the Executive Board of the National Art Education Association (NAEA). The topics for this anthology were drawn from those issues reflected in NAEA convention presentations over a period of several years. The editors also considered themes or issues (such as inclusion, legal implications, redefinition of public legislation, etc.) that were reflected in the literature of art education and special education at the time. An open call for papers, published in the *NAEA News*, was successful in providing a wide variety of submissions on topics related to these concerns. As it was impossible to include all of the submitted papers, the decision was made to focus the anthology on art education settings in the mainstream of education in the community and the public schools. Many others, such as clinical and therapeutic settings were beyond the possible scope of this one text. However, issues related to mainstreaming, inclusion, identification, assessment, and others, have been addressed in chapters written by art teachers, therapists, professors, and others working in traditional education settings. We hope these observations will provide guidance for teachers working in both traditional and nontraditional school environments.

Introduction

When developing a program for students with special needs, an art teacher may be faced with many challenges and questions: How can the art program provide each learner with the opportunity to attain his or her maximum potential? How does one address the needs of a student, whether it be through modification of instruction, learning objectives, or expectations, while continuing to provide instruction for all students? How can one learn about the specific needs of those students and understand the various strategies necessary for effective instruction to occur? Decisions concerning placements, physical adaptations, or behavioral modifications must be foremost in determining the least restrictive environment for instruction.

There are often numerous differences in the terminology used to describe students with special needs—terminology that produces confusion for the teacher when referencing or reading the literature in special education. The use and "political correctness" of terms, names, or "labels" often differ from one writer to another and in how it is reflected in the educational policies of one state to the next. Questions concerning the possible long-term effects of using labels to describe the needs of an individual have also been hotly debated in the literature. Unfortunately, the funding for educational accommodations is determined on the assessment of needs and abilities and, consequently, identification by the name or "label" describing an individual's special needs. These students spend most of their school day in a variety of settings, including self-contained classrooms, resource rooms, or other mainstreamed environments. Art teachers may find that students often have special needs, but teachers may not fully understand the characteristics or implications of a student's disability.

The Americans for Disabilities Act (ADA), passed in 1991, suggests that previous terms, such as "handicapped persons," be replaced with terms such as "persons with disabilities" or "individuals with special needs." In editing this anthology, the question of terminology was also difficult to resolve. When reviewing current textbooks authored by experts in the field of special education, it was discovered that there appeared to be little agreement on this issue. There are variations present in this volume as well; these differences often reflect the use of terms used by individual school districts or Departments of Education in one state or in another. In some cases, the authors' terminology has been retained, although sensitivity to this problem has been an important concern during the editorial process. Despite finding some variations in terminology, the reader will find a consistent use of terms or "voice" throughout most of the text.

This text combines the knowledge and experience of many teachers and will provide the reader with an overview of important issues as well as the

approaches and strategies that have been successful for each of these authors. Understanding the needs and abilities of all our students is tantamount to their success. Art education for all learners, whatever their abilities, should be our ultimate goal.

Chapter 1

Current Trends in Education for Students with Special Needs

Andra L. Nyman and Anne M. Jenkins

During the past three decades, researchers, teachers, and writers in the field of education have grappled with issues related to the importance of educating all students regardless of their individual needs and abilities. The literature is rich with philosophical arguments concerning the responsibilities of school districts and teachers. Legislative mandates, in the form of public law, have affected all facets of the educational process including identification and assessment, delivery of instruction, standards, funding practices, and the preparation of teachers. As students of all levels and abilities have been included in the educational process, art teachers have become increasingly involved in the planning and implementation of programs that include learners with special needs. However, art teachers often receive a minimal level of preparation and must often learn about specific needs and effective instructional strategies while on the job. With the increased level of inclusion of students with moderate to severe disabilities in all educational settings, there are many specialized skills that teachers need to acquire (Patton, Blackborn, & Fad, 1996).

The field of special education, now into its fourth decade of research and practice, can provide valuable information for art teachers. Issues related to mainstreaming, alternative placements, full inclusion versus placement in the least restrictive environment, and the practices of categorical labeling affect all levels of the educational system and must be considered (Hallahan & Kauffman, 1994). Historical examination reveals that attitudes concerning the education and treatment of individuals with special needs has been evolving "from one of providing services in segregated facilities to a much more inclusive notion of empowerment and self-advocacy" (Patton, Blackborn, & Fad, 1996, p. 308). As this shift has occurred, the need for knowledge of the individual learners' abilities and capabilities has become highly relevant.

Psychological and behavioral characteristics, perceptual motor skills, and social-emotional and maturational levels may be only a few of the factors that affect the success of students in the educational setting (Hallahan & Kauffman, 1994). The challenge for the art teacher lies in presenting information in such a way that these students can understand and integrate it,

as well as in being flexible and willing to adjust materials to proper levels and approaches.

The Role of Art Education

Art education for students with special needs, like all education, is a series of events in a child's life—events that guide, extend, and model experiences from the everyday, experiential world as well as the representational. Current trends and practices may call upon art teachers to acknowledge and accommodate students whose special needs may be related to developmental concerns, substance abuse, learning disabilities, physical impairment, and behavioral problems. In the past, art educators were trained to teach the practices and techniques of art rather than the more current approaches that include teaching students "about" art. As education has evolved, learners have been required to be more proactive. As a result of an ever-increasing level of interactivity, certain learners' needs have become even more apparent during the studio experience. Art teachers are required to adapt their presentations, assignments, and strategies in order to best meet the changing needs of the students engaged in the art education program. They must also reflect upon the work of teaching art and search for alternatives in order to help students learn.

Current Practices

A fully integrated setting has become the norm in recent years, along with the advent of highly personalized educational plans and strategies. In-class interventions, referrals for additional expertise, and utilizing adaptive strategies and modifications in curricular content are common approaches used in teaching students with special needs. Students often play a role in the development of their Individualized Education Programs (IEPs), an element of involvement that engenders a sense of ownership and responsibility in students who may have previously had little control. This often represents a further shift away from the dependent nature of the student's early years at home and in school, while contributing to the development of independence and initiative.

With the changes that have emerged from an examination of school programs, and subsequent adjustments to their delivery, the end product of school learning is also evolving. Secondary schools offer a wide range of program models to meet the needs of students, many of whom share common courses and classes. The process of completing school has many forms for the variety of students in the population, and students with special needs are no longer relegated to incomplete high school programs because of learning disabilities and similar challenges. Teachers offer a range of choices in assignment and test delivery that capitalize on the range of learning styles and needs of the class participants. Assessment, too, has evolved to a more refined level of articulating specific criteria in relation to learning out-

comes. Criterion-based assessment affords students greater clarity in their learning and greater conscious control of their achievement. By eliminating some of the mystery of assessment and evaluation, art teachers can spend more time in discussing quality art production with their students and less time wondering about the authenticity of the marks.

Issues and Approaches—From Our Field

The following chapters were written by teachers and therapists who represent many points of view and whose expertise, together, provides decades of experience working with individuals with special needs. The issues related to access to the most appropriate and least restrictive education are addressed by Schiller from the standpoint of inclusionary practice. Her overview of historical trends provides the requisite legal and ethical perspectives needed to fully appreciate the difficult path that led to inclusionary practice in North American education. Conversely, these trends are contrasted against former mainstreaming practices in which negotiations for adaptation or modifications for students were virtually nonexistent. Schiller examines how a variety of learning styles can be incorporated in the art curriculum due to the broad range of media and breadth of learning outcomes.

The management of students in the art setting is a vital key to successful learning for all. Guay outlines a structured approach to instructing students with disabilities in an integrated art setting. Planning, clarity, self-management strategies, and praise are recommended as key components to preventing problems and establishing improved behavior through instruction. Specific strategies are outlined for students with difficulties such as cognitive, visual, aural, physical, or multiple differences. Guay further explores the use of strategies such as cooperative learning groups and MAPS, as well as peer and adult assistants to enhance the learning process. Finally, she examines the need for curricular change (on three levels) suitable for students' special needs.

A unique perspective in the discussion of education for students with special needs must include Blandy's promotion of the disability aesthetic within art education settings so that people can experience the orientation regardless of their abilities. The broadening of art programs to include global art and culturally specific images and forms means that inclusion is redefined to include not only artists with specific needs, but also their emerging points of view.

Pappalardo provides numerous suggestions for adapting the regular visual arts curriculum on the basis of each student's special needs. Information about specific disabilities, as well as strategies for including the learner in the art classroom environment, provide the art specialist with valuable insights as well as guidance about effective procedures.

Loesl contributes to this anthology by highlighting the practical aspects of including all students within the art studio. Sensitization, support systems, and communication are intricately woven by Loesl to wrap the learn-

er in an environment that is designed to meet the needs of the child. In linking the art teacher with specialized service personnel of the school, Loesl ensures success for both partners in the learning environment. The support received by both parties makes the art learning a more natural and inclusive part of the school day. In utilizing Milwaukee's IDEA-funded model to develop informed school personnel for interaction at school, a wide ranging effect can be seen in school staff on a larger scale than more singular professional development aimed at attitudinal/affective change.

Once the educational milieu is reformed, students face further difficulties in school and within their communities when structures are not suitably equipped for all members of the population. Physical access, both practical and legal, is examined by Andrus along with programming opportunities at a variety of levels. Needs assessments, basic language, active involvement, multisensory approaches, and hands-on experiences are highlighted as items of specific concern to individuals in the community population who need differentiated art education. The integration of verbal, written, and visual art works affords art students a vast repertoire of experiences upon which they can draw to personalize the artmaking/critiquing event. By opening the doors to the breadth of choice and imaginative use of educators' skills, art students of all ages can develop artistically and aesthetically with the delight of no longer seeing a closed door approach to learning. In utilizing the public art galleries of communities, the very nature of art viewing is extended to more of the public for whom the collections have been developed.

The following chapters in this anthology focus on distinctly different aspects of art education. Clark and Zimmerman explore the abilities and needs of artistically talented students in rural communities, as well as assessment issues. The needs of this group of art students are as diverse and challenging as the aforementioned individuals', and the focus and ultimate direction of the learning is equally unique. Their research points to the extreme diversity in abilities within small rural settings and the need for some students to have supportive families in order to pursue specialized training for short periods of time outside of their community. For the artistically gifted student, the limiting factors of travel and availability of appropriate programs, as well as formal art spaces for exhibition and viewing, create a disadvantage through lack of exposure to the breadth of the art world.

The narrative accounts by Thunder-McGuire provide extensive insight into an approach to meaningful assessment for variously abled students. His approaches to uncovering and understanding meaningful human activity are particularly important in the art room as the manipulative nature of artmaking necessitates that the teacher assume an interpretative role. Utilizing stories and narratives in the art education process is a natural extension of historical storytelling and more current trends in articulating and designing educational paths and goals. Effective communication of needs and goals is

essential in matching IEPs to school completion plans. The thorough preparation of a plan for education that includes art must also account for the needs of the individual without restriction.

Eubanks describes the connections between visual language, meaning and symbol systems, and their role in the development of language. Citing the literature on language acquisition and research about persons with hearing impairments, Eubanks makes a case for the importance of art experiences for this population.

The Carpenters have outlined a carefully structured plan to help students with multiple disabilities experience art through a systematically developed "Looking and Listening" course of study. By exploring a wide range of media and focusing on specific types of art, from graphic design to architecture and painting, participants can develop an enhanced self-image through the accompanying visual and verbal inquiry. One encouraging aspect of this program is its flexibility, meeting the needs of a wide skill range in clientele while also limiting the experience to reasonable blocks of time for optimal learning.

Arnold discusses the need for building a strong support structure throughout all levels of the school system to meet the challenges facing the art teacher. Support structures are identified and suggestions are offered for customizing the curriculum to address the diversity of skills and abilities found among the school population.

Clements outlines the goals and practices of an innovative approach for use with persons with disabilities. Person-centered futures planning is based on the development of a support system with opportunities for inclusion into a community. This approach involves a process of ongoing planning that can enable art educators to develop supportive environments for art expressions by individuals with special needs.

Art Education, Special Education, and the Future

Researchers working in the fields of medicine, psychology, and special education are making tremendous strides towards understanding the neurological, physiological, and environmental factors that impact the development and maturation of individuals with disabilities (Institute of Medicine, 1989). The effects of parents, peers, and other societal influences are important factors that affect the development of these individuals.

In our role as art teachers, the development of the creative and expressive capabilities of all of our students is of paramount importance. The arts "stimulate intellectual curiosity, develop motor skills, reduce levels of physical and emotional stress, and foster appreciation for cultural heritage and human diversity" (Buck, 1997, p. 402). Whether a student's special needs are of a physical, emotional, or academic nature, we must consider the ways in which our programs can help to ensure the reality of quality education for everyone. It is hoped that this anthology will address issues and offer

approaches that are valuable in the development of curriculum and programs for students with special needs.

References

Buck, G. H. (1997). Creative arts: Visual arts, music, dance, and drama. In E. A. Polloway & J. A. Patton (Eds.), *Strategies for teaching learners with special needs* (6th ed., pp. 401-427). Upper Saddle River, NJ: Prentice-Hall, Inc.

Hallahan, D. P., & Kauffman, J. M. (1994). *Exceptional children: Introduction to special education* (6th ed.). Needham Heights, MA: Allyn and Bacon.

Institute of Medicine. (1989). *Research on children and adolescents with mental, behavioral, and developmental disorders: Mobilizing a national initiative.* Washington, DC: National Academy Press.

Patton, J. R., Blackborn, J. M., & Fad, K. S. (1996). *Exceptional individuals in focus* (6th ed.). Englewood Cliffs, NJ: Prentice-Hall, Inc.

Chapter 2

Access to Art Education: Ethical and Legal Perspectives

Marjorie Schiller

Often art education for children with special needs becomes focused on therapeutic uses of art, free time activities as rewards, or time fillers to use while waiting for the "real" content areas to be taught. This state of affairs needs to change. Typically, life-skills based special education curricula have little space for art-related learning, and teachers of children with special needs sometimes underestimate the ability of their students to appreciate aesthetic values and engage in talking about their likes and dislikes related to art. It is sometimes difficult for special education teachers to understand the potential that art activities have for their students.

Many art educators who have been teaching art to children with special needs know that art can be a wonderful way to "reach" some children. Art can have exciting potential for a child who may be visually motivated, yet have difficulty in other discipline areas. But, to provide art activities for children with special needs takes some understanding of current trends and issues. It is important for art educators to understand the legal and ethical implications of current trends and legislation that affect all public schools in the United States. Advanced curricular planning to meet the needs of a variety of learning styles and individuals is another area that requires the attention of art educators. This chapter will deal with legal/ethical issues and strategies for planning.

Special Education in the '90s

In 1990, there was a redefining of P.L. 94-142, a law passed in 1975 that mandated school districts provide appropriate education for all children with disabilities. The 1990 reauthorization changed the name of P.L. 94-142 from the Education for All Handicapped Children Act to the Individuals with Disabilities Education Act (IDEA). This change reflected current thinking and sensitivities to students with disabilities. Gone was the pejorative "handicapped" child, as the term *handicapped* connotes a condition that is static or nonchangeable. The term *disabled* is much less prejudiced, giving the impression that the child has the opportunity to work through the disability and is not forever and finally "handicapped." It is

also important to note that the new name focuses attention on the child, or individual, first; in other words, an individual with disabilities rather than handicapped child. Although it might be difficult for some of us to remember these slight distinctions, they are important.

The Individuals with Disabilities Education Act made other significant changes. Schools are required to plan for students' transitions from school to work, and there is now the addition of both traumatic brain injury and autism as separate categories of disabilities served under the law. Along with other legislation, the reauthorization of P.L. 94-142 began a new awareness of many of the inequalities of opportunities for individuals with disabilities.

Additionally, in 1990, the Americans with Disabilities Act (ADA) was passed. This is a more general law concerning individuals with disabilities. The ADA guarantees equal rights for individuals with disabilities regardless of age. This ADA is more focused on the needs of adults. It guarantees equal physical access and job access equality, and is representative of current legal dispositions toward individuals with disabilities. The ADA and IDEA are similar as they both deal with access issues for individuals with disabilities.

Roots of the Movement Toward Inclusion

There are new methods in schools today that help to integrate children with special needs into classroom settings. One current idea is that of *inclusion*, which goes beyond the old notion of least restrictive environment (LRE) found in P.L. 94-142, to including children with special needs in as much of the classroom day as possible.

The older concept of LRE presented a continuum of services for children with special needs. In other words, a child might be placed in an all-day self-contained special education classroom, with the intent to move him into a partial-day resource room environment as soon as his reading skills advanced a grade level. The shift from self-contained program to resource is a move to a *less restrictive environment*.

The LRE concept would be a sound one if, in fact, it worked. In reality, many children are not moved to less restrictive placements as they gain academic or behavioral competencies. What has happened in many states is that dual systems of education have evolved that separate nondisabled children and those with special needs. Educators find this system workable; special education teachers can work on their own curriculum with "their" children and other education providers don't have to worry about adapting their lessons. Some children with disabilities are placed into general education classrooms, but often the integrated educational setting consists of lunch, recess, and what most teachers consider to be nonacademic classes, art and music (Zigmond & Sansone, 1986).

It is, oftentimes, quite difficult to place children with disabilities into public classrooms, a practice often called *mainstreaming*. These classrooms, the least of the least restrictive classroom placements, are unobtainable for

some children no matter how competent they become, due, in part, to negative perceptions of children with special needs by classroom teachers and administrators. It is much easier for a building principal to restrict all *problem* children to *special* classrooms, and with the old P.L. 94-142, this was legal practice. However, with the new reauthorization that affects P.L. 94-142, and the ADA, the restriction of students to special classes has become much more difficult.

The federal government has recently offered monetary incentives to schools for including children with special needs in classroom programs. These incentives have recently made the practice of inclusion particularly inviting to administrators, but is it important to educate children with disabilities in the mainstream classroom from an educational or social standpoint? What happens to the children who do not have identified special needs?

Researchers who have studied children in self-contained special education programs have revealed some astonishing data. Children in self-contained classes appear to do no better academically than if they were in a mainstream classroom setting (Dunn, 1973). Socialization between children with disabilities and their nondisabled peers is also an issue when considering special placements. In a study by Roberts, Pratt, and Leach (1991) it was found that including children with disabilities in classrooms promoted interaction and acceptance with nondisabled children. Additionally, methods to teach children with disabilities do not differ significantly from those of general education classroom teachers (Smith, Polloway, Patton, & Dowdy, 1995).

There are few studies that document the effect of inclusion of children with special needs on the nondisabled children in the classroom. However, in many casual conversations, I have heard that many teachers believe the participation of children with special needs in their classrooms is a powerful positive influence. One teacher in particular feels that her children learn much about accepting their own limitations as well as learning to accept others for their differences.

Inclusion: What Is It? How Do We Prepare for It?

With the new awareness spawned by both IDEA and ADA, it is much more difficult to restrict children with disabilities to self-contained special education classes. The current trend is to include children with special needs in general education classrooms. The definition of *inclusion*, stated simply, consists of including all children in activities of the mainstream environment. Many schools that embrace the idea of inclusion use the help of special education teacher aides and special education teachers as consultants within the classrooms.

Inclusion is an idea that many educators in diverse fields support. It is not a particularly new idea and had its roots in the earlier version of P.L. 94-142,

the idea being to integrate children with special needs in general education classrooms as much as possible and, as soon as the child seemed ready for the "mainstream." That the practice of inclusion did not evolve as a natural progression of the initial legislation speaks to the discomfort that many general education classroom teachers, administrators, and parents have for children with disabilities. But is this an ethical decision, or one made of mistrust and a lack of information? Was this perception encouraged by special educators who sheltered their students from the seemingly unyielding demands of the general education curriculum? Unfortunately both miseducation and special educators' willingness to take charge of the "problems," seem to have affected the acceptance of the philosophy of inclusion.

For many years special and general educators have worked within a dual system that has kept them separate. The dual systems have made it almost impossible to communicate. This is exacerbated by the special education jargon that creeps into almost every conversation that special educators have about children with special needs. The conversations seem dominated by terms such as IEPs, DHs, and LDs; it's difficult to understand what is being said. And although classroom teachers are often involved in educational planning meetings for children with special needs, art teachers are rarely involved (Guay, 1994).

Art is a class that is often used as a test case for inclusive planning; if a child can "make it" in art then perhaps he is ready for other classes as well. However, art teachers are not always consulted before the test of inclusion is attempted. The art teacher might find out about a child with special needs when a problem emerges in the art room. Communication between special and specialist educators needs to improve if inclusion is to be successful.

Some professionals promote "normalizing experiences" for children in special education that include art curriculum that matches that of their nondisabled peers. Blandy (1989), for example, has written exclusively on the importance of art education for students with disabilities that includes all the components of quality art education found in the curriculum for the nondisabled student. This argument is backed by the new legal stance promoted by IDEA and ADA. Students with disabilities are entitled to the same quality education as their nondisabled peers.

The ethics of the argument to include students in art classrooms may seem obvious but needs to be stated. It is not an ethical decision to deprive any person of knowledge and experiences that might enrich life. Art is a discipline that is very deeply connected to the emotions and humanness of people; it is something that needs to be shared in all of its facets with all children. While most art teachers are inclusive by nature and have welcomed children with various disabilities into their classrooms, many still need to adjust their thinking. But are we, as art teachers, supposed to know all there is to know about children with disabilities, and should we be ready, willing, and able to take on new students with special needs, without any assistance? Unfortunately, this is the expectation in many cases. However, it is

University of Saint Francis - Ft Wayne IN

not in the true spirit of inclusion. How can an art teacher best prepare for inclusion?

Planning for Inclusion in the Art Classroom

In many schools across the United States there is a warning cry: Inclusion is coming! Inclusion is coming! Teachers panic, parents complain, principals shake their heads but stand firm because an edict has come from on high: You must include your students with special needs into classroom activities!

If done with some advance collaborative thought and planning, inclusion can actually work quite smoothly. Teachers must buy into it and be willing to risk a few "bombs," but special education teachers together with their general education peers can create some interesting and cooperative structures that support each other and the children that they are including in their classrooms. Special educators and their teacher aides must be willing to assist in classrooms when necessary, and teachers (especially art teachers) must be willing to ask for the help.

The first line of support for any teacher working with a child with special needs is the special education teacher. She usually can share enough information about a specific child to facilitate his integration into a specific classroom environment. It is an unrealistic expectation that an art teacher would have the time to go through the educational files of every child with disabilities who is integrated into her classroom. But an art teacher still needs to have enough information about a child to plan properly. One way to obtain the information needed is to send a note to the special education teacher that might go something like this:

Dear Ms. Jones,
I understand that many of the children from your class will be included in the art classroom, and I support the inclusion philosophy. My classroom routine usually follows this process:
1. Children come in and sit in a circle on the floor and we review the week's ideas, themes, and concepts.
2. Children pick up materials from their cubbies and the counter and then are seated at their worktables.
3. Children begin individual or collaborative work on projects that might include research and report writing, studio work, or discussion in small groups.
4. We usually review what we have done and the children return materials to their cubbies as the class ends.
There is usually quite a bit of movement and conversation during work times and I depend on students to be as independent as possible. Will these requirements be difficult for any of the students who will be included in my class? If so, let me know so we can work out the necessary adaptations.
Thanks for your time.
Ms. Art

Although the letter above is a bit formal, presenting expectations even by checklist, is a good way to let a special education teacher know that art class is not just fun and games, but a serious workplace. If students have trouble with reading and writing activities, perhaps they can be given time in a special education resource room to complete assignments, or if children have difficulty concentrating and prefer an isolated work area, that might be easily arranged within the art room. If students have physical disabilities, some strategies for adapting materials and media might be brainstormed with the special education teacher. Good communication between the art and special education teacher is essential and it never hurts to be the party who initiates a positive relationship.

Are We Art Therapists?

One mistake that is often made by special education and classroom teachers is that art class is a place where children with special needs will get therapy. *We are not art therapists; we are art educators,* and the two are quite different. It is important to dispel that myth as soon as you detect it as an expectation. Although the process of art production can provide a sense of catharsis, at times, for some people, it can also be extremely frustrating and stressful (as all of us who struggle creating our own artwork know!). It can provide an alternative form of expression and that can be very beneficial for some people—but this is not guaranteed for every individual.

Some children, including those with special needs, do appear to bloom in the art room and this, naturally, should be encouraged. However, a child who draws "disturbing" images or uses dark colors may not be experiencing negative emotional trauma at all. He may just be in the mood for dark colors, or perhaps it was the color closest to him at the worktable. It is never a good idea to make a diagnosis about a child through his drawings alone. If there is additional corroborating evidence that a child is experiencing emotional distress, a disturbing piece of artwork might be used by a professional art therapist as an entry point to a discussion about the problem. But, this type of investigation is never the job of the art teacher, unless of course, she has special training.

Cooperative Learning

One strategy that many art teachers have found to be useful for successful inclusion is cooperative, or group learning assignments. Art rooms are usually set up with several large tables; an ideal set-up for cooperative learning. Group learning can work well for students who have mild reading and writing difficulties. These students, who evidence the most common disability in our schools today, usually have various learning disabilities which generally make it difficult to keep up with reading and written assignments. When a teacher uses group assignment, the reading and writing can be split up and students can be responsible for only a portion of the whole assign-

ment. Ideally the portion that a student with a learning disability might be responsible for would link with one of his strengths; perhaps drawing, acting, or checking to make sure all the components of the assignment were moving towards completion. Getting to know your students as individuals and getting needed supplemental information from the special education teacher can help to facilitate this process.

One middle school art classroom that I have visited many times is based on group interdependence. The classroom is set up with six to eight worktables, four to six students to a table. Assignments are given and students work independently, with a partner, or in small groups at the table, but no one is considered finished until all students at the table are finished. Those who finish first help those who are having trouble. If anyone has a question, they may not ask the teacher until it is confirmed that no one at the table has the answer. The students are interdependent in a positive way, and the strengths of each can be utilized in any way by the group. It is very difficult to pick out the students with special needs in this classroom, with the exception of the students with physical disabilities, who are in wheelchairs.

It is challenge to establish cooperative activities in an art room that has not relied on this method in the past. Many students prefer to work alone on their art productions. Many have had negative experiences with cooperative learning in other classes ("I did all the work in my group" is a frequent complaint). Students who are not used to working cooperatively may bicker for power. However, after several experiences, students do begin to see the strengths of cooperative work. They realize that splitting a task has its benefits and compiling ideas has its strengths. Individual studio work may be one component to keep intact, particularly for older students, but a mural or large tile project can always benefit from many workers and lots of diverse ideas.

Individual Contracts

Many teachers have found that developing individual contracts with students is one way to allow for individualization to meet the needs of each child. Contracts can be simple and negotiated individually. It is better to use contracts with an entire class rather than as a "special" way to work with students who have special needs. Universal contract use avoids stigmatization of students with disabilities. If a teacher elects to contract only with her students with special needs, this is best done privately and not in class time. A contract might have the information contained in Figure 1.

Teachers do need to be cautious about low expectations. If students with special needs are always expected to do less work with minimal quality, then this will probably occur. Let the students choose their area of strength, and then challenge them to work hard to improve in that area. All students have strengths, and it is important for teachers to help students work through these areas.

Figure 1
Student Contract

```
Student Name _____

Period of Teacher_____

I Will Complete _____
_____

By _____Date_____

Student Signature _____

Teacher Signature _____
```

Using Special Education Teacher Aides

Some children, especially those with severe physical disabilities, may come to the art room with a teacher aide. It is still important to include these children in as many of the activities as possible. For example, if a child uses technology such as a communication board, be sure to give him or her the opportunity to express opinions. This is equally true for the child with auditory or visual disabilities. If a child uses signing to communicate and an interpreter accompanies him or her to class, give the child the opportunity to communicate through his or her interpreter.

One problem that I have encountered with some teacher aides is that they might help the child in their charge a bit too much. In other words, they might complete a studio project for a student who is unable to handle the materials. A much better solution requires adapting materials beforehand so that the child has some way of producing his own product. There are some computer programs that might be appropriate for some children or materials can be adapted for easier manipulation. A child with physical disabilities need not produce the same studio project as the other children, but he or she should be challenged to the best of his or her own abilities with a studio assignment that has some or many of the same conceptual objectives of the nonadapted assignment.

Teacher aides can also provide help to other children in the class. This is important to remember and to discuss with the teacher aide beforehand. If the identified child is doing fine, it is important that the aide move to assist a child who is experiencing difficulty. It is important for children to understand that all of us need help at times and that the child with special needs can be competent. This will help to accentuate the "sameness" between people rather than the differences.

Adapting Your Discussion or Written Assignments

Many teachers have found that all children, including those with special needs, enjoy talking about art and artists. There are strategies that can facilitate response to art for even the youngest of children. For example, just the act of providing a pleasurable aesthetic atmosphere is important. It is also important to change the environment and provide a variety of art to look at and respond to. In addition, it is important to provide opportunities for children to respond to the art using their most comfortable mode of expression; be it written, oral, or another mode jointly selected.

If a written assignment is given, consider accepting an audiotaped oral report as well. Another idea might be to allow oral reports or short skits that convey an idea, an artist's life, or art concept. For some, particularly young students, a simple game of "what is your favorite" print can be a good discussion starter. Everyone can choose a favorite, and discuss their selections, a nonthreatening approach for younger students.

For older students, if reading is part of an assignment, consider making an audio recording of the written material. This recording can then be available to all students at a listening post, or by private checkout—again in an attempt to minimize stigmatization. When reading aloud in the class, avoid "round-robin" (having students read aloud alternate passages) methods. This puts students with reading problems on edge, and further, it is not a very effective way for students to learn the material. Choral reading (everyone reads out loud at once), is a much more effective learning strategy for short passages. For longer material, have the students read a short portion silently, and then stop, discuss what they have read, and then read another portion silently. If you have nonreaders in your class it is always a good idea to provide them with written material beforehand, whenever possible. Make sure to provide nonreaders with a strategy to obtain the information, such as an audiotaped version, and the opportunity to listen to a discussion. Allow time for conversation with the student after class, or provide the materials to the special education teacher.

Conclusion

Much of the information that is currently available on the topic of art for children with special needs focuses on appropriate media or studio projects for children with varying abilities. There are few references that present strategies to engage all students in the process of art criticism, aesthetic inquiry, or the pursuit of how art relates to communities and self, particularly in the context of an inclusive art classroom. While it is important to address strategies for studio activities, this should not be the entire focus of art for children with special needs. A typical art curriculum, perhaps modified in terms of reading or written material, should be negotiated with the student and special education teacher.

It is imperative that children with special needs are given opportunities like those of more typically developing children and in the same environment. A wide variety of response modes and multiple opportunities to view and discuss art will ultimately enrich the visual art curriculum for all children.

References

Blandy, D. (1989). Ecological and normalizing approaches to disabled students and art education. *Art Education, 42*(3), 7-11.

Dunn, L. (1973). *Exceptional children in the schools: Special education in transition.* New York: Holt, Rinehart & Winston.

Guay, D. (1994). Students with disabilities in the art classroom: How prepared are we? *Studies in Art Education, 36*(1), 44-56.

Roberts, C., Pratt, C., & Leach, D. (1991). Classroom and playground interaction of students with and without disabilities. *Exceptional Children, 57,* 212-224.

Smith, T., Polloway, E., Patton, J., & Dowdy, C. (1995). *Teaching students with special needs in inclusive settings.* Needham Heights, MA: Allyn and Bacon.

Zigmond, N., & Sansone, J. (1986). Designing a program for the learning disabled adolescent. *Remedial and Special Education, 7,* 13-17.

A Way In: Strategies for Art Instruction for Students with Special Needs

Doris Guay

"A Way In" examines strategies for instructing students with disabilities in integrated art classrooms. It is designed to provide teachers with ideas that enable each special needs student to creatively express, through art, the ideas and encounters of his or her life experiences and to meaningfully respond to their own art and the art of others. By focusing on instruction in heterogeneous classrooms, it acknowledges the changes rapidly taking place in special education placement due to research, legislation, and case law.

Although integration has been a norm in art classrooms for students with mild disabilities, beginning in the late 1980s, students with more severe disabilities have increasingly been included in all general education environments. Amidst concerns that inclusion results in the loss of individualized instruction and attention, and that many teachers are not prepared (York, 1995), evidence supportive of inclusion is increasing and greater numbers of school districts have been adopting inclusion policies (Wolery, Werts, Caldwell, Snyder, & Lisowski, 1995). In a 1992 report, "Winners All: A Call for Inclusive Schools," the National Association of State Boards of Education (NASBE) envisioned the creation of an all-inclusive system of education for all students. With this vision, students with the broadest range of ability and disability are to be included in general education schools and classrooms at their base school and with their age peers.

Whether in inclusive schools or in schools that integrate students from special education classes, a majority of art educators teach special needs students in integrated classes. A 1993 survey of first-year professional members of NAEA revealed that 86% of the responding art teachers worked with special needs students. Two-thirds of these teachers integrated all students, and close to one-third taught some special needs students in segregated classrooms while they integrated others (Guay, 1994). In this study, many teachers revealed that they struggle to meet the diverse needs of individuals who have a broad range of learning, behavioral, physical, and sensory constraints.

This chapter cannot provide all necessary answers, nor can methods of instruction ever reach perfection. Special needs students are individuals and must be taught as individuals, not labels. They present us with an exciting

26

and challenging range of abilities, needs, and constraints, many similar to those presented by students not labeled as having a disability. Effective instruction in inclusive classrooms allows access to the art curriculum and, taking into account the unique needs of students with severe disabilities, to the same curricular activities as students not labeled as having a disability. *Instruction*, as defined in this chapter, includes those strategies a teacher uses to provide for learning. It includes instruction for classroom management, instruction for learning in and through art, instruction that modifies curriculum, and the evaluation of instruction.

Preventing Problems and Improving Behavior Through Instruction

Classroom management is central to the task of teaching (Doyle, 1986). The tasks of management include arranging the room, grouping students, establishing and monitoring rules and procedures, planning curriculum and instruction, and celebrating accomplishment.

Preventing Problems Through Planning
With careful planning art teachers create classroom environments in which all students can succeed. A well-designed classroom arrangement allows all students to be seen, to move in clear pathways, and to easily and quickly access supply areas, demonstration areas, clean-up, and storage areas. In addition to considering the needs of specific students and the activities of art instruction, teachers may guide their organization of the art classroom with the following questions:

1. Can all students be seen, eye contact made?
2. Are there clear teaching pathways for in-process assistance?
3. Have teaching pathways been established with consideration for sight lines needed to monitor the class while assisting one-on-one?
4. Are there easy pathways to the demonstration area, supply area, clean-up area and storage area?
5. Has congestion at these areas been considered either in room arrangement or in the establishment of procedures and routines?
6. Are media stored for teacher convenience and maximum student independence?
7. Can students be grouped and seated with consideration of their attentional, physical, or sensory needs?

Attention to the organization of the physical environment prior to the opening of the school year results in smoother functioning of routines later.

Preventing Problems Through Clarity

Probably the most vital tasks of classroom management are those that establish, teach, and monitor clear rules and procedures. All students need to know, understand, and, importantly, remember rules and procedures before they can follow them. Studies by Anderson, Evertson, and Emmer and Emmer, Evertson, and Anderson (as cited in Brophy, 1983) suggest effective classroom management results when (a) teachers spend considerable time during the first weeks teaching and practicing rules and routines; (b) they present this information clearly and concisely; (c) they do not ignore deviations from rules and procedures; and (d) they are able to predict and deal with confusions, distractions, and concerns. Other research associates high achievement with time spent by teachers organizing, giving organizational instructions, reminding students of rules and procedures, monitoring, and reteaching. Instructional attention to managerial concerns early in the school semester allows for learning later (Brophy & Evertson as cited in Brophy, 1983; Knop, as cited in Luke, 1989). In the art classroom, rules and routines are needed for (a) entering and exiting the room, (b) getting in-process artwork and/or supplies, (c) moving from one instructional area to another, (d) working behaviors for studio time, (e) getting assistance, and (f) cleaning up.

A teacher's ability to maintain a continuous working focus, engaging students while avoiding down-time, is crucial to accomplishment (Kounin, 1970). Kounin found two teacher traits that are essential to maintaining this focus. First, a teacher must be "with-it," aware of what all students are doing at all times. Frequent and rapid scanning of the classroom allows a teacher to handle a potential problem before it escalates to involve others in the class. The second essential teacher trait, "overlap," is the ability of a teacher to respond to two or more events at the same time. For example, the teacher can provide in-process assistance to one student while admonishing another student to return to work. In-process assistance, effective praise, monitoring, and acting promptly when nonproductive behavior is noted are methods essential to maximizing learning time.

Handling Misbehavior: Helping Students Manage Their Behavior

Dreikurs, Grunwald, and Pepper (1971) suggest four goals of student misbehavior: attention, withdrawal, control, and revenge. Each of these goals is accomplished through reinforcing reactions or responses by teachers and sometimes by other students.

An *attention seeker* is frequently off-task, asking for continuous help from the teacher, talking out of turn, wandering around the room, or engaging in similar unnecessary behaviors. The attention seeker is rewarded when teachers, through caring or feeling annoyed, address the behavior. This may seem like a problem with no answer because ignoring the behavior may encourage similar inappropriate behaviors in other students. Teachers have found the following solutions: (a) providing positive attention and feedback

when student is on-task; (b) asking table groups to ask each other for answers and assistance, summoning the teacher only when their group cannot help; (c) using visual and written directions on handouts or wall charts; (d) tape-recording lesson introductions and verbal discussion accompanying media demonstrations and suggesting the needy student re-listen to the directions; and (e) asking the student for an estimate of how many times he or she will need to engage in the inappropriate behavior during a class period, having him or her keep track of the number of times they actually do, and holding the student to this number, gradually diminishing the number of accepted occurrences.

A *withdrawing student* has given up on school and believes he or she cannot learn. It would be easy to tacitly give up on this student who isn't a class problem but won't or "can't" do the art assignments. This student requires our continued enthusiasm and belief that art can be learned, that it is a skill. Games, group involvement, and positive feedback even for small accomplishments may encourage participation.

Lack of drawing skill may become an excuse for a special needs student not to work. A change of attitude may be affected by exploring, with the student, which methods for learning to draw have not succeeded and by asking or contracting with the student to practice a different (new) method while building on all of the student's visible strengths and interests.

A *control or power-oriented student* attempts to engage the teacher in a "battle of wills." This student contradicts, defies authority, refuses requests, and may, if allowed, engage the teacher in debate or angry confrontations. Sometimes this behavior can be disarmed by simply stating, "I know I cannot make you do anything, you do not have to, but I am asking you to." Other suggestions are (a) postponing discussion to a better time; (b) giving legitimate power in the form of assisting or leadership tasks; (c) developing a contract specifying desired behaviors and rewards; and (d) calmly and matter-of-factly reiterating rules (a broken record) and, when warranted, carrying out specified consequences.

A *revenge-oriented student* is mistrustful. Harboring anger, this student engages anger or feelings of hurt in others through destructive verbal or physical behavior toward property, peers, or the teacher. Understanding the student's underlying anger may help the teacher to relate to this student with calm responses, respect, and encouragement. Again, clear rules and consequences that are calmly and firmly enforced are essential. Many revengeful behaviors challenge the teacher's self-control. To deter these behaviors teachers must refuse to be shocked and avoid authoritarian or commanding responses. Rather, teachers need to interpret and label the observed actions for the student and specify the unacceptable behavior. The student must be told that hurtful or destructive behavior cannot be tolerated.

Glasser (1977) also provides an effective approach to students who do not respond to generally effective classroom management techniques. It

begins with careful observation and reflection. A list is made of the management techniques practiced whenever inappropriate behavior occurs. Analysis of this list provides information about what works and what doesn't. While composing this list, the teacher strives to develop a better personal relationship with the student by praising, showing concern, and giving rewarding tasks. If the student's behavior remains unacceptable, Glasser suggests the following:

1. Ask the student to describe (completely) the disruptive behavior(s) and ask the student to stop these.
2. Call a conference. Ask the student to again describe the offensive behavior(s), the rules, or expectations violated. Set standards for what the student should be doing instead.
3. Repeat step (2) and negotiate a written contract for the development of positive actions to eliminate the misbehavior(s).
4. Use timeout or another isolating procedure during which the student is required to develop his or her own plan. Before returning to class the student makes a commitment to follow the plan as approved by the teacher.
5. The student is sent to a principal or to in-school suspension where the prior step is repeated or further action is taken.

Reward and Praise

For many students, accomplishment in art and seeing their work mounted and displayed is intrinsically rewarding. Grades and positive feedback through portfolio review are also rewarding. For others, contingent promises of art and non-art rewards such as extra art time, art games, use of special media, radio during class, artist guests, field trips, and end of class privileges will better maintain task focus. These types of rewards are preferable, however, at times teachers elect to or need to consider tangible rewards that require extra time and money such as stickers, treats, and complimentary notes to parents or to special education teachers.

Praise reinforces desired behavior only when it is specific to a student's needs and a consequence of desired behavior (Brophy, 1983). Praise as an extrinsic reinforcer runs the risk of reducing the degree to which students find working intrinsically rewarding (Leppe & Green as cited in Brophy, 1983). Praise or any reinforcer must be assigned in such a way that students think about their behavior. Brophy (1981) recommends that praise (a) be given contingent upon positive accomplishment and when given, specify the accomplishment; (b) awards attainment not merely participation; (c) attributes success to effort, task relevant activity, and/or ability; (d) uses prior accomplishment as context for present accomplishment, and (e) appears spontaneous and varied in form.

Instruction: Using Student Strengths

Instruction for inclusion must remain as similar as possible for all students. Structuring the classroom as a warm, encouraging environment uses student strengths, interests, and expressive modes. Many students with disabilities require little or no special assistance in art class. Others benefit from extra motivation, concrete visual and tactile experiences and examples, modification of tasks, or extra time allocation. An in-process assessment of a student's prerequisite skills and understanding of art concepts reveals areas for individual instructional emphasis if modification of an assignment becomes necessary. Instruction begins with needed personal assessment and is followed by discussions with the student, special education teachers, counselors, physical or occupational therapists, and/or parents. Through assessment, art teachers identify a student's strong or adequate skill areas and preferred learning modalities. Instruction is planned to develop and use these strengths. Further identification of skills that are inadequate allows the teacher to plan for remediation or compensation. Providing for instructional variety is a key to reaching students with diverse abilities. Students learn through playing, touching, listening, seeing, dramatizing, reading, discussing, constructing, and doing.

Instructing Students with Mild to Moderate Cognitive or Learning Differences

Effective integration involves all of the students in the class in empathetic, understanding, and cooperative relationships. Lyons (1992) provides some clear guidelines for the integration of children with mild disabilities. First, the classroom must be structured. The students should know class signals, what is allowed, and what is not allowed. Clear beginnings and endings for learning activities and class provide predictability and natural levels of consistency, thus lowering students' anxiety and acting-out behaviors.

The following strategies based on guidelines developed by Gearheart, Weishahn, and Gearheart (1992) are recommended for teaching students with mild to moderate disabilities in art:

1. Be positive. Many students with mild cognitive or learning differences do great in art. Maximize group and personal motivation.
2. Monitor or provide organizational assistance for students as they set up and begin studio work.
3. Use simple instructional language and visually or concretely demonstrate vocabulary and concepts.
4. Teach peer tutors or table buddies to model, prompt, demonstrate, and clarify for the student with a disability as they work on their own studio assignments.
5. When possible, use videos, films, or filmstrips to visually introduce and contextualize ideas.
6. Break tasks into subtasks. Create pictorial charts or individual work-

sheets for media processes or assignment sequences.

7. Involve student in heterogeneous group experiences. Structure both group and individual opportunities to use art vocabulary and concepts.

8. Plan concrete motivational experiences that are tactile or that connect with the larger community environment.

9. Structure art assignments that have multiple and personalized solutions rather than ones that require imitation.

10. Assess students by determining individual growth. Find the uniqueness of each artwork and step-by-step development of art skills.

11. Help students develop metacognitive skills by modeling self-questioning and self-talk during demonstrations. Teach table peers to do the same as a means of prompting and assisting.

12. Find and use opportunities to generalize and conceptualize. Review these ideas at the end of each class.

Instructing Students with Visual Disabilities

Visual disability may take the form of low vision or blindness. About 15% of students with visual disabilities have no useable vision (Gearheart et al., 1992). Partially sighted students, however, use their sight with varying degrees of efficiency. Partially sighted students use a variety of magnification means. They may position their head or their work for maximum vision. Some students with visual disabilities are sensitive to excess light and prefer low light while others require intense lighting for the best vision. The teacher's physical position in relation to the student is important. Window glare (either behind the teacher or on the teacher's face, the blackboard, and visuals) prevents a student from using available vision. Laminated visuals are particularly prone to glare. Art educators find assistance from district vision specialists or special education teachers. Those specialists know the availability and access to braille or recorded art textbooks and adaptive equipment to enlarge visuals and text. Art teachers also rely on school copy machines to enlarge visual and printed matter. Both public and private sources supply special equipment to students with visual disabilities. Students may benefit from using a rubber-matted drawing board for drawing on acetate with a stylus. This produces a raised line that can be colored with overhead markers or the board can be used by the teacher to illustrate ideas or concepts. Art teachers may request relief maps and globes, skeletons, models of animals or other natural and man-made objects, and wooden figure models. Scented markers and crayons, colored glue to create raised line drawings, and fluorescent paints that reflect light differently make art more accessible to some students with visual disabilities. Paints can be mixed with sand for texture and kitchen extracts for scent. Black marker lines make paper edges more visible. Although all media may be accessible, verbal clarity, tactile choices, and concrete objects and experiences are motivational for students with visual disabilities.

Instructing Students with Hearing Disabilities

The term *hearing impaired* is "a broad descriptive category inclusive of all degrees of hearing loss, with deafness the most severe form" (Sisterhen & Ratatori, 1989, p. 94). Some students with hearing disabilities learn to communicate orally, some manually, and some through a combination of these, called *total communication*. Oral students are taught to use auditory and visual cues and speech (lip) reading to understand and produce intelligible oral speech. When students use oral communication, teachers and other students should face the student and speak clearly but normally. Light, without glare, should be on the speaker's face and not behind the speaker. Art teachers integrating students with hearing loss may be asked to use a wireless microphone that maximizes sound to the student's auditory trainer. When students rely on auditory clues, classroom noise must be kept to a minimum. Information not understood needs to be rephrased, not just repeated, and a signal is needed to indicate who is speaking during class discussions. If an oral trainer is in use, pass the microphone to the speaker.

Students using manual communication may be accompanied to art class by a sign-language aide who translates oral speech to manual communication. Teachers should speak directly to the student even when a sign-language aide is present. There is a growing trend toward the use of total communication in education (Moores as cited in Sisterhen & Ratatori, 1989).

Students who have a hearing loss hear differently. Increasing volume does not necessarily make sound clearer (Rees, 1992). Rees suggests students with hearing disabilities need extra assistance to ensure understanding of expectations, routines, and rules, and to ensure fluent, two-way communication. Other teachers suggest discussing the best seating with the student, using visual approaches to learning, assigning the student to small collaborating groups, providing a peer assistant and note taker, and providing directions in both written and oral forms.

Instructing Students with Orthopedic Disabilities

Experience has shown that the art abilities of students with orthopedic disabilities should not be underestimated. With proper positioning or adaptive equipment many students with orthopedic or physical disabilities fully participate in art instruction. The school's physical and occupational therapists have expertise that will assist the art teacher in suggesting, purchasing, or making appropriate adaptations. Art teachers have invented a variety of devices to assist individual students with specific media constraints. They have stabilized paint containers with Velcro closures, placed them on wooden ramps or in wooden tray holes, taped paper to turntables, and invented scissor holders and handles for drawing media and paint brushes. Teachers have recently found Crayola's Model Magic™ ideal to wrap and thicken crayons, markers, and brush handles. It molds to a student's hand and when dry, forms into a variety of permanent, individualized holding devices.

The student with an orthopedic or physical limitation should be encouraged to be as independent as possible. This requires careful organization of the room and media in use. Using wheelchairs requires clear pathways. To maximize involvement in art, students may be seated in their wheelchair or in regular seating at tables. They may use easels, the wall, or the floor as a work area. Anderson (1994) provides action photographs and diagrams of many excellent art equipment and tool adaptations for students with orthopedic disabilities. As computer technology has become more available to the art room, students with extreme upper body involvement may find creative success using computers. A variety of adaptation devices to access art and design software are available. Special education personnel have knowledge of special adaptations to access computers used by students with orthopedic disabilities.

Instructing Students with Severe, Profound, or Multiple Disabilities

General education classrooms including art classrooms have become the least restrictive environment and thus appropriate placement for increasing numbers of students with severe and multiple disabilities (Guay, 1995). The following guidelines may assist the art teacher:

1. Each student in an art class, regardless of disability, needs to engage in and learn skills that represent the major intentions of art education, creating art and responding to art.

2. Students with severe disabilities must be provided with opportunities to make choices and learn functional art skills and behaviors that serve them in succeeding educational and community environments.

3. Target skills for students with the severest disabilities must be age appropriate and lead to independent choices and spontaneity.

4. Target skills for students with severe disabilities may be those embedded in natural art studio routines such as cooperating with peers, setup and clean-up, securing and organizing personal supplies, creating at developmentally appropriate levels with a variety of media, and displaying artwork.

5. The approach of partial participation demands assessment of the skills necessary for an age-appropriate art task and comparison of these with the skills of the student (Blandy, Pancsofar, & Mockensturm, 1988). The student engages in the art behaviors that he or she can do, regardless of how small. Allowing for creative choice, assistance is then provided for the art behaviors that are too difficult to manage independently (Sternberg, 1982). Steps of a studio assignment may be eliminated, or different media processes or tools substituted.

6. Observation of the student's actions and choices provides the art teacher with clues to appropriate instructional objectives.

The following suggestions for working with students with severe disabilities are adapted from Putnam (1992) for art education: (a) modify student response methods, point rather than verbalize; (b) reduce the complexity of a studio project; (c) modify the level of learning for the student by developing objectives at the lower levels of Bloom's Taxonomy, recognition and understanding; (d) work on prerequisite skills or media processes according to the ability level of the student; (e) create a unique curriculum related to the curriculum of the class but one that is more functional or more creatively pleasurable; and (f) allow the student to participate in the class as an artist's apprentice, learning and doing one aspect of a studio process.

When the art abilities of the student are too disparate from those of class peers, opportunities for peer tutors and peer interaction prevent isolation (Putnam, 1992). Students with very severe disabilities can assist with group projects by performing tasks that show recognition or knowledge and by helping with decisions.

Instructional Support Strategies

There is contradictory research regarding the influence of integration on attitudes of nondisabled students. A variety of instructional strategies have been used to facilitate learning and appropriate interaction. It is evident that teachers must make specific efforts to both facilitate learning and prevent prejudice, stereotyping, and rejection (Gearheart et al., 1992) of students with special needs. Cooperative learning, including cooperative goal structuring and other tested strategies: the Maps Action Planning System program (Forest & Lusthouse, 1990); and peer assistance or table buddies are some of the successful strategies used by art teachers.

Cooperative Learning Groups

Numerous studies have shown cooperative learning to have a positive effect on social and academic learning of both nondisabled and special needs students (Putnam, 1992). Cooperative learning begins with the belief that "no one is as smart as all of us." In cooperative learning everyone helps, shares ideas, and assumes responsibility for accomplishing shared goals. Various structures of cooperative learning have been created. They generally involve heterogenous groups of students in accomplishing interdependently structured objectives. Students may choose or may be assigned their role. Each may choose a part of a project to be accomplished, or all may work together sharing, listening, and contributing to success. Students are taught social interaction skills and techniques to assess the effectiveness of their group. Teachers supervise and provide the cooperative groups with feedback or a member of each group is assigned to observe and provide feedback about specific interrelational behaviors such as good listening, taking turns talking, and allowing each group member to contribute.

As cooperative group assignments, teachers have recommended variations of mural projects as those found in *Art Based Games* (Pavey, 1980), critical inquiry discoveries and interpretive work, art historical research and reporting, and simulation activities such as "art on trial," museum or gallery games, debates based on current political and artistic issues, and group responsibility to study for tests. Art teachers also use variations of published cooperative group activities such as cooperative goal structuring and jig-saw. Readers will find information in Johnson and Johnson (1986 & 1987) and Rynders, Johnson, Johnson, and Schmidt (1980). These writings also help the teacher structure cooperative work among students with disabilities and nondisabled peers.

Map/McGill Action Planning System (MAPS)
MAPS (Stainback, Stainback, & Forest, 1989) was designed as a strategy for effectively integrating students with severe disabilities. It has worked for integration in both middle and high school art classrooms. The method appears adaptable to lower level classes. The MAPS system provides for both instructional and social support.

MAPS begins with a visit by the art teacher to the classroom or residence of the student to be integrated. He or she meets the student and from the student, teacher and/or parent/guardian/careworker discovers the student's strengths, needs, likes, dislikes, and response potential.

Before the special needs student comes to art class, the teacher engages the class in a discussion or possibly a simulation of disabilities, eliciting class feelings, perceptions, and knowledge. Efforts are made to recognize similarities among people and to understand functional physical, intellectual, and emotional differences. Information gathered in the initial interviews is then used to introduce the student, to describe his or her unique needs, and to solicit potential tablemates and a circle of friends. When possible these students later meet with the art teacher and a special education teacher or counselor to discuss and prepare a written list of things they can do to welcome and assist the student.

After a few weeks, a second meeting with the circle of friends and tablemates, the special needs student, teachers, or a parent/guardian is called to review what is happening and to solicit additional suggestions. Stainback et al., (1989) list questions asked in this type of meeting. These include, "What is (name)'s history?" "What is your dream for (name)?" "What is your nightmare?" "Who is (name)?" (soliciting personal traits) "What are (name)'s strengths, gifts, and talents?" "What are (name)'s needs?" "What would an ideal day for (name) look like?"

Peer Assistance
Teachers integrating students with disabilities have found that other students are natural and very important partners in the classroom. One or more peer assistants often share an art table with students who have special

needs. Stainback and Stainback (1985) suggest training peer assistants. By observing naturally occurring interaction among students, teachers select behaviors to foster in peer helpers. Peers are formally trained and unobtrusively prompted by the teacher to cue, prompt, reinforce desired actions, interact socially, model behaviors, talk through the steps of an assignment with a special needs student (Kohl, Moses, & Stettner-Eaton, 1984), and consequent their behaviors. While peers naturally help each other when appropriate, nondisabled peer assistants must be cautioned not to provide too much assistance or become overprotecive (Stainback & Stainback, 1985). In art studio settings peer helpers are taught to use a cue hierarchy; first, to ask if help is needed, then, to supply only as much assistance as needed; telling, showing, assisting, supplying something, or doing a task for the student. Through instruction nondisabled students learn to work as effective learning assistants.

Adult Aides/Tutors
Paraprofessional adults work under the direction of the art teacher when in the art room. When appropriately trained they can play an important supporting role for students. Appropriate training precludes an aide from providing excessive assistance or doing the art studio work for the student. With several short training sessions, paraprofessionals learn to use task analysis and a cue hierarchy, to prompt, reinforce, talk a student through a task, and assist only as much as necessary. Paraprofessionals may be trained to position students with orthopedic disabilities, manage health needs, and secure adaptive devices as instructed by other school professionals. Caution is necessary that students accompanied by paraprofessionals do not become overly dependent or that their presence does not isolate the student from art class peers (Putnam, 1992). With increasing flexibility of special education rules, paraprofessionals and even special educators can teach or assist nondisabled students in an inclusive classroom.

Curricula Modification Through Individualized Strategies
Just as each student with a disability will reveal different strengths, abilities, and constraints, art curricula manifests the range of strengths, interests, and abilities of art teachers and the constraints imposed by the political, social, and economic forces of a school district. Although each situation is different, a general framework for curricular modification is possible. Three aspects of curricula may be modified to meet the special needs of students. These are (a) the cognitive complexity of subject matter being taught; (b) the complexity or sophistication of media skills or forming processes being taught; and (c) the complexity or sophistication of visual, written, or verbal products being produced. Modification may need preplanning but can often occur during individual, in-process instruction.

Modifying Cognitive Complexity
The cognitive subject matter of art varies from simple to complex. Students with cognitive disabilities may require learning activities at the simpler levels. Students with special needs may also be gifted and capable of dealing with art problems at complex and sophisticated levels. With its genesis in an article by Tarver and Curry (1992), the following hierarchy of cognitive complexity may guide the formulation of questions and assignments.

Simpler Content Levels:
1. To make personal and spontaneous choices about art.
2. To learn (point to, say) about art elements, art subjects, facts, and definitions.
3. To use and respond to artist's use of the elements of design in art related to personal and community level subject matter.
4. To understand, describe, or use details (e.g., design elements, subject matter) with works of art for communication/interpretation.
5. To understand and use art concepts (e.g., design principles, meanings based on critical and/or historical inquiry techniques).

Complex Content Levels:
6. To generalize applying knowledge from one situation to another.
7. To apply information to discuss issues (e.g., aesthetic, historic, sociopolitical).
8. To apply information to solve problems (e.g., artistic, research).
9. To interrelate ideas in patterns or themes across topics.

A word of caution is necessary. Students at all developmental levels need opportunities to make choices, discuss opinions, use imagination, and share perceptions. Maintaining a perspective to help each student grow challenges the teacher to provide opportunities for students to respond from their personal encounters, knowledge, and experiences.

Modifying Media or Forming Process Complexity
Media are used with varying degrees of sophistication. Simpler creations result from discovery and exploration while planning and experience lead to complex works of art. Whether sculpture, printmaking, painting, ceramics, photography, collage, or electronic media, each has a range of techniques or processes from simple to complex, which can be substituted for one another to allow students to work at their own level of competency. With encouragement from the teacher more complex or detail oriented uses of the media are tried and eventually mastered in a step-by-step process.

Creativity, complexity, and use of critical judgment results from extensive media experience. However, students at the lowest level of media processes need encouragement just to explore and to come to know the properties of the media. As they gain knowledge and eye-hand control, through interac-

tion with the teacher, peers, and works of art, students begin to understand the representational possibilities of a media. At this point, teachers can provide opportunities to learn specific techniques and processes and to work with structured assignments that allow for personal meaning.

Modifying Art Products

Visual, verbal, and written products result from comprehensive art instruction. Modification of any product is considered when a student's developmental level, physical coordination, energy, or tolerance of frustration precludes success, when assignments require a time expenditure beyond that of other students, or when a communication modality is weaker than the product demands. Age appropriateness is always a prime consideration when making product modification.

Visual products include paintings, drawings, sculpture, weavings, ceramic pieces, advertising, product or architectural designs or models, prints, and collages. As described, each of these can be created with a variety of media and simple to complex techniques or processes. Subject matter or themes for these, likewise, can be simple or complex. Teachers may consider aforementioned partial participation techniques or allow the special needs student to maintain spontaneity and choice while using some prepared materials. They may also substitute one media or technique for another. For example, collaged visuals may be substituted for drawing or painting, hand-building for wheel throwing, or simplified looms with color coded warp for a more complex one. All art products are enhanced by appropriate mounting or framing. Students with special needs often value their own work more when seeing it mounted or framed.

Written or verbal products of art curricula may include monologues, dialogues, dramas, or debates based on works of art, puppet shows, critical and historical reports, reflections, personal critiques, and plans for future art products. These products are modified either by simplifying the level of cognitive content of the assignment or by substituting visual, oral, or written communication modes using the student's communication strengths. A student who has difficulty writing may tape-record or orally present information. They may use a peer recorder or contribute to a cooperative group effort without using weaker communication skills. Similarly, a student may express ideas in a drawing that cannot be expressed in words.

Evaluation

Evaluation is essential to all education. It is a vital aspect of instruction. Throughout this chapter evaluation of student development and student needs, as well as assessment of the effectiveness of strategies has been recommended. Without ongoing evaluation, student needs cannot be understood, curricula cannot be implemented at appropriate levels, and judgments about the effectiveness of methods of instruction and strategies for

classroom management cannot be made. The teacher must gather and process evaluative information in order to plan.

In addition to its diagnostic and decision-making functions, evaluation is used to assess progress toward meeting the objectives of art education as defined by a school district. Evaluation procedures that focus on what a student "should" know rather than what a student does know are detrimental to students experiencing disabilities. What a student does know and understand, and the skills that have been mastered can be determined through observation, class discussion, formal interviews, checklists, letters to the teacher that are either tape-recorded or written, fulfilled contracts, and portfolios or process folios. Assessment through observation or questioning during class may provide a false picture of nonmastery. Students with disabilities may be unresponsive or seem disinterested, fearing embarrassment in front of peers. Formal tests also present many disadvantages. Students with disabilities may not be able to read the questions, to comprehend the language used, or to understand the form of what is requested. They may be distracted by noise, movement, or even fear during a test. If the art teacher has developed individualized goals for the student, these can be evaluated through a checklist format. However, the checklist may not assess all of the student's knowledge, understanding, and accomplishments.

Evaluative formats that are individualized and that reflect the students' own progress are preferable. Although these forms of evaluation may seem too time-consuming, many of them can be accomplished within cooperative or peer assistance formats. Using oral, tape-recorded, or written communication modes, students can discuss their knowledge, understanding, valuing, reasoning, and concerns in the form of letters or messages to the teacher. They can present reports as visual displays, dramas, or written/taped documents.

Much has been written about portfolios or process folios as evaluative tools in contemporary art education. A portfolio or process folio preserves assignments, contracts, preliminary plans, sketches, false starts, incomplete works, completed work, contemplated work, and the reflective or assessive thoughts of the student in taped or written modes. Using questions appropriate to the student's level of cognitive complexity as outlined in a previous section, a teacher reviews with the student his or her accomplishments over a period of time. Portfolio reviews provide more detailed information for understanding student needs, evaluating progress in meeting art education objectives, and for developing individualized curricula.

Conclusion

"A Way In" for students with special needs requires a comprehensive approach. This includes good environmental management, good student management and disciplinary practices, knowledgeable approaches to modifying instruction and curricula to meet the diverse needs of individual stu-

dents, and ongoing assessment of practices and outcomes. As the art teacher works to provide for effective integration or inclusion, he or she must feel comfortable. Discomfort indicates a problem exists, signaling the use of daily reflection and classroom research methods, and to consult or collaborate with others (Guay, 1995). The teacher, as well as students, needs to feel successful, and secure. With well planned strategies, problems can be lessened or solved.

References

Anderson, F. E. (1994). *Art-centered education and therapy for children with disabilities.* Springfield, IL: Charles C. Thomas.

Blandy, D., Pancsofar, E., & Mockensturm, T. (1988). Guidelines for teaching art to children and youth experiencing significant mental/physical challenges. *Art Education, 41*(1), 60-66.

Brophy, J. (1981). Teacher praise: A functional analysis. *Review of Educational Research, 51,* 5-32.

Brophy, J. E. (1983). Classroom organization and management. *The Elementary School Journal, 83*(4), 264-285.

Dreikurs, R., Grunwald, B., & Pepper, F. (1971). *Maintaining sanity in the classroom: Illustrated teaching techniques.* New York: Harper and Row.

Doyle, W. (1986). Classroom management and organization. In M. Wittrock (Ed.), *Handbook of research on teaching* (3rd ed., pp. 292-431). New York: Macmillan.

Forest, M., & Lusthouse, E. (1990). Everyone belongs with the MAPS action planning system. *TEACHING Exceptional Children, 22*(2), 32-35.

Gearheart, B. R., Weishahn, M. W., & Gearheart, C. J. (1992). *The exceptional student in the regular classroom.* New York: Merrill, an imprint of Macmillan Publishing.

Glasser, W. (1977). Ten steps to good discipline. *Today's Education, 66,* 61-63.

Guay, D. M. (1994). Students with disabilities in the art classroom: How prepared are we? *Studies in Art Education, 36*(1), 44-56.

Guay, D. M. (1995). The sunny side of the street: A supportive community for the inclusive art classroom. *Art Education, 48*(3), 51-56.

Johnson, D. W., & Johnson, R. T. (1987). *Learning together and alone: Cooperative, competitive, and individualization.* Englewood Cliffs, NJ: Prentice Hall.

Johnson, D. W., & Johnson, R. T. (1986). Mainstreaming and cooperative learning strategies. *Exceptional Children, 52,* 553-561.

Kohl, F., Moses, L., & Stettner-Eaton, B. (1984). A systematic training program for teaching non-handicapped students to be trainers for severely handicapped schoolmates. In N. Certo, N. Haring, & E. R. York (Eds.), *Public school integration of severely handicapped students* (pp. 185-196). Baltimore, MD: Paul H. Brooks.

Kounin, J. (1970). *Discipline and group management in classrooms.* New York: Holt, Rinehart, and Winston.

Luke, M. D. (1989). Research on class management and organization: Review with implications for current practice. *QUEST, 41,* 55-67.

Lyons, C. M. (1992). Teaching elementary school children with mild special needs in the regular classroom. In L. C. Cohen (Ed.), *Children with exceptional needs in regular classrooms* (pp. 37-47). Washington, DC: National Education Association.

National Association of State Boards of Education Study Group on Special Education. (1992). *Winners all: A call for inclusive schools*. Alexandria, VA: The National Association of State Boards of Education.

Pavey, D. (1980). *Art based games*. Denver, CO: Love Publishing.

Putnam, J. W. (1992). Teaching students with severe disabilities in the regular classroom. In L. C. Cohen (Ed.), *Children with exceptional needs in regular classrooms* (pp. 118-142). Washington, DC: National Education Association.

Rees, T. (1992). Students with hearing impairments. In L. C. Cohen (Ed.), *Children with exceptional needs in regular classrooms* (pp. 98-118). Washington, DC: National Education Association.

Rynders, J., Johnson, R. T., Johnson, D. W., & Schmidt, B. (1980). Producing positive interaction among Down syndrome and non-handicapped teenagers through cooperative goal structuring. *American Journal of Mental Deficiency, 85*, 268-273.

Sisterhen, D., & Ratatori, A. F. (1989). In A. F. Ratatori & R. A. Fox (Eds.), *Understanding individuals with low incidence handicaps: Categorical and noncategorical perspectives* (pp. 93-132). Springfield, IL: Charles C. Thomas.

Stainback, S., & Stainback, W. (1985). *Integration of students with severe handicaps into regular schools*. Reston, VA: The Council for Exceptional Children.

Stainback, S., Stainback, W., & Forest, M. (1989). *Educating all students in the mainstream of regular education*. Baltimore, MD: Paul H. Brooks.

Sternberg, L. (1982). Perspectives in educating severely and profoundly handicapped students. In L. Sternberg & G. L. Adams (Eds.), *Educating severely and profoundly handicapped students* (pp. 3-9) Rockville, MD: Aspen.

Tarver, S. B., & Curry, J. A. (1992). Gifted students in regular classrooms. In L. C. Cohen (Ed.), *Children with exceptional needs in regular classrooms* (pp. 143-162). Washington, DC: National Education Association.

Wolery, M., Werts, M. G., Caldwell, N. K., Snyder, E. D., & Lisowski, L. (1995). Experienced teachers' perceptions of resources and supports for inclusion. *Education and Training in Mental Retardation and Developmental Disabilities, 30*(1), 15-26.

York, J. (1995). Issues raised in the name of inclusion: Perspectives of educators, parents, and students. *Journal of the Association for Persons with Severe Handicaps, 20*(1), 31-44.

Chapter 4

A Disability Aesthetic, Inclusion, and Art Education

Doug Blandy

Dennis Bye chronicles his life in books of his own making.[1] All are bound along the left-hand edge with minute pieces of masking tape interwoven within the pages. Each page is collaged from the debris of Bye's life and the lives of his friends, colleagues, and acquaintances. Any given page of Bye's books may contain images constructed of cellophane tape, newspaper circulars, magazine illustrations, mail-order catalog pictures, calendars, Polaroid film packages, Polaroid photographs, mattress tags, bumper stickers, work reports, shopping bags, and political circulars. Bye's books are about 100 pages in length. Most of the instant photographs in the books were taken by Bye; many of the photographs are self-portraits.

Bye uses his books as a source of communication with others. His books are meant to be experienced with him sitting at your side, as you and he leaf through them. For Bye, they are a primary source of communication. His speech is difficult to understand and few of those he encounters know sign language.

Bye is middle-aged. The details of his life are largely unknown; however, those years that experts in human development acknowledge as formative were spent in a large state-run residential institution for people labeled mentally retarded. Acquaintances of Bye believe that it was while confined to this institution that he began making books. It is likely that this setting provided him with little beyond absolute necessity. Imagine his life with little or no art education, few art materials, limited personal space, no personally guaranteed safe place for keeping books, and little if any encouragement to make books. Bye was perceived by others as limited intellectually, with a future predicated on disability rather than ability.

Bye's books confront the prejudices with which he has to live. Through his books he insists that we see him as passionately connected to that which he holds to be important and as an intelligent observer and documentarian of what transpires around him. He refuses to portray himself as a victim or as helpless, demanding that he be recognized as an active, expressive, and contributing member of the community. His books are more potent than any document drafted by educators or human service workers defining him as mentally retarded.

Bye's books, because of their self-advocacy and attention to his story of living as a person called disabled, embody an emerging aesthetic orientation that is being identified by members of the disability rights movement as the "disability aesthetic." In this chapter I will describe this aesthetic orientation and present artists who are involved in its evolution. I will also discuss the disability aesthetic in relation to disability culture. Multicultural approaches to art education that can accommodate the disability aesthetic will be recommended. Readers are encouraged to include this aesthetic in a variety of art education settings.

A Disability Aesthetic

Performance artist Cheryl Wade is a primary proponent of the disability aesthetic. Wade proposes, in the November/December 1994 issue of the *Disability Rag*, a manifesto for those artists working with this aesthetic orientation. An artist known for exploring her experience of rheumatoid arthritis, Wade suggests that art emerging from a disability aesthetic consciousness tells stories about people with disabilities, "where we came from, where we're going, how we got here" (p. 29). For Wade, this is the art of survivors, art that makes the invisible visible; "the silenced insisting on Voice" (p. 29). This is an aesthetic defined by shame and pride, an aesthetic that encourages people with disabilities to make art that "entertains, enlightens, educates. Art that takes us out of isolation. Art that transforms lives. Art that embraces every complex part of who we are, alone and together, in this horrifying and exquisite journey" (p. 31). Other visual artists who are assisting in the evolution of the disability aesthetic are cartoonist John Callahan, photographer David Hevey, and painter Ernie Pepion.

Callahan's cartoons, which are syndicated nationally and have also been collected in several books, illustrate the dissonance being experienced as conceptions of disability are radically redefined. In one of his cartoons, *Old Gymnast's Home*, four older adults are shown doing handstands on their walkers. In another, a faith healer commands a wheelchair user to "heal," only to find him out of his chair, by his side, and acting the part of a heeling dog (Callahan, 1990). Callahan's drawings demand that viewers rethink conceptions of disability as they simultaneously become uncomfortable with the stereotypes that people bring to their encounters with people who have disabilities.

Photographer David Hevey (1992) speculates on disability and artistry through photographs that attend to images of people with disabilities that are common to charity and advocacy campaigns, or images made by fine arts photographers who portray people with disabilities as grotesques or naives. Hevey's photographs, and the workshops that he facilitates, provide the means through which people with disabilities can put themselves in the picture (Finger, 1994). Photographs are conceived by him as part of a lib-

eratory process through which people with disabilities actively subvert commonly held stereotypes associated with disability.

Ernie Pepion's paintings respond to discrimination in his experience as a Blackfoot Indian and a quadriplegic. In a letter to Lucy Lippard (1990) Pepion wrote that "painting is the language I use to express my feelings about the degradation we all experience at different times" (p. 41). Exemplary of Pepion's work is *Sun Dancer* which came about after he dreamt of dancing at a Powwow and *Buffalo Jump* which "shows him riding a hobby horse/wheelchair over a cliff, wearing a trucker's cap that reads 'oops'" (Lippard, 1990, p. 41).

Wade, writing in a climate the produces artists like Bye, Callahan, Pepion, and Hevey, continues to define and clarify the disability aesthetic. For example, in a review of several film/video documentaries, she notes that artists with disabilities are "beginning to control some of the images that reveal us to ourselves and others" (Wade, 1995, p. 30). That is "disability comin' at ya from the inside out" (p. 30). She believes that images made from this consciousness can provide contextual information about what it means to live as a person with disabilities and the history of the disability rights movement. Such images present a multidimensional view of people with disabilities "having fun, working, playing, loving...body image, crip pride, activism, medical oppression, anger, 'helping systems,' access, language, sexuality" (p. 31).

Bob Flanagan and his partner Sheree Rose are two artists who are working to present multidimensional views of what it means to live as a person with disabilities. Flanagan's and Rose's art is controversial and disturbing to many. Flanagan, who has cystic fibrosis, and Rose, who does not, present multimedia installations that explore Flanagan's experience of the relationship between sex and illness.

The multidimensionality of people with disabilities, and the disability aesthetic, is also being elaborated when Julia Trahan (1994) describes herself as "being a 27 year old flamboyant but shy performance artist, hemiplegic tomboy dyke who walks with a fluorescent-colored crutch" and her home as "those wonderful moments when I am complete in all my tough but sweet, limping brains and beauty" (p. 13). Ralf Hotchkiss's desire to design wheelchairs that are "hand-powered vehicles that will handle rough ground as well as fit in a house" (*Designer dreams of ultimate wheelchair*, 1994, p. 4D) or Marilyn Hamilton's "screaming neon" chairs that communicate there is no shame in being disabled (Shapiro, 1994, p. 213) also present the multidimensionality of people with disabilities.

The disability aesthetic is fostered by an emerging disability culture that is reinforced by the continued growth in numbers and power of the disability rights movement, consisting of a loose coalition of such groups as the Disability Rights and Defense Fund (DREDF), American Disabled for Accessible Transit (ADAPT), and the Association for Retarded Citizens (ARC). The disability rights movement is united behind the belief that hav-

ing a disability is nothing to be ashamed of, is under no condition a rationale for discrimination, and is not "tragic or pitiable" (Shapiro, 1994). This movement recently coalesced around efforts to pass the Americans with Disabilities Act (ADA) in the late 1980s and early 1990s. However, the history of the movement can be traced to the civil disobedience of the League for Physically Handicapped during the great depression, the post-World War II advocacy efforts by parents of children with disabilities, actions by members of the community with disabilities in the early 1970s to encourage the full implementation of Section 504 of the *Rehabilitation Act of 1973*, and the Gallaudet student protests in the late 1980s (Shapiro, 1994).

A 1985 Louis Harris and Associates poll reported that 74% of people with disabilities believe that they share a common identity. Forty-five percent believe that as people with disabilities they constitute a minority group. With the estimated number of people with disabilities at between 43 million and 120 million, this would make them by far the largest minority group in the United States. It is likely that the ground swell of activity within the community of people with disabilities promoting the passage of the ADA has increased group identity (Shapiro, 1994).

Cheryl Wade is also a prominent advocate of disability culture. For her, "disability culture is passing the word that there's a new definition of disability and it includes power" (Wade, 1994, p. 15). Disability culture "is the moan and wail of blues. Maybe it's the fierce rhythms and clicking heels and castanets of flamenco. Maybe it's outsider art. Passing the word. Maybe the word is authentic movement, that dance that flows from the real body notes of cripples. Maybe it's the way pieces of cloth are stitched together to commemorate a life, to remember a name. Maybe it's American Sign Language, a language that formed the foundation of a cultural identity for a people, Deaf people, and bloomed into ASL performance art and ASL mime." (p. 17).

Wade's assessment of disability culture is in keeping with Lippard's (1990) views on culture in America. Lippard observes that women and artists of color "are struggling to be perceived as subject rather than object, independent participants rather than socially constructed pawns" (p. 7). Wade's description of disability culture certainly indicates that the struggles of women and people of color are common to people with disabilities as well. This is a struggle to reclaim personal identity resulting from a collision of self with what Lippard recognizes as "stereotypes and other socially constructed representations" (p. 11). This reclamation process is another driving force behind disability aesthetics.

The Disability Aesthetic and Art Education

Art educators working in schools, museums, galleries, community art centers, and recreation facilities have responded to the laws and initiatives encouraged by the social actions of the disability rights movement. For example, since the mid-1970s art educators have been teaching students

with disabilities in mainstreamed or inclusive classrooms as a result of the Education for All Handicapped Children Act (now Individuals With Disabilities Education Act). A substantial body of instructional strategies and curricular plans promoting the inclusion of students with disabilities in art education has been produced. Exhibits congruent with the Rehabilitation Act of 1973 have been held in numerous museums and galleries. The National Assembly of State Arts Agencies (NASAA) and the National Endowment for the Arts (NEA) recently published a comprehensive guide for arts organizations on designing and implementing accessible art environments and programs (National Assembly of State Arts Agencies & National Endowment for the Arts, 1995).

Art educators should now expand upon these responses to constituencies with disabilities by acknowledging that significant numbers of people with disabilities believe that they belong to a specific cultural group characterized by shared values, attitudes, and beliefs, as well as a history of discrimination and prejudice. This acknowledgment should include recognizing that integral to disability culture is an emerging aesthetic orientation that is expressive of the group's common experiences of living with a disability.

Art educators can seek guidance in general education, special education, and art education for accommodating the disability aesthetic. Particularly useful is the research of Carl A. Grant and Christine E. Sleeter (1985; 1989) on multicultural approaches to education. The research of these scholars is already familiar to the field through Stuhr's (1994) discussion of their work in relation to social reconstruction and art education. Grant and Sleeter, through their exhaustive review of English language resources on multicultural orientations, formulated five approaches to including multicultural perspectives in educational programs. These approaches include teaching the exceptional and culturally different, the human relations approach, single group studies, multicultural education approach, and the multicultural and socially reconstructivist approach (Grant & Sleeter, 1989).

It is possible to accommodate the disability aesthetic within all five approaches. However, for the purposes of this chapter, I will concentrate on only two: the multicultural approach and education that is multicultural and socially reconstructivist. The socially reconstructivist orientation of these two approaches is congruent with the goals and aspirations of the disability rights movement and the disability aesthetic. The latter responds, in part, to perceived well-documented social inequities experienced by people with disabilities. People with disabilities experience economic, political, social, and psychological hardships that can only be described as very serious and sometimes deadly. Employment training programs are few, medical services tenuous; and poverty, rape, and sterilization not uncommon (Fine & Arch, 1985; 1988).

Art educators and students subscribing to Grant and Sleeter's multicultural education approach teach and learn about the disability aesthetic within an educational environment dedicated to equal opportunity, social

justice, the equitable distribution of power, and the elimination of discrimination and prejudice. The entire educational program is devoted to the "awareness, acceptance, and affirmation of cultural diversity" (Grant & Sleeter, 1989, p. 53). Art educators and their students, teaching and learning within this approach, promote an educational experience in which what is taught and learned is as important as the environment in which the teaching and learning takes place. For example, faculty members are reflective of the cultural diversity that exists in American society; therefore, faculty with disabilities would be expected. Art by people with disabilities is included to communicate the insights and experiences of this cultural group. The disability aesthetic would be included among the aesthetic orientations of other cultural groups. Self-representations of various cultural groups is emphasized. For example, Pepion's paintings are studied because they portray Blackfoot tradition as well as identify with people who have disabilities. Hamilton's wheelchair designs are studied to encourage insights into disability pride. Callahan's cartoons might help illustrate cross-cultural conceptions of humor.

Art educators and students teaching and learning within Grant and Sleeter's multicultural and socially reconstructivist approach are multicultural in their orientation to art and aesthetics as well as socially critical. Within this approach art educators and their students reflect on their place in society and learn skills for initiating social action towards a more equitable society. Generally accepted assumptions about society are questioned. Cooperative relationships among interest groups for the purpose of effecting social change are encouraged.

The activist character of some images produced by artists with disabilities is emphasized in the multicultural and socially reconstructivist approach. Also emphasized is the depiction of personal goals and aspirations in relation to sociocultural contexts. The liberatory process that is integral to the disability aesthetic is fully congruent with this form of critical pedagogy. Within this approach Bye's books, for example, are studied for their social change rhetoric and advocacy for changing public perceptions of mental retardation. Hevey's photographs could be considered in much the same way. Wade's media criticism is studied in the larger context of art criticism as advocacy criticism.

Conclusion

This chapter promotes the inclusion of the disability aesthetic within art education settings. People with disabilities contribute to this aesthetic orientation by making art that self-advocates, is self-referential, is at times socially activist, and which documents the experience of being disabled. This is an aesthetic that can be appreciated both by people with, and without, disabilities, one that is evolving across arts disciplines. Within the visual arts disciplines it is evidenced in the fine arts, the popular arts, and indus-

trial design. It is also an aesthetic orientation that is being experienced in how people think about their everyday lives. This aesthetic is emerging from a disability culture shaped by decades of social action towards the construction of an equitable society. Art educators are encouraged to adopt multicultural and/or multicultural and socially reconstructivist approaches to art education as a means for including the disability aesthetic in art education programs. Inclusion must now be understood to be more than just the physical accommodation of people with disabilities in art education settings. Inclusion must also be understood as the accommodation of the cultural expressions of this community, embracing a disability aesthetic.

References

Blandy, D. (1991). The handmade books of Dennis Bye: Self-documentation as aesthetic-expressive criticism. In D. Blandy & K. G. Congdon (Eds.), *Pluralistic approaches to art criticism* (pp. 96-102). Bowling Green, OH: Bowling Green State University Popular Press.

Bye, D. (1992). Artist's book. *Northwest Review, 30*(3), 77-89.

Callahan, J. (1990). *Do not disturb any further.* New York: Quill.

Croce, A. (1995). Discussing the undiscussable: When players in a production aren't just acting out death but are really dying—as in Bill T. Jones's "Still/Here"—is it really art? *The New Yorker, 70* (43), 54-60.

Designer dreams of ultimate wheelchair. (1994, December 26). *The Register-Guard*, p. 4D.

Fine, M., & Arch, A. (1985). Disabled women: Sexism without the pedestal. In M. J. Deegan & N. A. Brooks (Eds.), *Women and disability: The double handicap* (pp. 6-22). New Brunswick: Transaction Books.

Fine, M., & Arch, A. (1988). Introduction: Beyond pedestals. In M. Fine & A. Asch (Eds.), *Women with disabilities: Essays in psychology, culture, and politics* (pp. 1-37). Philadelphia: Temple University.

Finger, A. (1994). Toward a theory of disability photography. In B. Shaw (Ed.), *The ragged edge* (pp. 28-33). Louisville, KY: Advocado Press.

Grant, C. A., & Sleeter, C. E. (1985). The literature on multicultural education: Review and analysis. *Educational Review, 37*(2), 97-118.

Grant, C. A., & Sleeter, C. E. (1989). Race, class, gender, exceptionality, and educational reform. In J. A. Banks & C. A. McGee Banks (Eds.), *Multicultural education issues and perspectives* (pp. 49-66). Boston: Allyn and Bacon.

Hevey, D. (1992). *The creatures time forgot: Photography and disability imagery.* London and New York: Routledge.

Lippard, L. R. (1990). *Mixed blessings: New art in a multicultural America.* New York: Pantheon.

National Assembly of State Art Agencies & National Endowment for the Arts. (1995). *Design for accessibility: An art administrator's guide.* Washington, DC: Author.

Shapiro, J. P. (1994). *No pity: People with disabilities forging a new civil rights movement.* New York: Times Books.

Shaw, B. (Ed.). Finger, A., & Wade, C. (Guest Eds.). (1995). A celebration of disability culture. *The Disability Rag and Resource, 16*(5).

Stuhr, P. L. (1994). Multicultural art education and social reconstruction. *Studies in Art Education, 35*(3), 171-178.

Trahan, J. (1994). Finding my way home. *Mouth, 5*(2), 13-14.

Wade, C. M. (1994). Disability culture rap. In B. Shaw (Ed.), *The ragged edge* (pp. 15-18). Louisville, KY: Advocado Press.

Footnotes

[1]For a more detailed discussion of Dennis Bye's books see Blandy (1991) and Bye (1992).

[2]The disability aesthetic is not universally embraced. For example, see Croce's (1995) comments on Bill T. Jones's *Still/Here*. Croce describes this dance as "victim art." As such, she chooses not to review it. Croce argues that "the cultivation of victimhood by institutions devoted to the care of art is a menace to all art forms..." (p. 5).

[3]For more information on disability culture see the September/October, 1995 issue of *The Disability Rag and Resource*. This issue features several articles on the topic (Shaw, Finger, & Wade, 1995).

Curricular Issues: The Visual Arts and Students With Disabilities

R. Gloria Pappalardo

Reaching Out to Reach Within

As we enter the 21st century in education, we must be concerned with a quality visual arts education for all students. Every elementary and secondary school should provide a sequential visual arts curriculum that integrates the study of art production/creative expression, aesthetics, art criticism/analysis, and art history/culture. Because the visual arts have always been considered a universal language and a discipline that reaches out to all students, we must plan and create a visual arts curriculum that includes the student with a disability. The study of the visual arts develops the intellect and increases visual sensitivity, therefore enabling the student to identify and solve problems more effectively through manipulation of materials and/or verbal discussion. More and more schools are mainstreaming and/or including students with disabilities in a general education classroom. One will find less self-contained "art classes" for students with disabilities. These students have become a part of the general educational program requiring the provision of the least restrictive situation and more involvement with general education students and society.

As this has occurred, little has been done by school districts to prepare the visual arts specialist with knowledge or assistance as to means for working with students with disabilities or addressing curriculum or units of study for these students. Visual arts specialists struggle with how to reach the student with disabilities, often watering down the unit of study or lesson and/or lowering standards for them. This chapter is designed to provide some information for visual arts specialists who work with mainstreamed and/or included students with disabilities. It is the point of view of this writer that with a basic understanding of the students with disabilities, the art specialist can adapt the regular visual arts curriculum, allowing students an opportunity to enjoy positive visual arts experiences and an opportunity to express themselves verbally and visually. Thus, the visual arts will become a natural part of their learning process and of great value to students' abilities to create their own images and forms, and to make aesthet-

ic inquiries, as well as informed judgments and understanding of art history and culture based on knowledge and experience.

"How do you treat a person with a disability?" "How do you plan a visual arts program for a person with a disability?" By far, the most important thing to keep in mind is that the student is an *individual* first—an individual who just happens to have a disability; you are dealing with a *person*, not a *label*. Many barriers faced by students with disabilities are attitudinal. For instance, many people see them as "different" and treat them as such. The teacher should treat them as any other students deemed more "able," concentrating on their *strengths* rather than their weaknesses; be *positive* and *honest*.

You will discover that these students have much in common with you and all other people, and then you will cease to be uncomfortable. The population of people with disabilities includes individuals who have speech, hearing, or vision impairment, or physical, emotional, mental, or learning disablilities. Within each category of disability, the range and variation of personalities and traits are as extensive as with all people. In general, people with physical and mental disabilities have the same desires to succeed as anyone. The visual arts give them the opportunity to express themselves both verbally and visually, developing self-worth and self-esteem.

The more you know about specific disabilities, the more comfortable and natural you will feel around people with disabilities. You will enjoy knowing them as individuals and be able to concentrate on what they *can do*, rather than on what they cannot do. Units of study will stress their level of learning and/or style of learning including the same concepts and objectives. The visual arts curriculum will be adjusted to meet the needs of the student with disabilities, but not "watered down."

How Do You Treat the Special Person?

In understanding students with special needs you must realize that some students have multiple disabilities. For example, a person with mental retardation may also be visually impaired; a student who is deaf might have an emotional disability; a person with a physical disability may also have a learning disability. While the disabilities have been categorized under specific headings, you may need to incorporate several of the teaching methods or areas discussed, based on the students' needs. Keep in mind that some individuals may be on medication that may make them appear lethargic.

Try to reduce competition by avoiding comparisons between individuals' work with the group, especially in a mainstreamed or included situation. Vary your method of presentation, allowing for alternatives that may work better. Include demonstrations, role-playing and movement, visual reinforcement, oral as well as written instructions, and tactile (feeling or touching) experiences.

The enthusiasm you generate will be contagious. Patience—Patience—Patience! Verbal and nonverbal praise encourages continued interest and

motivation. Don't be afraid to reward appropriately. Your positive attitude will be recognized by students with special needs and by nondisabled students and will create a positive environment for all. Seek assistance from the child study team. They are great support professionals. Check students' Individualized Education Program (IEP) and participate in writing it.

When teaching art lessons, it is often better to *show* the students than to *tell* them how to do something. When speaking, seek eye contact and call students by name. Allow students to work independently. If an aide or another student helps the student with disabilities, don't let them rob the student with a disability of his or her opportunity to create.

If someone has a seizure (convulsion) in the art room, follow these rules:

- Clear away any objects on which the student might be injured if he or she falls or flails.
- Do not try to restrain his or her movements.
- Do not force anything between the student's teeth. He or she will *not* swallow the tongue.
- The convulsion should be over in less than 2 minutes. If he or she does not appear to be coherent after the seizure, send for help. Alert medical personnel of the situation.
- Be calm—do not overreact and upset others.

General Information

Learning Disabilities (Neurologically Impaired, Perceptually Impaired)
A student with a learning disability generally has average or above average intelligence and can learn at the same time rate as his or her age peers. Unfortunately, the method of learning is somewhat different. He or she has trouble with one or more of the following skills: listening, thinking, speaking, reading, writing, spelling, arithmetic, fine and gross motor coordination. This student needs success, large and small! All visual arts activities should be organized from simple to complex in order for the student to experience some positive success. Give directions one step at a time, using varied methods: verbal, visual, and kinetic. If teaching art history/culture, doing aesthetic scanning or critical analysis allow the student time to think and respond verbally. Make positive comments and ask leading questions.

The student with a learning disability may

- Become frustrated easily. Reduce this by limiting directions, background noise, visual confusion, space.
- Be clumsy and awkward or have trouble making his or her hands do what the eye sees.
- Exhibit disruptive behaviors such as restlessness, short attention span, or a hostile attitude. Do not assume that the student is not enjoying the

activity. It could be that he or she is afraid of sounding foolish, of making a mistake, or of becoming frustrated.

When working with a student with a learning disability

- Give extra motivation and lots of praise. Establish and maintain routines (time patterns).
- Give directions in single units. For instance, instead of saying "Take out your art journal, and using pencil and white paper, copy the vocabulary words in column one," *instead say*, "Take out your art journal (pause) now open to a clean page and take your pencil (pause), find the vocabulary column one (demonstrate). Now copy the words into your journal." This rule applies to older students as well as to younger ones.
- Provide secluded and/or quiet areas for students with distraction problems.
- Offer a choice of media for exploring techniques and skills. Allow for individual needs.
- Be aware of low frustration levels. Help the student address the problem and deal with it.
- Be positive and praise when necessary, always considering a student's self-esteem.
- A buddy student or an aide will be helpful in keeping the student on target. Be sure the person only helps the student with a disability with *understanding* the problem but *does not do the task for him or her.*

Orthopedic Disabilities (Orthopedically Handicapped)
An individual with an orthopedic disability has a condition that prevents or slows down the ability to move. People with physical disabilities can be recognized as those requiring, for example, wheelchairs, crutches, braces. Some may have involuntary musculature movements or sensory loss. Individuals with physical disabilities may or may not have mental retardation. Do not assume that someone with limited motor and communication abilities has mental retardation. Some common types of physical disabilities are cerebral palsy, muscular dystrophy, spina bifida, and others that may have occurred due to an injury.

The person with a physical disability may

- Have a poor hand grasp.
- Have jerky or shaky motions and uneven body movements.
- Have a startled reaction when approached or suddenly touched.
- Often trip or fall if ambulatory.
- Have difficulty in imitating motor movements.
- May move slowly due to crutches, braces, or a wheelchair.
- May not have all his or her limbs.

When working with individuals with physical disabilities:

- Be sure materials are easily accessible and use adaptive devices, if needed, to increase independence. Use appropriate materials (i.e., wider pencils for handgrip, squeeze scissors, and open-mouth containers for paint or paste for uneven body movements).
- Many people with physical disabilities can move around independently and maneuver their own wheelchairs. Some may require assistance with ramps, doors, etc. However, *ask if they need help before you give it.* Remember that they are dealing with their disability and don't rob them of their independence.
- Ensure that facilities are accessible, appropriate, and safe. Remove unnecessary obstructions when experiences are designed to motivate physical exercise.
- When planning, ensure that there are opportunities for personal expression and self-worth.
- Allow twice as much time for movement.

Emotional Disabilities and Behavioral Disorders

The person with an emotional disability may exhibit one or more of the following characteristics, which adversely affect educational performance:

- An inability to learn that cannot be explained by intellectual, sensory, or health factors.
- Inappropriate behaviors or feelings such as being easily frightened or having irrational fears.
- Inability to build interpersonal relationships with peers or teachers.
- A pervasive mood of unhappiness or depression or rapid mood change.
- Physical symptoms of behavior associated with personal or school problems (i.e., hostile attitude, destructive behavior, impulsive behavior).
- Avoidance of direct eye contact.
- Responsiveness to directions by squirming or being hostile.
- Hyperactivity or withdrawal.
- Need for an unusual amount of prodding to complete a given task.

When working with the individual with emotional disabilities, check with support personnel. Follow the general guidelines for a consistent, well-coordinated planned behavior program. Observe the following general guidelines:

- Have lessons as structured as possible but flexible with individual expression. Give the student a small amount to do at one time with praise at each step to encourage completion.

- Provide the student with activities in which he or she is able to expand energy positively, foster confidence through quickly achieved success, and build on it.
- Have a minimum of supplies within reach, particularly if they can be spilled or broken. Give verbal and nonverbal recognition for efforts.
- Give the student extra attention if he or she responds to it, but do not force attention on the student if he or she withdraws. Reward positive behavior with concrete or nonverbal (i.e., wink, smile) expression.
- Encourage group discussions on personal expression through arts to help the student learn to express his or her emotions (anger, joy, sadness) in appropriate ways.
- Identify each person's individual space where the student feels safe and cared about.
- Establish procedures, rules, and expectations and follow them consistently. Be prepared by planning alternatives and appropriate steps for discipline. If a student's behavior becomes too disruptive, send for help. *Do not* leave the group.
- Look at the student when you ask short questions. Listen attentively.

Behavioral Disorders (Socially Maladjusted)
The personal with a behavioral disorder has a consistent inability to conform to the standards for behavior set by the school. Characteristics include

- Difficulty with interpersonal relationships with peers or adults.
- Inappropriate behaviors such as fighting and loud talking.
- Rebelliousness to authority figures.
- Difficulty accepting authority figures.
- Behaviors that reflect hostility and possible destructiveness.
- Extreme difficulty in following socially expected behaviors and school rules.

When working with the student who has a behavioral disorder, be sure to check with support personnel and/or administration in order to be as consistent as possible and maintain realistic expectations.

- Be as positive as possible.
- Give the student activities that are within his or her capabilities.
- Provide positive reinforcement when appropriate and possible.
- Follow exactly the disciplinary plan specified by support personnel and administration.
- Establish procedures, rules, and expectations.

Visually Impaired (Visually Handicapped)
Only 10% of the legally blind population in America has complete loss of sight or only light perception. The other 90%, termed "visually impaired"

by the American Foundation for the Blind, has varying amounts of residual vision.

A person who is legally blind is simply someone who cannot see as well as his sighted counterpart; intelligence level is not affected by being blind.

The problem of *mobility* is probably the biggest concern for individuals who are blind. Never go up to a person who is blind and grab an arm to lead him or her around. Rather, when working with a person who is visually impaired, ask if he or she would like to take your arm and be guided. Keep the following things in mind when guiding a person who is blind:

- Stand next to, and a little ahead of the person. Bend your arm at the elbow, allowing his or her hand to be placed on your forearm.
- Walk normally, but perhaps a little slower.
- Give verbal cues along the way to orient the person to his or her surroundings.
- Give advance warnings of potential obstacles (a flag pole, an exhibit case, any protruding object, etc.).

In a world of accurate visual perception, it is crucial that the blind person be provided with (a) the opportunity to handle the object he or she is learning about, and (b) a guide who is able to give a detailed accurate description of the visual world around him or her.

For the sight-impaired, *touching is seeing*. If you are demonstrating a craft, allow the person to place his or her hands on yours as you demonstrate the activity. If the lesson was planned as a cut-and-paste activity, have the person feel the form and tear it. Place your hands over his or hers as you explain the activity.

When working with individuals with visual impairment, remember to

- Identify yourself and let them know that you are talking to them.
- Tell them if you are leaving before you walk away.
- Avoid using gestures and other visual communication that would not be available to them.
- Speak in a normal voice. Blind people are not deaf.
- Talk as you would normally. Do not be embarrassed to use words like "see" and "look."
- Remember, touching is not the only way a person who is blind can learn. If you provide a detailed verbal description of an object or of what you are doing, it can be visualized in the mind's eye. Include a description of everything: texture, weight, scent, size, volume, and even color. Try to keep the description concrete and related to familiar things. For example, rather than saying a tepee is a conical shape, compare the shape to an upside down ice cream cone. Some people who are blind have trouble with spatial relationships. Rather than describing the size of something in feet and inches, say, "It is the size

of your index finger," or "if two people as tall as you stood on your shoulders, that's how tall it would be."

- Sometimes it is helpful to give directional assistance by using the clock face method. "Your crayon is at 1:00, your paintbrush is at 7:00."

Hearing Impairments (Auditorily Handicapped)

The term *deaf* refers to a profound degree of hearing loss that prevents understanding speech through the ear. "Hearing impaired people" or "people with a hearing loss" are expressions used to indicate any degree of hearing loss, mild or profound.

A hearing impairment affects the individual's ability to learn auditorily, but he or she has some degree of usable hearing that can be improved via a hearing aid.

If the person lost his or her hearing before the age of three, he or she will have been deprived of the opportunity to establish a solid language base. As a result, a deaf person will usually be lacking in language skills, including reading and writing skills. However, it is very important to remember that inadequate language skills are not indicative of low intelligence.

When communicating with a deaf person, you must remember that he or she receives messages visually, and may depend upon lipreading or manual communication. If you are talking to someone whom you do know to be a lipreader, keep the following things in mind:

- Avoid changing your message suddenly, as in saying, "By the way, does anyone know what time it is?"
- Try to be in good lighting when talking to the person so he or she may be able to see your lips.
- Never look away or cover your mouth while you are speaking.
- Do not try to overcompensate for the person's hearing loss by shouting. Often that will result in a distortion of sound.
- Use simple, basic language, speaking clearly and at an even pace.

Many persons who are deaf are trained in the use of total communication, where a combination of sign language and finger spelling as speech is used. To many deaf people, English is a second language; they talk and think in pictures. The passive voice and slang have no place in their language. Therefore, even if you are being translated by an interpreter, keep your verbal usage simple and basic, avoiding abstractions.

Give verbal and nonverbal instructions and praise through expressions and gestures when working with people who are deaf and hearing impaired.

When working with people who are deaf and hearing impaired:

- Emphasize nonverbal communication as much as you can. Use facial expressions and gestures to help communicate your thought.

Demonstrate or act out the message you have for the person! Draw a picture.

- Carry a pad and pencil around with you to jot down key words or phrases or for any questions the person may have.
- Deaf individuals have varying abilities of spoken language skills. Listen carefully and try to understand what they are saying. If you cannot understand, do not get upset or make the person feel bad. Simply ask him or her to repeat what he or she said slowly, first; then have him or her write the question down or to act it out. Remember to repeat the question/statement to the whole class.
- Try to avoid coming up suddenly from behind deaf people. Since they cannot hear you coming, they can be startled, and can have balance or coordination problems. Be careful of quick movements that would make them dizzy.
- It is very important to let them physically manipulate objects around them.
- Remember that deaf people cannot look at an object and hear an explanation for it at the same time. The instructor needs to explain what it is they will be seeing. *Give them ample time to view and handle it*; then repeat any important instructions or explanations, slowly and clearly.
- Explore using all the senses to encourage students to communicate in nonverbal ways to more effectively express themselves.

Mental Retardation (Mentally Retarded)

A person with mental retardation is characterized by a below-average intelligence functioning and by defects in adaptive behavior. Often he or she will behave like a person much younger in age. Often he or she will progress through normal development stages but at a slower rate than other youngsters.

Degrees of mental retardation are described as:

- Mild—Individuals with mild mental retardation have the ability to learn basic academic skills and are commonly referred to as EMR (Educable Mentally Retarded). Ninety percent of individuals with mental retardation fall into this category. They can be taught the same projects as general education students but will probably take longer to finish them.
- Moderate—Individuals with moderate mental retardation are able to learn some academic, communication, social, and occupational skills. This category is commonly referred to as TMR (Trainable Mentally Retarded). They often need a greater level of direct supervision. For example, in this group are individuals with Down syndrome or with hydrocephalic, and microcephalic conditions.
- Severe/Profound—Individuals with severe/profound mental retardation are characterized by more limited abilities. They require continu-

al close supervision. Usually they can learn basic self-care skills such as washing, toileting, and feeding, and most can benefit from some training in language development and physical mobility. Persons with profound retardation are sometimes completely dependent on others for all their needs. Only 5% of individuals with mental retardation fall into this category.

Depending on the degree of the disability, a person with mental retardation might

- Exhibit poor motor and hand/eye coordination.
- Have a short attention span.
- Have a low frustration level.
- Learn best by imitation (a proper role model is important).
- Have poor abstract reasoning ability.
- Have difficulty seeing fine detail.
- Have little self-direction in choosing activities.
- Exhibit inappropriate behavior.
- Be overly affectionate, wanting to cling or hug.

When working with people with mental retardation, establish simple, consistent procedures and rules.

- Keep directions simple; break the task into progressive steps; demonstrate each task.
- Provide frequent motivation and praise.
- Be patient and allow extra time to observe and think.
- Use repetition in directions and actions. Identify all materials verbally.
- Deal in concrete ideas and terms with which they will be familiar; don't assume ability to generalize or associate from past experience.
- Use multisensory approaches to motivate.
- Allow and encourage the students to do their own work: step-by-step procedures will ensure this.
- Take a student's hands and guide him or her through the motions if the process is too difficult.
- Avoid paying attention to distractions.
- Remember that these individuals *are* capable of *learning* and are able to appreciate new experiences.
- Encourage cooperation and assistance among students.
- Plan lessons within their ability range, not chronological age.
- Encourage discussing art forms, how they were created, how they make you feel.
- Remember, they will give honest, simple answers—accept them with praise.

Preschool Delays (Preschool Handicapped)

Children between ages 3 and 5 may have developmental delays or disabilities of any type or types (language difficulties, speech problems, motor problems, etc.). These children require specialized intensive programming in a small class that may be located in the school district or elsewhere. Often occupational therapy, physical therapy, and/or speech therapy is necessary.

Generally, these children have limited academic mainstreaming or included opportunities because of their age, but they can participate in school events like assemblies and programs. When working with these children, keep in mind

- Their young chronological age.
- The possible disparity of developmental levels with age.
- The need for clear, simple, verbal messages.
- The need to be a part of the school community.
- The ability to profit and learn from being with nondisabled children.
- The possible inability to identify themselves, their address, and their telephone number.
- The need to use materials (such as paint, clay, paper, wood) in order to develop skills and use of appropriate tools or equipment.
- The need to use the visual arts as a means of expression both verbal and visual.

Communication Disabilities (Communication Handicapped)

A student with a communication disability has difficulty receiving and expressing information particularly when language is involved. Despite average intelligence, the student often appears not to understand clearly what is being said. Thus, responses are not accurate nor completely related to questions posed or information presented.

This student requires limited directions, clear and concise statements, and clarification of concepts. Use of visual clues is often helpful.

When working with a student with a communication disability:

- Be sure that he or she understands what is to be done.
- Use short, simple verbal directions and provide written ones as well.
- Clarify understandings, especially word meanings.
- Keep auditory and visual distractions to a minimum.
- Try to establish eye contact when conversing with him or her.
- Use visual images to explain a procedure.
- Use visual images created by the student to express his or her feelings or ideas.

Conclusions

The classifications used in this chapter are current terminology. The terms in parentheses are unique to the State of New Jersey. Other states may have different categories to identify students with disabilities. Recognizing the disability will enable the reader to concur with the terms unique to that respective state or part of the country. The New Jersey State Department of Education is preparing a curriculum framework for grades K through 12 at the present time. The framework will include an addendum including the basic visual arts curriculum for *all* students, including those with disabilities.

Students with disabilities will develop intellectual and visual sensitivity through visual arts experiences. The visual arts will enable them to identify and solve problems more effectively and allow them to make more positive contributions to society. Allowing these students to not only create art, but to talk about art, to view art, and to study art history and cultures will open broader horizons for them and allow them to more effectively be included in the school and community they live in.

In planning units of study in the visual arts for students with disabilities, the art specialist must keep in mind the student whose disability they are working with. Visual arts lessons must be planned carefully, allowing for the disability, but the curriculum must be developed to address a most positive, involved environment that will include *all* students. It is through patience and careful planning and working with other professionals, both art and special educators, that this is achieved.

The writer is aware that a small self-contained classroom of students with like disabilities might be easier to plan for and teach visual arts in, but this is not always the least restrictive environment. Educational settings should be offered that include the opportunity to have social experiences and inter-action with all students. In some cases this is the *best* environment but not the *least restrictive*. Each student will have an IEP (Individualized Education Program) developed by the Child Study Team, a plan that includes parental involvement. The art specialist should be aware of the IEP in order to better address the needs of the student. If possible, the art specialist should participate in meetings in which the team plans the IEPs for those students they are working with. Many school districts mainstream and/or include special population students in the general education visual arts classes. It is our obligation as art specialists to plan lessons carefully to include these students, so they may meet success and develop further feelings of self-worth as well as have better opportunities to function in society and enjoy a finer quality of life. If an aide isn't available for visual art classes, perhaps a student in an upper class can come in to assist while gaining credit for community or school service.

The mainstreamed situation and/or inclusion does work in the visual arts classroom. Be Patient—Be Calm—Be Positive!

Resources

Isaacs, Illene. Executive Director. Very Special Arts New Jersey, editing and personal conversations. 703 Jersey Avenue, New Brunswick, NY 08901.

"Kids on the Block." Series of programs of puppet performances that teach audiences what handicaps are all about. Handicapped puppets used to explain their feelings and needs. Audience participation and handicapped awareness. Heidi Goldstein, 201-379-1700.

Miele, N., Director of Special Services and Pappalardo, R. G. Supervisor of Visual Arts. Coauthors, *Students with disabilities: Understanding their needs. A guide for teachers— "Reaching out to reach within."* Randolph Township Schools, 6 Emery Avenue, Randolph, NJ 07869. 201-662-8899.

New Jersey Administrative Code Title 6 Education, Chapter 28 Special Education, Division of Curriculum and Instruction, 1994-1999 N.J.A.C.6:28.

Nutley, J. Very Special Arts of Indiana. Indianapolis, IN 46240.

Schectman, A. E.. Certified Art and Special Education Educator, personal conversations.

Schectman, A. E. (1995, September). *Insights: Art in special education: Educating the handicapped through art in special education* (6th rev. ed.). Cherry Hill, NJ: Art Educators of New Jersey. A guide for teachers of art and special education including lesson plans designed to meet needs of students with disabilities.

Very Special Arts Educational Programs, John F. Kennedy Center, Washington, DC 20566. This group provides current media, publicaitons, and resources on the disabled.

Art Education for Students with Disabilities: Practical Strategies for Successful Inclusion

Susan D. Loesl

Introduction

"The practice called 'inclusion,' can be problematic if staff do not get the time, training, and extra hands necessary to make it work" (Fischer, 1995, p. 10). This chapter will explore issues of and approaches to inclusion in schools that have experienced some difficulty including students into the art education program. This practitioner has concluded that the issues related to inclusion are nearly universal. Similarities exist between urban and rural settings, elementary through high school, and apply in affluent as well as in poor districts. Although larger urban districts may have more children with complex disabilities, they generally also have greater resources to address the needs. Most approaches that will be discussed are readily adaptable to general classroom teachers and all economic settings, while others may be unique to the art teacher. Milwaukee Public Schools, Wisconsin, has invested district funds and Individuals with Disabilities Education Act (IDEA) funds to provide the time and training to art teachers and special education teachers to move toward successful inclusion. Additionally, written documentation and district policies have been developed to ensure "informed" personnel are available to assist inclusion in the art program.

The Problem

When approaching inclusion, many teachers (art included) "get stuck" thinking that all the assistance for inclusion must come from "somewhere out there," and not from within their own repertoire of skills. Some teachers assume that they have the tools, insights, and strategies to be instantly successful with all students with disabilities in their classrooms, yet do not change the way they usually teach. Conversely, others feel that since they haven't been adequately trained to work with students with disabilities, that it shouldn't be their responsibility to get training or assistance. "If they are coming to my art class, you'd better come with them and help. I don't have

time to be sitting with only one student, you know!" Mary Falvey, in the workshop entitled, "Implementing Inclusive Education in Your Classroom," stressed that methods of working with students who have disabilities need to initially come from within oneself, and that there are a number of ways to look at the same student and the inclusion situation. We can choose to look positively or negatively at how the student's "abilities" are manifested within the classroom. Once awareness of abilities and a positive view become practice, teachers can begin to accept the inclusion process as being a team effort focused on children and not just an imposition on the general education teachers from the special education teachers.

In working with general education, special education, and art teachers in Milwaukee Public Schools, it has come to this practitioner's attention that a number of art teachers are having difficulty including students with disabilities in their art classrooms. The difficulties are felt by art teachers with art rooms and by those traveling "ala carte," from room to room. Many art teachers have stated that they entered art education to teach art, aesthetics, criticism, color theory, and a host of other "art education" issues; not sit and color all day with students who are oral with their materials or whose behaviors are completely inappropriate for an art class. Some say that "those students" will never be able to do more than scribble and be disruptive. Some feel that if students with disabilities are included in art classes it will look like the students with disabilities are "getting away with" doing what they want. It has even been stated by a high school art teacher that "the best thing you can do for me is to get them out of my building and we won't have to deal with this at all!" These statements have been expressed by art teachers at all levels who lack training, feel imposed upon, and most likely feel afraid to work with students with disabilities because they don't think they know how. What is needed are strategies that will help art teachers have positive attitudes about the inclusion process.

The Strategies

The strategies that Milwaukee Public Schools have developed include: Total School Involvement, Clarifying Misconceptions, Sensitivity, Support Systems, and Communication Strategies. Successful inclusion requires support from special education teachers and assistants, support from colleagues who are successful with inclusion, and practical ideas such as lesson plans and adaptations. Art lessons and adaptations should be available that are almost "guaranteed" to work until teachers feel confident enough to continue on their own. Most importantly, time is needed to develop a positive attitude and to practice approaches to make these strategies work toward inclusion practice. These issues are not impossible to address and implement, but they do take some understanding, patience, and time for success.

Sensitization

Mary Falvey's emphasis on first looking at one's own perceptions of persons with disabilities truly is the most important place to begin the process of inclusion. Far too many teachers are looked upon as being insensitive and uncaring if they do not eagerly embrace the inclusion process. Administrators must look to sensitizing their staff to a variety of reactions, and acknowledge the "right" of individuals to feel the way they do. The teachers who question inclusive practices must be given a voice and understanding, or they may never have the opportunity to change their minds. They may even offer some insights that were overlooked by the inclusion "pros." If teachers are expected to look at *students* as individuals with feelings, dreams, and goals, why don't we recognize that the *staff* is made up of individuals with differing feelings, dreams, and goals?

Sensitivity awareness can be very vital to a staff that is beginning the inclusion process. A national organization (with a chapter in Wisconsin) called Very Special Arts provides training workshops for all artists in residence programs and arts (art, music, and physical education) teachers. These workshops are designed to expose artists and teachers to strategies for working with students who have disabilities. These one-day workshops focus on basic characteristics of disabilities, so as to create a common language and understanding and provide appropriate activities for a wide variety of disabilities. It is stressed that each student is an individual, and although he or she may be referred to as exhibiting a certain disability, each student is a unique person, not just a disability. A number of arts teachers in Milwaukee have participated in these workshops and have expressed how it made a difference in their work. From this workshop format, the arts teachers were able to return to their own schools and more readily attend to their specific school's sensitivity training and issues. Unfortunately, many schools do not provide sensitivity training. Ideally, participation in workshops of this kind would be an opportunity to have total staff involvement in the inclusion process from the beginning.

A school can provide its own sensitivity awareness or training program in a number of ways. It can be modeled after the Very Special Arts format, or it can be created for a specific school. As a start, the school can use its own special education staff to present a general "disability overview." This presentation could be followed by a discussion of how the disabilities are specifically manifested in the classrooms in the school. This can save some time for the teachers in examining all the IEPs (Individualized Education Programs required for students with disabilities), which can be overwhelming for an art teacher of 700 students, one-fourth of whom may have a disability. Specific behavior modification techniques, reward/token economy systems, and success stories can round out the presentation. Another strategy relies on exceptional education and classroom teachers from other schools to present a process that has successfully begun. Support staff of the school district may be another vehicle through which the information is

delivered; however, outside speakers may be perceived as being more objective about the situation. Locally or nationally recognized speakers may also be an option. Topics may include a disability overview of general characteristics of most of the disabilities in the specific school building, sensitization activities (such as handicapping the participants and having them complete a task both as an assistant to and as the individual with the disability); a discussion of P.L. 94-142 and its legal impact on education for students, the history of inclusion (from self-contained in workshops, centers, to inclusion, and all others in between); specific small group discussion topics related to issues of classroom or material adaptations; and finally, a working plan for implementing the inclusion process in the school.

It is important to note that one inservice will not change the attitudes of the persons involved, but it is a start. Providing another similar inservice a few months later, or in the next semester, focusing on the school-specific issues that arose in the various stages of the process, will again help the entire staff feel supported and empowered to continue the inclusion process. Remember that for many people, change is difficult and usually unwelcome. Continuing the dialogue throughout the school year in teacher meetings, inservice days, and other staff opportunities will allow the staff and administration to assess the process. As the learning theory reminds teachers, there may be a time of regression before real changes can occur, and this process can occur again and again as new learnings are integrated in the program, teaching styles, and attitudes of the staff.

Support Systems

By far the most important support for the inclusion process is the staff and support resources of the school itself. The special education teachers usually have more opportunities for direct observation of students with disabilities as up to three-fourths of the student's day may be spent in the special education classroom, depending upon the severity of the disability and the inclusion options available. These teachers also have a wealth of information about their students written within the IEPs. The IEP, in the student's cumulative file, provides the most current functioning levels of the student, with vocational, recreation/leisure, domestic/self-care, community, academic, and post high school transitional goals for the current school year. This document is confidential and legal, and all teachers working with students with disabilities have a right to access this information and are responsible for knowing its contents. Another support are the assistants who may be assigned to the student or class. These individuals often can share information about the student's day in an ongoing fashion as the student, or group, moves from class to class. Other resource personnel such as occupational or physical therapists can also provide valuable information about a student's physical functioning. School counselors can support the efforts of the staff by providing behavioral management strategies and insights into the student's behaviors. Too often, the teachers in a building that is becoming

inclusive do not look toward their own staff colleagues as resources because there may continue to be negative attitudes surrounding change. Outside support may have to be involved, in some cases, to continue the process.

Adapting teaching styles, curriculum, and art materials to the needs of the students with disabilities is part of the process of inclusion that may require more specialized support. As a direct support to the art teacher, some districts provide the services of adaptive art specialists or art therapists to work side by side in the classroom. These specialists can help solve the specific issues of that particular classroom and make connections with other teachers who often use the arts in their teaching. As well, these specialists can provide many adaptive tools and materials that are not only art specific but can assist the student with disabilities to be as independent as possible in all areas of his or her education.

Ideas for Adapting in Art

Probably the most difficult adaptation involves cutting with scissors. Sax Arts and Crafts, Fiskars, and other school supply companies are providing more adaptive scissors for teaching, encouraging, and continuing the cutting of materials for individuals with disabilities. Many times, an assistant will still need to be available to monitor the cutting with adaptive scissors, or help hand-over-hand, but many students may eventually be able to work independently with these tools.

Another area of adaptation need is the gripping of art materials such as crayons, paintbrushes, or markers. Often, a student may grip too tightly or have limited strength for a grip and can't be independent in his or her art-making. The art materials can be adapted in a number of ways depending upon the degree of a student's disability. A buildup of masking tape around a sponge can be used to insert a variety of art tools. Foam rubber insulation for pipes can be purchased at the hardware store and cut to the student's hand size, individualizing the adaptation. Depending upon the width of the hole in the piping, pencils, markers, paintbrushes, crayons, and colored pencils can all be used. If a student's hand grip is weak and he or she cannot grasp the piping or art tool and hang on to it, a hand grip used for eating utensils called a "universal cuff" or "hand grip" can be purchased. Consultation with occupational or physical therapists is advised for locating sources for these tools. This tool has a Velcro strap that goes around the student's hand. The student can flail his or her arms, or have other uncontrolled arm movements and still hold the tool, minimizing markers and crayons as projectiles. Unfortunately, paint will still fling off the brush onto the next available surface, but the brush will stay put! Other adaptations may be student specific, and communication with the special education teacher, the occupational therapist, or physical therapist can be beneficial in assisting the student's unique needs (see Reference/Resource Section).

Communication Strategies

Very little can be accomplished in the inclusion process without communication between/among all the persons working with the students with disabilities. Communication takes time and effort, and often schedules do not permit time or opportunities to converse. Add to that all the extra responsibilities that educators assume in order to run a successful school, and a recipe for failure is imminent. The staff must try to find ways to communicate effectively and in a timely fashion for successful inclusion with minimal frustration. Consider some of the following options.

The art educator creates a general form (see Figure 1) to provide to all the special education teachers whose students will be in the art classes during the semester. The special education teacher will return it within 2 weeks to the art teacher. This will provide a baseline of expectations for behaviors that may manifest themselves in the art classroom and the strategies that the special education teacher has successfully implemented, usually based on the IEP. This time-saving strategy will provide enough information so that a thorough reading of the IEPs will be unnecessary and the art class can begin.

One problem with this strategy is the volume of papers to write and read. Realistically, it is a great deal easier for the art teacher than reading a complete IEP for each student. Additionally, it can be a great experience for the special education teacher to summarize the behaviors of the individual students. Another problem of this strategy is that because of confidentiality issues, some special education teachers do not feel that the art teacher needs this information before working with the student, but our position is that student and teacher safety and learning must supersede confidentiality. "Discovering" self-abusive behaviors after giving a student a pair of scissors can lead to a very dangerous situation. Other special education teachers may feel that the art teacher could become biased by the information and not give the student an adequate opportunity to be successful with the "labels and instructions." One way to adapt this is to distribute the form only to the teachers of the students with severe and profound disabilities, as the behaviors and precautions are usually more significant and potentially more dangerous. As other students with disabilities demonstrate difficult behaviors, the forms can be provided on an individual basis, as needed. Ideally, the special education teachers should provide timely student updates to the art teacher, especially regarding medication changes. In extreme cases, a log of the student's behavior of the day can be sent along with the student to the art classes, particularly if the information about a current situation at home or in school that day is affecting the usual behavior patterns of the student. The art classroom is often the place where the students may "act out" their feelings about a situation, and if possible, the art teacher needs to be informed for the safety of the student and others in the class.

Figure 1
Student Information for Art Class

STUDENT NAME_____

SPECIAL EDUCATION TEACHER_____

CLASSROOM NUMBER_____PREP PERIOD(S)_____

Chronological age of student _____Approximate mental age of student_____

What is the student's disability? (Example: Emotional Disturbance, Severe Cognitive Disability,

Traumatic Brain Disorder, etc.)_____

Are there any characteristics of this student that could be dangerous to him/herself or others?

(Examples: abusive behaviors to self or others, tendency to put things into mouth, head banging,

etc.)_____

What are the medical problems we need to be aware of? (Example: seizures, allergies, fatigue,

medication effects that could occur during art—sleepiness, hyperactivity, etc.) _____

What adaptations does this student currently use or could use to be successful in the art class? ____

What other information might be important to this student's success in the art class? _____

Thank you for your help. Please return this to _____in Room _____or in

my mailbox by _____,Thanks again.

Another strategy recommends a time to meet with all educators to discuss the issues of the students with disabilities. As mentioned previously, the staff in most school buildings have a wealth of knowledge and experience to share. When possible, tapping into these valuable resources will ease the inclusion process. At the beginning of the school year and between semesters are usually the best times to help the inclusion process to be as successful as possible. Schools where inclusion has worked have teachers who have "gone the extra mile" to go to school earlier or stay later periodically, or have found other common meeting times, including evenings and weekends. All teachers have increasing responsibilities both in their personal and

school lives and may cringe at this suggestion. These teachers will continue to struggle with the process of inclusion and will, in essence, make the path for the students with disabilities that much more difficult. Once lines of communication have been opened and there is a sense of genuine interest in the success of inclusion, a few words at lunch or in the hallways between classes may be all that is needed to update and support everyone in the ongoing inclusion process.

We must remember that inclusion of students with disabilities in all curricula is a process; as students grow more independently capable of working with art materials, we need to be ready to move forward with new adaptations. No singular adaptation will work in all situations, but it is rewarding to find the ideal for a particular situation. As art educators, our attitudes toward inclusion may be diverse, but so are the options for success. If we take the opportunities to become aware of the positives of the differing abilities in all our children, then inclusion will be a positive step toward a more sensitive society.

Reference

Fischer, B. (1995, March). *NEA Today, 13*(7), 10-11.

Resources

The following list of persons and resources may be helpful in developing a program for students with special needs:

Anderson, F. E. (1992). *Art for all the children* (2nd ed.). Springfield, IL: Charles Thomas, Publisher.

Falvey, M. (1995). *Implementing successful inclusive education in your classroom.* Workshop presented at The Ramada Inn, Milwaukee, WI.

Henley, D. (1992). Exceptional children, exceptional art. Worchester, MA: Davis Publicaitons, Inc.

Herberholz, B., & Hanson, L. (1984). *Early childhood art.* Dubuque, IA: William C. Brown.

Loesl, S. (1994). *Low to no tech in the arts—adaptations of art materials.* Paper and workshop presented at the Wisconsin Technology Access Conference, Milwaukee, WI.

Milwaukee Public Schools Art Education Office. (1995). *Adaptive arts approaches for early childhood education.* Milwaukee, WI: Author.

National Art Education Association (1993). *Insights: Art in special education—Educating the handicapped through art.* Reston, VA: Author.

Professional Health Care, Fred Sammons, Inc. Catalog of supplies for adaptations for persons with disabilities. Brookfield, IL.

Rodriguez, S. (1984). *The special artist's handbook.* Englewood Cliffs, NJ: Prentice Hall.

Sax Arts and Crafts. School art supply catalog. New Berlin, WI.

Schroeder, C. D., exceptional education teacher at Washington High School, Two Rivers, WI. Colleague with author in an inservice on inclusion, April 1994.

Simpson. C., art curriculum supervisor, Milwaukee Public Schools, Milwaukee, WI. Colleague with author in an inservice for art teachers, March 1993.

Ulin, D. M. (1984). *Art for exceptional children* (3rd ed.). Dubuque, IA: William C. Brown Publishers.

Very Special Arts, Wisconsin District #1. Director, Anne Harvancik, West Allis, WI.

Wisconsin Department of Public Instruction. (1990). *A guide to curriculum planning in arts for EEN students.* Madison, WI: Author.

Chapter 7

Opening the Doors: Museums, Accessibility, and Individuals with Special Needs

Lucy Andrus

During the early 1980s, I had the privilege of developing and implementing a museum education program called Matter at Hand at the Albright-Knox Art Gallery of Buffalo,[1] New York. This was America's first comprehensive full-time museum education program for persons with special needs directed by a staff member with training and expertise in fine arts, art education, art therapy, and exceptional education. The philosophy, goals, and methods of this innovative program have stood the test of time; it remains one of a handful of museum education programs of its kind today.

My experiences in developing Matter at Hand provide the foundation for this chapter. Since much of the available literature on museums and individuals with special needs centers on removing barriers to physical and environmental accessibility for those with disabilities, I will focus on insights gained concerning ideology and guiding principles for including individuals with special needs in the cultural institutions of our communities. My purposes then are to furnish an overview of museums and accessibility in America; to discuss the philosophical underpinnings of creating access; to offer others inspiration and a springboard for new programming ideas through description of a successful museum education program for persons with special needs; to share specific techniques and approaches to programming; and to extend an invitation to cultural institutions to review and reassess their initial efforts to include people with special needs as regular members of their constituency, staff, and volunteers.

In this chapter, the term *art experience* encompasses the activities of viewing, discussing, interpreting, and creating art, while distinguishing between *special needs* and *disability*. The former includes *all* individuals who may require special consideration and/or adaptation of methods and materials in order to participate more fully and equitably in the experiences at hand. Thus, in addition to those with disabilities, *special needs* encompasses children at risk, older adults, persons managing addiction, and others challenged by barriers due to economic, social, and/or cultural difference, who may have very real special access and programming needs.

Museums and Accessibility in America

Prior to the civil rights movement and the more recent passage of state and federal laws mandating access for citizens with disabilities, very few cultural institutions made provisions for individuals with special needs. The Metropolitan Museum of Art of New York may have been the first to do so when, in 1913, its lectures began to include touchable objects and braille for visitors with visual impairment. Metropolitan records in 1924-25 report a story hour for children with physical disabilities and later, in 1926, lectures geared to those with hearing impairment (Steiner, 1992). Another early example of a museum's accessibility can be found in the records of the Children's Museum of Boston, which was founded in 1913 and began offering classes for children with visual and hearing impairments by 1916. During the 1970s, the Smithsonian Institution was one of the first organizations to research, publish, and disseminate information on museum audiences with disabilities.

Passage of the Rehabilitation Act of 1973, specifically Section 504 prohibiting discrimination based on disability, caused cultural institutions in America to think about making themselves accessible on a larger scale to citizens with identified disabilities. This was especially true of federally funded establishments, as the law stipulated that federal funding would be unavailable to public institutions failing to comply with the accessibility standards of Section 504; in addition, they would also lose existing funding.

The initial flurry of activity to accommodate cultural facilities to persons with disabilities in the 1970s ranged from removal of architectural barriers (the majority of effort) to removal of institutional programmatic barriers, accomplished largely without benefit of readily available museum-specific literature offering clear-cut and consistent guidelines for national compliance. Providing their answers to this need in 1979 and 1980 respectively, the National Endowment for the Arts and the National Endowment for the Humanities mandated in their regulations access to any federally funded program or service for individuals with a variety of disabilities (Terry, 1990).

More sweeping legislation ensuring access and focusing on full inclusion in society for citizens with disabilities occurred with the passage of the Americans with Disabilities Act (ADA) in 1990. This landmark law augments Section 504 of the Rehabilitation Act and, today, extends civil rights protection to approximately 45 million Americans with disabilities. The ADA also expands prohibitions against discrimination to private nonprofit museums and those receiving state or local government support (Wodatch, 1992).

As museum professionals are coming to realize, the changes in their operations brought about by compliance with the laws passed in the last two decades, coupled with concern for accommodating audiences with special needs, have advanced services for all museum visitors. Specific examples of

these improvements for the public include the preferred use of ramps and elevators by those pushing baby carriages and carts, large-print labeling that accommodates everyone, film and video captions that enhance children's reading skills, and exhibitions presented at heights accessible to wheelchairs that also accommodate children and adults of short stature (Murray, 1992). Indeed, fully accessible facilities and exhibits are "making museums safer, more comfortable and more meaningful for everyone" (p. 6).

There is still much work to be done as our cultural institutions continue to bring their facilities into compliance, expand their views of what constitutes "special needs" and fully accept their role in promoting public attitudes and actions by reaching out to underserved communities in meaningful ways that support equality for all people. Factors, including recent legislation supporting rights of individuals with disabilities, the changing demography of America, and our growing social consciousness of pluralism and tolerance in an increasingly diverse society, have and will continue to bring civil rights issues into focus as we move toward the new millennium. These issues, and the concerns they raise, suggest that cultural institutions may be at a crossroads between accessibility and inclusion as new programs are being developed, and established programs are being reviewed and assessed. In order to do either task well, I believe we must go back to the beginning in some essential elemental principles that ought to be the foundation of museum programming for individuals with special needs.

The Matter at Hand Program

It was in the spirit of accessibility for citizens with special needs, evoked by Section 504, that the Albright-Knox Art Gallery embarked on the museum education program called Matter at Hand. In 1973, the Gallery's Junior Group and education curator Charlotte Buel initiated the Matter at Hand project that eventually developed into a comprehensive program for children and adults with special needs, the first of its scope in the country.

During its inception, Matter at Hand was offered intermittently on a limited basis and consisted of Gallery tours and workshops for audiences with visual impairments. In the late '70s, these experiences were expanded to include individuals with physical disabilities and mental retardation, offered annually for a period of 1 to 3 weeks. Until 1980, the Matter at Hand workshops were largely staffed by Gallery docents and community volunteers and relied heavily on external funding sources.

With the success of these workshops and the enthusiastic response of participants, it became clear that there was a great need for such programs. The format and delivery of the early Matter at Hand barely scratched the surface in responding to citizens with special needs and including them in the regular offerings of the Albright-Knox. In 1981, additional funding made it possible to expand Matter at Hand, making it a regular, ongoing

program of the Albright-Knox's Education Department. Thus, in the fall of that year, a full-time pilot project was designed and implemented for the Education Department. A resounding success, the Gallery furthered its commitment through procurement of an endowment set up by the James H. Cummings Foundation, which secured the continuance of the Matter at Hand program in its revised and expanded format. The Matter at Hand program consisted of two major components: single Gallery tours and workshops, and ongoing community outreach programming. In an effort to reach the largest possible audience throughout the year, any group of individuals with special needs was offered the opportunity to schedule unlimited single sessions at the Gallery, consisting of a specific tour of the collection followed by a related hands-on activity in the studio space. The outreach component of the program involved three intact community groups in a series of 12 sessions conducted at the group's site as well as at the Gallery each semester. The weekly experiences for each group were sequentially planned and revolved around focus themes that were established according to the needs and levels of functioning of participants. Ongoing groups experienced twice-yearly Gallery exhibitions of participants' artwork with a formal opening reception to which the community at large was invited.

It is important to note the value of incorporating an outreach segment into programming efforts for people with special needs. Organized community outreach plays a vital role in establishing a relationship between museums and community members who have limited interaction in public. It is characterized by positive interaction, a sense of belonging, and mutual respect. Furthermore, programs that consist of multiple, sequential experiences combining visits to the museum with visits to the participants' regular site may greatly affect learning.

Despite a fluctuating economy and budget over the years, Matter at Hand remains a regular, full-time program, expanding its audience to include families of individuals with special needs and continuing to employ professionals with expertise in art, therapy, and special needs.

Laying the Foundation for Accessible Museum Programming

Woven into the discussion that follows are philosophical underpinnings upon which the Matter at Hand program was developed and which may offer valuable guidance to others trying to create accessibility today.

Begin at the Beginning
Some fundamental questions in public planning must be addressed in any attempt to create accessibility: Who comprise the potential audiences with special needs? How can we encourage them to become involved? How do the museum and its administrators view accessibility and inclusion? What are the attitudes of the museum, its administrators, staff, and docents toward individuals with special needs?

Who in the community have special needs? Much of the literature on museums and individuals with special needs has focused on audiences with disabilities, reflecting a limited sense of what may constitute a "special need." Expansion of this definition is necessary but has been slow. For example, attention to older adults as a unique population with many nondisabled members emerged only in recent years (Steiner, 1992).

Formulating a philosophy and program structure must depend upon a conviction that accessibility is for *everyone* and that museums exist for the benefit of all. This principle is at the core of every public museum's mission but may often be overlooked. Pilgrim (1992) speaks eloquently to this issue: "Barriers of all kinds—intellectual, social, cultural, and physical—prevent museums from fulfilling their potential as educational and cultural centers" (p. 8). Programs need to speak to a larger community and invite all citizens, including those with special needs. Individuals with special needs need to be convinced that the experiences available in cultural institutions are for everyone, including them. Thus, the range of people served should expand to include children and adults of all ages; individuals with mental, physical, or emotional disability; able older adults; those for whom English is a second language; those from diverse economic, social, and cultural backgrounds; children with learning problems; individuals in recovery programs; adolescents in residential treatment facilities; and individuals coping with life-threatening illness. Participants can be found in all community settings: schools, neighborhoods, community centers, mental health facilities, clinics, day treatment agencies, special education facilities, medical hospitals, nursing homes, senior citizen centers, inner-city after-school programs, rehabilitation, self-help and support groups, and residential facilities.

How do we encourage those with special needs to become museum consumers? Many of the Matter at Hand participants, if not most, had never been to the Gallery before and did not generally envision involvement with art or art museums to be within the realm of their life experiences. Many individuals with special needs do not perceive an art museum as a place where they can feel comfortable. Children and adult participants consistently asked if they were "allowed to be here" and if they "could come back." Like many in the general public, those with special needs have stereotypical notions that art and museum experiences are meant for a different segment of the population. While many people may be unaccustomed to thinking of themselves as museum visitors (and makers of art), these exclusionary notions may be more ingrained in persons with special needs precisely because they have been outside the mainstream or on its fringes for so long.

It is important for museum planners to realize that a large percentage of individuals with special needs continues to assume that public places in general are inaccessible; thus, the first task includes finding ways of attracting and bringing this audience into the museum.

On a practical level, the best way to start is to get acquainted with the local community of individuals who have special needs and the agencies and schools who provide services to them, whether children or adults.[2] Typically, those with special needs visit museums through group tours sponsored by agencies and schools, which are invaluable resources for program planning as well as dissemination of information. Integral to this first step is the formation of an advisory committee whose members include representatives from agencies and special needs populations whom the museum intends to serve. As Edward Able, president and CEO of the American Association of Museums points out, the model museum programs featured in *The Accessible Museum* shared one strategy that was instrumental to their success: "They listened to their audience and incorporated their concerns into the planning" (1993, p. 80).

In addition to flyers mailed to schools and agencies, and announcements in the Gallery's brochures and calendar, as well as agency newsletters, it is helpful to visit agencies and meet the clients in their unique community. This is especially important in cases where potential visitors do not receive information from printed matter or who live in institutions or with family caregivers, and have limited opportunity to choose their activities. This initial outreach effort also allows formulation of basic needs assessments for various groups, an essential component of planning appropriate experiences. Encouraging individuals with special needs to visit can be accomplished through appropriate publicizing of available services and cooperation with consumer organizations (Lehman, 1981).

Creating access to facilities, services, and programs, and publicizing them is one matter; helping those with special needs to actually feel *welcome* in museums is another. As many museum professionals have come to realize, accessibility is much more than installing ramps and rails, offering touch tours and even creating museum education programs tailored for individuals with special needs. Experts talk about museum accessibility as supporting inclusion, promoting independence and dignity, and operating from a standpoint of mutual respect (Able, 1993; Pilgrim, 1992; Steiner, 1992). Reaching these ideals is impossible without careful and sincere attention to attitudes. Today, we need broad museum action that goes beyond surface alterations and compliance characterized by one program, such as tours with sign language interpretation. We need new solutions. To move forward, we must alter attitudes. This may be a more challenging task than removing physical barriers; it is certainly at the heart of cultivating an audience among those with special needs, and what follows offers insight into this process.

Begin with the Right Attitude
Many museum professionals agree that adopting the right attitude is critical to success. To do so requires that two central questions be answered: What are the attitudes of administrators, staff, docents and other volunteers

toward accessibility? What are the attitudes of these museum personnel toward individuals with special needs?

In answering the first question, museum administrators must examine their motivation for creating accessibility. All too often, attitudes toward removing barriers are based more on the need to comply with legal requirements and lack sufficient understanding or acceptance of the philosophical and educational foundation for including people with special needs in the mainstream of society of which our cultural institutions are a vital part. Merely completing a list of requirements mandated by a law results in a cursory approach to accessibility. As Steiner states, "The fiction of a prescribed solution explains why, over the years, museums keep repeating the same mistakes and why the field of museum accessibility...has moved forward ever so slowly" (1992, p. 12). Those who create accessibility based mainly on the law or the threat of lost funding should be aware that they stand to lose the potential contributions of millions of people toward the support of the arts in our society.

Even those voluntarily ensuring accessibility to their facilities and programs must examine attitudes. In addition to achieving inclusion for all people, they must acknowledge the benefits of welcoming people with special needs and the opportunity their presence affords museums to grow and learn about the "many able Americans who are interested in their collections and activities" (Terry, 1990, p. 27) and who constitute larger audiences for the arts.

Vigilance to attitude will help to correct mistakes and to change for the better. An example is the practice of hiring someone with a disability to conduct tours or other experiences for audiences with similar disabilities. On one hand, this is surely a positive step for a museum attempting to create access, but on the other hand, why shouldn't the person be conducting tours and offering such experiences to *all* audiences? The Art Institute of Chicago has set an example in this respect; it was the first to hire persons with physical disabilities to lecture to both the general public and audiences with special needs (Mims, 1982). Accessibility is not a one-sided venture: everyone stands to gain from increased interaction, and what better way to promote it than through the universal appeal of the arts?

In answering the second question about the attitudes of museum personnel, administrators, staff, and docents must examine their *personal* attitudes and biases toward those with special needs. Since biases affect the way one sees and interprets the actions, values, beliefs, and art expressions of particular individuals or groups, it is essential to uncover one's prejudices if interaction with any group is to be positive and constructive. Moreover, if facilitators are not aware of their own biases, it is unlikely they will recognize bias in instructional materials, methods, speech patterns, and administrative practices. Despite consciousness raising and media attention to diversity and equality for all in recent years, fears, misconceptions, and unfounded prejudices about individuals with special needs still pervades

this country. These negative attitudes must be addressed in order to ensure that museum experiences and staff and docents' behaviors are as welcoming and appropriate for individuals with special needs as they are for any museum visitor. Adjusting attitudes and making necessary changes does not happen by itself. The museum must take steps to confront these issues with its staff and docents through inservice education and training. Throughout this process, it helps to remember that museum programs should "speak to multiple voices, needs and concerns," which include the interests of those having special needs (Pilgrim, 1992, p. 9).

Be a Role Model

It is important for program coordinators to model appropriate attitudes and behaviors for administrators, staff, docents, volunteers, students-in-training, and the visiting public. For example, initial suspicions or apprehensions can give way to greater awareness and understanding of diverse visitors as welcoming behaviors are modeled. At the Albright-Knox, one security guard was initially fearful that "those people" were likely to touch a painting or, worse still, knock over a sculpture. With time and experience and good role modeling, this man evolved from an overly vigilant sentinel to a staff member more comfortable with himself and others. He became eager to facilitate tours and often interjected his own insights about an artwork that was being studied.

Most employees of art museums have had very little, if any, personal contact with persons having special needs. I believe this is true of the average Gallery visitor. Programs like Matter at Hand provide opportunities to broaden conceptions about diverse populations, challenge stereotypical ideas, and help people come to feel more comfortable around individuals who may look or act differently from themselves on the outside. In a sense, these programs are engaged in teaching tolerance to all those touched. Over months and years, the initial staring at wheelchairs, adaptive devices, or appearances gives way to matter-of-fact acceptance by others. Often, visitors will join special groups in touring collections if a welcome is extended. These moments allow participants with special needs an opportunity to feel more like a natural part of the daily stream of visitors to the Gallery, a goal of "normalization." Also, the aura of an art museum, filled with human expressions of the deepest kind, may facilitate, perhaps like few other experiences, the process of discovering our essential shared humanity.

Goals to Consider in Program Development

It is important for museum professionals to understand that basic goals and objectives for programs designed to meet special needs are the same as those formulated for general audiences. In recent essays, Diane Brigham, of the J. P. Getty Museum, and Kathleen Walsh-Piper, of the National Gallery of Art, remind us of fundamental goals and objectives for museum education pro-

grams that should apply to all populations and ages. Brigham (1994) talks about three broad goals that underlie the Getty's education programs for children: To enable them to see and respond more thoughtfully to works of art, to explore ideas about art and culture based on their own observations, and to become confident and able in using museums as resources for life-long learning. In discussing the change in emphasis by museums today from collecting to educating, Walsh-Piper (1994) discusses a variety of purposes for education programs ranging from gaining an understanding of the concept of museums and having first-hand experience looking at and making works of art to increasing abilities to relate art to its cultural and historical contexts and to the "fabric of life" (p. 1). Just as these goals and objectives are basic to any museum education program, they should be fundamental programs designed for persons with special needs as well. In our efforts to adapt programming to meet diverse special needs, we must be careful not to lose sight of these basic goals, and to adapt attitudes, approaches, methods, and materials as appropriate and necessary to make them attainable by individuals with special needs.

Of course, additional goals related to accessibility will be integrated into this foundation. Several have been implied throughout this chapter, and some are discussed here. Each goal statement is followed by additional insights gained from the Matter at Hand program that remain relevant today and may be useful to others involved in planning.

Creating greater accessibility to a community institution for children and adults with special needs. A guiding principle regarding adapting attitudes is to balance the need to increase our understanding of various special needs and how they are manifested, with the ability to look beyond others' "labels" by also focusing on their strengths. To do otherwise will result in lost opportunities to maximize participation by diverse audiences. As examples, how many of us inadvertently limit people because we falsely assume that one who is deaf or blind possesses below average intelligence? Or we avoid certain works of art because we assume that a person who has little or no sight cannot adequately conceptualize certain ideas and, therefore, does not want or need to hear about color or talk about two-dimensional works of art. Again, the challenge to facilitators is to present the same basic material as they would to any audience but with adaptations to approach, method, and material that will optimize participation. We must also monitor our attitudes and assumptions when working with those whose cognitive ability is below average, lest we lower expectations to the point of underestimating ability and thereby exclude from certain experiences those with mental retardation. Awareness of one's preconceived notions about different cultural backgrounds is also imperative. Lack of sensitivity to cultural uniqueness perpetuates misinformation and damaging stereotypes, depriving both parties of an enriched learning experience.

People generally rise to the level of our expectations, including those persons with special needs. If we project negative or defeatist attitudes onto

others, they will tend to act accordingly. We've seen this all too often with many older adults who have somehow adopted the negative ageism attitudes that unfortunately still pervade our society. Museum personnel must commit to their own education and adjustment and project an attitude of positive acknowledgment, acceptance, support, and respect for all whom they serve if our cultural institutions are to be truly accessible and welcoming environments.

"I'm glad I can come to the Art Gallery. Can I bring my mom and dad here, too?" (Young participant in the Matter at Hand program)

Providing opportunities for individuals with special needs to respond to art as viewers and makers. Involvement in art and museum programs allows individuals with special needs to make a variety of connections they might not otherwise make: to a concept or a lost idea, to a part of the inner self long silenced, to other people and the shared human condition. Involvement in the arts is often the key to discovering unrecognized abilities and facilitating their expression if we are willing to make the necessary adaptations. The arts provide an alternative channel for perceiving, responding, and communicating personal ideas and feelings about our environment (Andrus, 1982).

All humans have the capacity to invest objects with meaning. Finding meaning in an art object causes one to attach a symbolic value to it and thus have greater feelings for it. As this process unfolds, perception and concepts come into play, and as Laura Chapman (1982) explains, "Concepts organize sensory impressions, the result of which can be informed, feeling perception, a personal interpretation of the meaning of something" (p. 48). In art, this kind of enrichment and learning does not depend on absolute or prescribed notions. Experience in viewing and making art allows persons with special needs greater opportunities for self-discovery and interaction with their world and challenges their faculty for comprehension and self-expression. I regularly observed the benefits of this process in the Matter at Hand program, as participants' regular teachers would remark that they had never before seen their student or client exhibit the new skill or positive behavior they were witnessing.

"I've noticed a carryover of learning into the classroom that is a direct result of [the children's] involvement in the Matter at Hand sessions." (Special education teacher)

Since the arts are an equalizing force (Andrus, 1994) where issues of "right or wrong" are immaterial, self-expression through art experiences offers the person with special needs a chance to control and manipulate elements in his or her environment at a personal level and pace, an experience often unavailable. The benefits to one's self-esteem, general well-being, and productivity as a result of involvement in art experience have been attested by hundreds of human service professionals in the arts, education, and therapy. Museum programs can make this experience available to per-

sons with special needs, many of whom would otherwise have little or no contact with the visual arts.

"This is beautiful, I can't believe I did it! I'll put my name up in the corner because the design is the most important part to see." (An older adult participant who resides in a nursing home)

"I learned how artists can use color to show a feeling." (A teenaged participant with a physical disability)

Including the person with special needs in the social mainstream of the community through the arts. In creating truly barrier-free facilities, museums must embrace their roles as cultural and educational centers that serve a public comprised of a diverse group of people with various needs, concerns, abilities, and limitations (Pilgrim, 1992). In moving beyond compliance, museums are making a socially responsible commitment to advance the transition in national attitudes and actions in regard to inclusion.

Promoting the inclusion of individuals with special needs provides opportunities to the general public to become more aware of and involved socially with diverse groups. One such opportunity occurred regularly through semiannual Matter at Hand exhibitions. Exhibiting participants' artwork proved to be a powerful agent for promoting new awareness and changing attitudes, as increasing numbers of individuals from the community attended the opening receptions and mingled with the artists. Written descriptions accompanying the artworks enhanced viewers' understanding of participants' experiences and abilities.

"Upon entering the exhibit, my first thought was, boy, this isn't at all what I expected from people [with special needs]. What did I expect? I don't know but that thought stayed with me as I explored the exhibit. When I left, my thoughts held hope…" (Written in the comments book by a person from the community)

Providing a unique resource for educators, therapists, and other human service professionals. Art educators have always been encouraged to make greater use of museums as resources for their own work, and many museums regularly offer teacher inservice programs specially designed to meet the needs of these professionals. Museum programs have begun to cultivate new inservice audiences by extending professional workshop offerings to special educators, art therapists, and others engaged in education, therapy, and rehabilitation. Art museums have been traditionally underutilized by these groups. A significant number of the educators, therapists, and other caregivers who accompanied the Matter at Hand participants had little or no previous interaction with the Albright-Knox Art Gallery or with art as an integral part of programming for their students and clients. Their involvement produced three desirable effects:

1. They became more aware of the resources available in an art museum, and most continued to make use of them both professionally and personally.

2. Personal fears and misgivings on the viability of bringing particular groups to the Gallery were allayed (many of these professionals had felt that their clients/students "couldn't benefit from" or "couldn't handle" a Gallery experience).
3. The majority of the professionals whose clients or students have been involved with Matter at Hand have witnessed unexpected responses and significant behavioral changes in the participants they accompany.

In many instances, these positive changes have influenced the professionals to continue the unfolding process begun during their involvement. They have also learned firsthand how the cultivation of relationships between people and works of art, coupled with the use of educational and therapeutic art activity, can enrich life, learning, and growth for everyone.

Approaches and Techniques in Programming

In considering how a facilitator might make the actual study and creation of art objects "accessible," three strategic considerations must be infused into programming for children and adults having diverse needs and learning styles:

1. Participants must be equipped with a basic language for exploring and making art.
2. Participants must be helped to make personally relevant connections to art, artists, and artmaking.
3. Participants must be able to become actively involved with original works of art and participate in personal artmaking.

Providing a Basic Language
A common language is necessary to view, discuss, understand, interpret, and create works of art. For everyone, it means acquiring fundamental knowledge and understanding of the basic elements and principles of art and how these are used by artists to give form to personal visions. For some, it may also mean that a certain person or group literally requires the use of another language such as sign language or other nonverbal communication medium such as a board with art icons. On a more abstract level, it can also mean that information is presented and examined within a framework or "language" that considers cultural context. This might be the case when involving resistant teenagers or persons of various ethnic backgrounds or older adult nursing home residents.

Connecting People to Art
In the process of helping people to make personal connections to art, initial activity might focus on a discussion of the relevance of museums to the gen-

eral populace. Such dialogue should include museum operations of collecting, preserving, exhibiting, educating, and how and why these functions concern not just experts or artists, but ordinary people as well. Many participants have never before considered that art objects constitute not only a history of their cultural heritage but were also a record of humankind. For participants new to a program, and often the museum, itself, a site visit prior to the museum experience offers the opportunity to present and discuss these ideas, helping to bridge participants' everyday environment with the art museum: two settings within the same community that rarely intersect. This kind of early experience lays the foundation for continued development of personal connections to art.

Encouraging the discovery of personal relevance in works of art requires that the facilitator help people bring to a conscious level areas in which they can truly connect to the work of art, the artist who created it, and/or the sociological context within which it was created. When people can find personal relevance in something, they tend to invest it with greater feeling and intelligence (Chapman, 1982). When this happens, motivation increases, as does the ability to contemplate and accept new ideas in the process of learning.

A classic example of this phenomenon occurs when the average person is introduced to the works of some of the abstract expressionist painters such as Jackson Pollock, one of the movement's major artists represented in the Albright-Knox collection. Museum educators are familiar with typical responses of viewers, particularly adults: "What's so great about a bunch of colored lines?" "My 4-year-old child could do this." etc. Many of these initial viewpoints evolve into more informed criticism, however, when the facilitator engages viewers in an investigation of the work characterized by discovery of personal relevance coupled with interaction between viewer and artwork (see specific interactive techniques that follow).

When people understand and are able to personally connect with the artist's ideas, feelings about the world, and life circumstances, they are better able to appreciate the outward expression of these experiences as reflected in the work. The process of forging such a relationship fosters greater understanding not only of art but of the human condition. A memorable example occurred during a Matter at Hand tour with a theme that focused on the use of color, brushstroke, and subject matter to express emotion in art. Participants had been exploring *The Yellow Christ* (1889) by Paul Gauguin, learning ways in which color can convey a feeling as well as something of the artist's circumstances and dejected state of mind at the time this work was painted. A man in the group who had been remarkably quiet until then announced that he "understood how that artist felt" because he "knows what it's like to be depressed." Through identification with the artist, this man, whom others considered nonverbal, shared something about his own recovery from mental illness and, following the tour, created a painting of colors depicting his feelings which he was able to talk about

with the rest of the group. For many participants, "demystifying" art through the use of narrative, particularly concerning the artist's personal story, exposes the basic humanness that readily creates connections among us and, in the process, opens up new avenues for more meaningful inquiry into the artwork. Thus, opportunities for increasing understanding and appreciation of art are amplified.

Active Involvement

The third programmatic strategy concerns actively involving program participants, as much as possible, in all facets of the museum experience. Educators are well aware that experiential learning or active exploration of concepts at hand maximizes the acquisition and retention of knowledge. Minimally, creating opportunities for active involvement must comprise the following:

A Multisensory Approach

Incorporating varied layers of experience for learners, including active use and integration of sensory abilities, promotes the use of multiple sensory capabilities throughout the learning process. Thus, for example, a concept might be presented as well as perceived through auditory and tactile modes or experienced visually and kinesthetically, as in the *posing* technique discussed in the next section. A multisensory approach works equally as well for average audiences as it does for those with special needs. What child or adult wouldn't enjoy and benefit from the opportunity to see, hear, touch, or otherwise sense an object or an idea in the process of understanding and interpreting works of art? Direct, sensual experience with concepts is an effective way for everyone to learn and is especially important for those whose sensory functioning may be compromised. Such compromise may not necessarily be due to a disability or neurological impairment. The early sensory experience of children labeled "at risk" has often been restricted due to such conditions as poverty, neglect, or abuse. These children exhibit underdeveloped sensory intelligence and ability, which, in turn, affects language development, particularly expressive speech. Lack of stimulating experience in everyday living also contributes to sensory deprivation among certain groups of older adults.

Hands-on Experience

Aligned with a multisensory approach in promoting active involvement of participants is the provision of hands-on opportunities for participants. This might mean putting a soft-sculpture shape into the hands of young or highly distractible participants at the start of a museum tour, immediately focusing them and involving them in an active search for elements of design. It also means finding additional ways, beyond posing good questions, to ensure active involvement by giving participants responsibility for their own learning experience. A hands-on activity enhances opportunities for partic-

ipants to arrive at their own answers in the search for meaning and connection.

Meaningful Interaction with Original Works of Art

Interactive experience with original works of art involves participants in a dynamic relationship of discovery in ways that encompass multiple avenues for perception and self-expression. Interaction in this context moves the museum visitor beyond passive observer to active participant, using thoughtfully chosen, age-appropriate techniques that promote personal involvement in the inquiry process. These techniques and strategies might also incorporate other expressive art modalities such as movement, drama, poetry, and sound in exploration of the artworks. An interactive approach to the study of artists and art objects in the museum setting is extremely effective in helping diverse groups connect to our artistic cultural heritage. Such opportunities stimulate personal growth and creatively motivate and strengthen general knowledge and skills without sacrificing basic goals of museum and art education. Indeed, studio activity relating to a museum tour is a highly desirable aspect of programming. The benefits of such experience need no further explication here, except to encourage museum personnel to incorporate studio time and space into their planning and remind others that creating lifelong learners in the arts is more likely when they have access to actual, personal experience with art forms through manipulation of art media and materials.

Other Strategies

These strategies of providing a language, facilitating personally relevant connections, and creating opportunities for active involvement ought to be a part of every museum education program, including those for persons with special needs. These strategies are possible for any museum, regardless of other factors such as budget and staffing that influence program design and implementation. However, implementation of other effective approaches and techniques worthy of consideration will depend on the type of facility, program, and staff expertise available. Three that warrant brief explanation are:

1. Preliminary assessment of participant's needs.
2. Incorporation of established goals and objectives in curriculum development.
3. Use of thematic, interdisciplinary planning.

These aspects of curriculum planning are interrelated and follow a natural progression that yields effective results.

A basic *needs assessment* is always the first step in designing a tour and related studio activity. For groups who book a single experience, a mini-needs assessment can be conducted over the telephone prior to the sched-

uled visit. Speaking with a group's teacher, therapist, or caregiver provides a general overview of the participants' special needs, levels of functioning, adaptive devices used, necessary information on individuals within the group, and a briefing on general goals and objectives currently being addressed at the group's regular setting.

Notation of this information, made on a one-page form that also includes practical information on who the group is, when it visited, and where it was coming from, proves to be an invaluable record for numerous uses, including development of mailing and telephone lists, a record of attendance, and a source of information in planning future visits for the group.

The task of formulating a needs assessment for ongoing groups who would participate in a series of in-gallery and on-site experiences over a span of time can be accomplished during an initial site observation and discussion with the group's leader. This information becomes the basis for planning the totality of experiences for the group. Needs assessments diminish the element of surprise that might adversely affect the experience, thus, optimal preparation can accommodate a variety of participants' special needs.

Needs assessment planning need not be an elaborate affair. A staff member with the appropriate background and expertise can formulate such an assessment fairly quickly and efficiently, and since many of the same participants will return in the future, this task becomes even more efficient and productive with time. Benefits far outweigh the work involved.

With needs assessment as the starting point for planning, *consideration of established goals and objectives* for a group follows smoothly and offers a natural basis for designing art and museum activities. For those with special needs, the success of experiences that take place away from their regular settings will largely depend upon the degree to which these experiences incorporate and reinforce goals and objectives maintained in their regular educational, therapeutic, community, or other programs (Andrus, 1983). This approach to planning clearly reinforces the strategy of helping participants make personally relevant connections to art, a factor responsible for successful encounters between individuals with special needs and museums.

The possibilities for *interdisciplinary, thematic planning* in the museum education setting are ripe with potential. In developing curriculum, information obtained through the needs assessment provides the basic theme for museum tours and related studio experiences for both single and ongoing groups. Works of art to be explored are selected for their relevance to the theme, and studio activities are designed to complement the tour experiences. For example, a group of children from a preschool language development program coming to the museum for a single visit might be involved in the "Elements of Art" tour and studio activity, where the emphasis would be on acquisition of basic art knowledge concerning line, shape, color, and texture through an approach promoting identification, discrimination, and descriptive language skills, abilities called into play during initial stages of

the art criticism process. The activities presented would focus on promoting such goals, revolve around the established theme for the day's experiences, and often integrate some aspect of movement, creative dramatics, or music with the visual art experience. For a group of adults in a recovery program, the theme of the tour and studio experience might center on the recognition and expression of emotions and emphasize the artist's use of color, line, brushstroke, and/or subject matter to convey emotion and mood in a work. For participants coming from a psychiatric out-patient center, the focus might be reality orientation and exploration of realism in artistic expression. For a group of older adult nursing home residents exhibiting low motivation and sensory deprivation, the theme might be "Every Picture Tells a Story" with a focus on interaction with artworks depicting activities likely to have been performed by the visitors at some time in their lives and helping to stimulate memory and life review. One particularly poignant experience involved a woman in her late eighties who "came alive" as we explored the Degas work, *Rose Caron* (c. 1885-90). The work depicts a famous operatic soprano whose performances were characterized by a certain stately decorum (Nash, 1979). Provided with a selection of actual objects to handle and use in pantomime, the woman eagerly selected an elbow-length glove. As she pulled the glove onto her own arm with an elegance similar to that displayed by the woman in the portrait, she suddenly exclaimed that she, too, had worn long gloves and an evening gown to a special occasion "like the lady in the picture." As this woman began to share her reminiscences, an important activity for the elderly, other members of the group began to talk about their own memories of similar special times. With this increased interest, it then became possible to delve deeper into the artwork, the artist, and his intention in painting this portrait. In the process, participants came to better understand and appreciate Degas's insightful ability to capture his subject's personality in paint.

A thematic, interdisciplinary approach to curriculum development together with the use of needs assessment and established goals in planning experiences for persons with special needs does not compromise art content as some might fear. In fact, these methods actually enhance connections among art, artists, people, and life in general. In the process, the separation between art and the everyday world is minimized. Isn't this the goal toward which art educators strive?

A Selection of Interactive Techniques

The following specific examples of interactive techniques encompass the three basic strategies: multisensory, hands-on, and active involvement. They naturally overlap, are often integrated into one technique, and are used in conjunction with traditional methods of posing good questions as facilitators involve participants in a personal discovery of meaning in artworks.

Since adults also enjoy active participation in the museum setting, techniques need to be age-appropriate in content and presentation.

Props. The use of props is a very simple and basic technique that can be applied to a variety of approaches in exploring artworks. It involves participants holding or manipulating, during viewing and discussion, actual objects related to the artwork being studied. The opportunity to use a sense organ other than sight and hearing when learning about art can "make or break" the museum experience for some. The fundamental purpose of props is to make the artwork meaningful for participants as they explore concepts and ideas and discover connections and meaning. Some props and techniques used successfully include:

1. Primary color acetate swatch sets that participants could use to visually explore the artist's use of color concepts (overlap and/or view work through while noting changes).
2. Participants handle actual objects contained in the artwork such as swatches of variously textured fabrics during an exploration of Lucas Samaras's *Reconstruction #28* (1977), a composition of sewn fabric scraps.
3. Manipulating objects representing basic art elements such as 10-inch chenille stem "lines" (pipecleaners) that could be turned, twisted, bent, and added one by one to a block of Styrofoam during an exploration of the qualities and use of line in the Naum Gabo sculpture, *Linear No. 2, Variation* (1962-65).
4. Holding and feeling the edges of various geometric mattboard shapes as participants with visual impairment learned about the alphabet of shapes in Herbin's painting, *Vie No. One* (1950).

The possibilities are limited only by the facilitator's imagination and creativity.

Posing. Posing is another simple technique that can tremendously influence the viewer's capacity to understand an artwork and an artist's intention in the process of arriving at a personal judgment. Both children and adults enjoy exploring a figurative artwork when verbal discourse is inadequate. With this technique, participants are asked to use their own bodies to explore the artwork by assuming the actual pose of the two- or three-dimensionally rendered figure or object. Meaningful questions about the artwork are asked while participants maintain their stance so that their responses are enriched by a deeper understanding aided through kinesthetic as well as cognitive exploration. Participants can be asked to further extend their imagination, as well as their sense of the artwork, by adding a movement and/or a sound to their pose that seems to be implied by the artwork.

A memorable example of the posing technique that allowed an artwork and an abstract concept to become accessible to preschool children with

varying degrees of physical disabilities concerned the sculpture *Eve* by Rodin (1881). As one might imagine, giggles were the children's initial response to this nude female figure in bronze. It was the posing technique that "saved the day" as children, including those in wheelchairs, were asked to assume the same position as the lady in the sculpture to the best of their abilities. As the children moved their bodies and maintained their pose, I asked them how they were feeling in their humble positions of arms crossed over chests, heads recoiling down into arms, one knee bent inward as legs came together. These 5- and 6-year-olds murmured while in the pose: "feel funny…" "I don't feel good…" "…like I did something bad." Through their own kinesthetic sense, they were able to arrive at the heart of meaning in this work, to understand that this "lady" (representing Eve from the Garden of Paradise) felt shamed and guilty as befitted the artist's intended symbol for the fall of man. Needless to say, the giggling simply fell away from the children's experience of this artwork.

Recreating the environment of the artwork. The props and posing techniques described above can be used together to further understanding of a work by having participants re-create some aspect of the environment depicted. Matter at Hand participants enjoyed the use of props and posing to explore the George Segal work, *Cinema* (1963), a three-dimensional installation complete with a freestanding, life-size plaster figure appearing to hang or adjust the letter "R" on a "theater marquee" mounted on the wall. Inquiry into the work and discussion of Segal as a pop and environmental artist took place within the context of our re-creation of the everyday street scene the artist might have envisioned in creating this work. Upon naming some kinds of people that might be found on a city street, participants were provided with related props such as a taxi driver's hat, a flower vendor's basket, a newspaper seller's bag, a hat and tie worn by a person going to work, tickets for the theater usher, people in line at the "cinema," and so on. Having donned their props, and with direction from the facilitator, participants actualized the street scene by pantomiming the actions of each of the figures described. This activity was followed by exploration of how Segal created the life-size plaster figure while two participants, one "artist," the other model, mimed the process with guidance from the facilitator. Finally, questioning and discussion focused on concepts whose understanding requires higher-order thinking enhanced and further enabled through participants' hands-on experience and interaction with the original artwork.

Re-creating the Artwork

An activity that proved popular with older children and adults involved their use of large black elastic bands to explore the properties of line in space by re-creating a kinetic sculpture on the Gallery floor, using themselves and the bands as art materials. In this activity, the elastic bands were

sewn together to form approximately four 5-inch diameter circles, whose use required plenty of floor space.

Another example employed collage as participants of all ages, studying a Romare Bearden work, attached pre-cut magazine images to create a group composition, each person using a glue stick to add their selected image to the white background paper mounted on cardboard. In this process, having discussed the artist, his style and imagery, a theme for the collage was determined, and participants were encouraged to choose their image thoughtfully, place it, and describe its meaning to the total collage in progress.

Integrating Verbal, Written, and Visual Imagery in Exploring Artworks

Few will argue that our society is increasingly visually oriented and that everyday communication, learning, and absorption of information takes place primarily through visual and linguistic modalities. This fact is currently reflected in our use of technology as we communicate with each other in new ways via computers, using icons to command words and images. Thus, integrating visual, verbal, and written forms of imagery and language seems like a natural means of helping others learn about and make sense of their world, including efforts to educate about art. Interactive techniques based on these ideas and used in the museum setting prove to be a stimulating way to engage young people with special needs in elementary processes of art criticism, to promote descriptive language skills, and to develop greater academic self-confidence, particularly for children with learning disabilities and problems organizing and interpreting incoming information. These students often fare poorly in language arts. Due to their academic struggles and failures, they become resistant to using words and language for self-expression. Art provides them an alternative means of learning, self-expression, and success, and their insights into the artworks are often surprising.

Techniques that rely on the use of words in language and poetry have facilitated participants' discovery and understanding of the "story" told by artists in certain artworks. One that is especially useful with elementary school-aged children and adolescents is the task of literally finding a selected artwork using poems intended to conjure up imagery in the unknown artwork while supplying "clues" to determining its actual whereabouts in the gallery. Younger children enjoy becoming "art detectives" as they focus on the meaning of the imagery evoked by the words in the poem to help them search for the artwork about which it is written. The children are divided into four or five small groups, each with an appointed secretary who is supplied with a clipboard containing the poem, complete with a "hint" and brief notes about the work, extra blank paper, and a pencil. The small groups read the poem together, decipher its meaning, and use this information as clues to help them find the designated artwork. Once the artwork is

discovered, the children are given the primary responsibility of studying the piece and beginning the process of criticism by describing basic elements they see in the work as the secretary records their responses. Next, the process engages children in initial interpretations of the work. The facilitator moves from group to group offering suggestions, providing additional insights, asking provocative questions, and helping to move the inquiry forward. Finally, all come together again, and each secretary shares the discoveries and learning of the small groups with the entire group. What follows is an example of a poem used in this technique with second graders with special needs:

> I'm made by an artist
> who thought it was neat
> To take one single object and
> repeat, repeat.
> The object he used
> was dear to his heart
> So he decided to use it
> to make some art.
> Everyday he had me,
> he loved me a bunch.
> I'm a picture of something
> he always ate for lunch!

Hint: I have only three colors in me.
Artwork: *100 Cans* (1962) by Andy Warhol
(Campbell's soup cans)

Rather than the facilitator filling the primary role of information-giver and "tour guide" in this technique, the participants are their own teachers in a sense, as it is their work and their responses that guide and shape both the process and the product of the experience. The implication that people can be successfully responsible in many ways for their own learning engenders a greater sense of competence and thus increases self-esteem while generating appreciation of art.

Conclusion

Although museums have made considerable progress toward accessibility and inclusion for persons with special needs, this work has just begun. It seems to me that we have arrived at the next phase of accessibility that requires us to reexamine old concerns, answer new questions, and make changes. Museums need to grapple with complex attitudes and ideology and to question their purpose for serving audiences with special needs in order to progress. They need to attain a clearer understanding of why museum

collections and programs should be accessible and inclusive of a wider range of members of our society than has previously existed. Philosophy derived from this understanding should then be reflected in the mission statement of museums and their education departments. In the same spirit, museum educators need to consider more inclusionary programming as they plan for more diverse audiences.

In reviewing accomplishments, questions, and concerns that have been raised in this writing, it occurs to me that most programming efforts inadvertently contribute to the segregation between general museum audiences and audiences with special needs through their specific focus on the latter. Inclusion-promoting programs such as Matter at Hand are vital and necessary and need to be maintained, but other possibilities ought to be explored as well.

Perhaps we need to look to the inclusion model currently being implemented in more and more public school classrooms. This model could serve as a guide for a variety of creative programs and strategies to promote inclusion in the museum setting. For example, rather than offering separate family workshops, one for the general public, the other for those with special needs, isn't it possible to offer workshops that deliberately bring together all kinds of families, including those with members having special needs?

Programming that stresses diversity is much more commonplace today than ever before. Why not shed some of the inhibitions associated with "special needs" and create and honestly advertise museum experiences intended to bring diverse people together, such as multigenerational programs where older adults are deliberately brought together with children. Isn't it possible to schedule a school tour that combines a group of children from a general education class with children from a special education class, pairing each child with a "new buddy"? After all, although inclusion in the classroom is growing, it is still the exception and not the rule in many public schools. Museums are capable of creating such opportunities for people to come together to experience art. Museum educators are creative individuals who can certainly meet the challenge of designing and implementing innovative inclusionary museum experiences.

In espousing what Steiner (1992) calls "a necessary, broader museum action towards accessibility" (p. 15), administrators ought to investigate the possibilities for extending recruitment efforts so that persons with special needs not only serve on volunteer advisory boards, but also hold positions as employees. Like the University Museum of Southern Illinois University, more museums might consider developing training programs for individuals with special needs who have the potential to serve in a variety of capacities, including teaming with docents in guiding tours.

Finally, it would be foolish not to acknowledge that many of these ideas for new directions and programs, as well as the maintenance of existing ones, present a challenge to museums whose resources are limited. But, as many museums have discovered, when there is a willingness to explore,

unforeseen possibilities and resources often present themselves and, when the challenge is embraced, become realities. This is part of the rich legacy of the Matter at Hand and other exemplary museum programs across the country that serve as inspiration for continuing the work of assuring that every person in America has access to this nation's cultural treasures.

References

Able, E. H. (1993). Access to equity. *Museum News*, 72(2), 8.

Andrus, L. (1982). *Developing cognitive, affective, and psychomotor skills in multiple handicapped children through an educationally integrated creative arts program*. Unpublished manuscript.

Andrus, L. (1983). *A museum reaches out to the handicapped*. Paper presented at the National Art Education Association Convention, Detroit, MI.

Andrus, L. (1994). Art education: An equalizing force in the inclusion setting. In *Inclusion: Buzzword or hope for the future?* New York State Council of Educational Associations.

Brigham, D. (1994). Some guiding principles: Gallery teaching for school students at the J. Paul Getty Museum. *NAEA Advisory*.

Chapman, L. (1982). The future and museum education. *Museum News*, 61(2), 48-51.

Lehman, S. (Ed.) (1981). Focus on the disabled. Roundtable reports. *The Journal of Museum Education*, 6(2), 3-14.

Mims, S. K. (1982). Art museums and special audiences. *School Arts*, 81(7), 32-33.

Murray, D. W. (1992). Foreword. In *The accessible museum: Model programs of accessibility for disabled and older people*. Washington, DC: The American Association of Museums.

Nash, S. A. (1979). *Albright-Knox Art Gallery: Painting and sculpture from antiquity to 1942*. New York: Rizzoli International.

Pilgrim, D. (1992). Preface. In *The accessible museum: Model programs of accessibility for disabled and older people*. Washington, DC: The American Association of Museums.

Steiner, C. K. (1992). Introduction. In *The accessible museum: Model programs of accessibility for disabled and older people*. Washington, DC: The American Association of Museums.

Terry, P. (1990). New rules will require even greater access to museums. *Museum News*, 69(1), 26-28.

Walsh-Piper, K. (1994). Art museums and children in the United States. *NAEA Advisory*. Reston, VA: National Art Education Association.

Wodatch, J. L. (1992). Some ABC's of the A.D.A. *Museum News*, 71(2), 84-90.

Footnotes

[1]The Albright-Knox Art Gallery of Buffalo, New York, enjoys a worldwide reputation as an outstanding center of contemporary art. Its collection has been cited as "one of the world's top international surveys of contemporary painting and sculpture" and is particularly rich in American and European art of the past 50 years. The AKAG has over 6,000 works in its collection, including paintings, sculpture, drawings, graphics, and photographs. Impressionism and Post-Impressionism are well represented by many of the leading French artists of the 19th century. Significant works by Picasso, Braque, Matisse, Derain, Miro, Mondrian,

Rodchenko, and others document the revolutionary trends of the Cubist, Surrealist, and Constructivist movements of the 20th century. Abstract Expressionism, Pop art, Op art, Color Field, Kinetic art, Conceptualism, Minimalism, and other trends of the '70s and '80s are splendidly represented in the work of Pollock, Still, de Kooning, Stella, Frankenthaler, Moore, Rauschenberg, Lichtenstein, Escobar, and others. The Albright-Knox presents over eight major exhibitions yearly accompanied by related events such as lectures, films, concerts, seminars, special tours, and workshops. The Gallery's Education Department sponsors a number of programs for children, adolescents, adults, families, and teachers, including the Matter at Hand program.

[2] For my initial database and mailing list, I obtained a directory of agencies from the County Office of Human Services.

Chapter 8

You'll Never Find Artistically Talented Students in That Rural Community: Art Talent Development in Rural Schools

Gilbert Clark and Enid Zimmerman[1]

This anthology is devoted to issues and approaches to art students with special needs. Although many art educators would readily accept students who are physically, emotionally, or mentally challenged as in need of special education services, students with high interests and visibilities in the visual arts often would not be included as a student population with special needs. We have authored a number of publications that summarize ours and others' research related to artistically talented students, their teachers, identification procedures, curricular frameworks, and educational settings appropriate to their special needs (Clark & Zimmerman, 1992, 1994a, 1994b, 1997, 1998; Zimmerman, 1995, 1997).

In the area of academically gifted and talented students, there is considerable research about teaching, curriculum notification, assessment, educational settings, and programming opportunities, although most studies and development activities related to the education of high-ability students have taken place in urban and suburban contexts. In visual arts education in general, and in artistically talented education specifically, there are few studies that have been conducted with emphasis on rural schools. At a National Art Education Association convention in 1990, we reported work we were conducting with an artistically talented project in a rural Indiana community (Carroll, Clark, & Zimmerman, 1990). After we described characteristics of the community and its precarious economic condition, a member of the audience called out, "I think you're crazy. You'll never find artistically talented students in that rural community, no matter how hard you try!"

This is an example of how too many people, including teachers, have "written off" rural communities and continue to characterize rural students as educationally challenged, culturally deprived, and economically disadvantaged. There is a great need to find out more about students from rural communities who exhibit interests, talent, and abilities in the visual arts and to develop effective programs adapted to their special abilities. It also is necessary to recognize the abilities and needs of art teachers who work in rural areas with high-ability art students. There were no large-scale identification

or curriculum modification projects being conducted in year-round, local schools for rural gifted and talented visual arts students until we were funded in 1994 to conduct Project ARTS (see p. 104). (Bachtel, 1988; Leonhard, 1991).

In this chapter, findings about artistically talented students from rural schools are reviewed. These findings are described in (a) programming opportunities for rural, artistically talented students; (b) case studies about particular rural students and their educational situations; (c) assessment issues, including interviews with students who attended a summer visual arts program and their teachers, and excerpts from teacher journals and parent evaluations; and (d) community involvement in special programming. Following this discussion suggestions are made that emphasize creating appropriate educational opportunities to meet the special needs of rural, artistically talented students.

Programming Opportunities

Visual arts programs in rural schools exhibit special needs due to lack of funds for materials, lack of appropriate instructional resources, and lack of support for specialized teachers. There also is a need for curriculum modifications and extensions and newer teaching strategies in visual and performing arts programs for rural, disadvantaged students (Arends, 1987; Hembree, 1990; Nelson & Janzen, 1990). Brown (1982) described development of a model arts education program for rural students intended to foster visual and performing arts skills and abilities while also emphasizing traditional academic subjects. A premise of the staff was that traditional identification measures, such as IQ scores, were not sufficient to identify gifted and talented arts students in general and rural students in particular. An alternative matrix of rating scales, nominations, achievement scores, and auditions in the arts were used successfully to select students for this program.

Concern for newer curriculum models and instructional resources for visual and performing arts education has been expressed in the National Art Education Association's endorsement of "quality art education" goals and similar endorsements by arts organizations supporting participatory arts programs in schools (Fowler, 1988; Leonhard, 1991; National Art Education Association (nd); National Endowment for the Arts, 1988; Stake, Bresler, & Mabry, 1991). In most rural school districts, students lack access to cultural resources such as museums, art galleries, libraries, concert halls, or other urban facilities because they are far from large population centers (Nachitgal, 1992; Spicker, Southern, & Davis, 1987). Teacher education institutions often are too distant from rural schools to offer local teacher or administrative workshops. Local gifted programs in rural communities generally lack student populations large enough to justify specialized visual arts grouping, specialized teachers, or access to models, mentors, and other

resources (Baldwin Separate School District, 1982; Bolster, 1990; Regional Laboratory for Educational Improvement of the Northeast and Islands, 1989). Visual arts teachers in such communities should be offered opportunities to share curriculum content and teaching strategies appropriate for their talented arts students as well as access to newer instructional resources and technology available from teacher education institutions and commercial sources.

Case Studies

Students in rural communities face many challenges that are similar to, but different in many respects from students residing in urban and suburban areas in the United States. There have been a few case studies about artistically talented students from rural backgrounds that have used interviews as appropriate methodologies for obtaining information about art talent development.

Diane

Nelson and Janzen (1990), in "Diane: Dilemma of the Artistically Talented in Rural America," used case study methodology to describe "Diane" and her academic and art education. Diane had personality characteristics of students with high abilities in the visual arts, such as creativity, independence, nonconformity, tenacity, love of solitude, and low tolerance for boredom. In seventh grade, based on her IQ score, Diane was placed in a gifted and talented program with out-of-school activities that allowed her to study oil painting with a mentor, although school remained unchallenging for her. In high school, she became severely depressed and a psychologist recommended early college entrance. She went to college early and graduated after spending only 3 years there. Her career plans were to earn an MFA and become a college art instructor.

Factors that helped "Diane" succeed in her rural environment were strong family support, a psychologist and gifted coordinator who encouraged appropriate educational options, and mentors in her junior high school art program. Other factors included support she received in college and her own personality, described as stubborn, with integrity, and having a spirit of independence (Nelson & Janzen, 1990).

Carol

Another case study of an artistically talented student, "Carol," who grew up in a rural, Indiana community, also presents some of the advantages and disadvantages that children in rural schools face (Roach, 1993). When the term *disadvantaged* is used, people often associate it with impoverishment, but that was not true in Carol's case. She grew up on a 200-acre farm owned by her parents who certainly were not impoverished. She did encounter, however, many conditions that rural children experience, such as isolation,

lack of resources, limited art experiences at school, few instructional resources, and lack of exposure to the arts.

Although elementary art teachers recognized her art abilities, art classes were not considered important in her school. Carol rarely had enough time to finish her artwork, but because she rode a school bus, staying after school to do artwork was out of the question. Although school activities provided some stimulation from the world outside Carol's home, access to books, supplies, and input from peers was limited. Like many rural children, Carol participated in 4-H clubs and her art skills were enhanced through arts and crafts and home furnishings projects. While these were valued experiences, most were completed in isolation, and her contact with peers or others interested in art was limited. Winning prizes in school and community art shows provided a major form of encouragement for her growing interest in art and family support for those interests. These, however, were the only art shows that she attended; she was 17 before she first went to an art gallery or museum.

While preparing her high school class schedule, counselors tried to discourage Carol's interest in art because she was academically able; she chose, however, to keep art in her schedule. Between her junior and senior high school years, she held an after-school job and saved money to attend a residential summer college art program. Although her parents did not support the idea of their daughter spending 2 weeks away from home, she did attend. This was an awakening experience that encouraged her to continue to pursue her interests. She later became a junior high school art teacher in a rural Indiana community.

Like students everywhere, students in rural schools vary in their ability levels, behaviors, attitudes, values, and personalities. Extremes of abilities, at both ends of the continuum, are evident in rural schools as they are in schools in urban and suburban parts of the country. Diane and Carol were fortunate in that they had supportive parents and were able to attend special art classes and travel beyond their rural communities. Nevertheless, they did experience some disadvantages typical of students growing up in rural communities.

Assessment Issues

Based on our awareness of the lack of information about highly able visual arts students from rural backgrounds, we created a Summer Arts Institute at Indiana University specifically for 60 to 70 artistically talented students per summer, from upper elementary, junior or middle, and early high school grades. The students were predominately from rural schools throughout Indiana, although students also attended from urban areas and several other states and countries. The students attended three, 2-hour visual arts classes every day, as well as other arts-related activities.

At the Institute, a variety of informal assessment measures were used to determine how well goals set for students and teachers were being met and how improvements could be made. Goals of the Institute were to extend knowledge, skills, and understandings about all aspects of the visual arts and provide opportunities for students to interact and work with others with similar and different backgrounds, interests, and abilities as well as with professionals in the arts. Assessment measures used to determine how well Institute goals were met included journals kept by teachers and students, interviews with teachers and students, observation reports, and evaluation forms filled out by Institute teachers, teachers in an endorsement program, students, and parents (Zimmerman, 1992). Journal entries provided a means for students to reflect about their art learning experiences, initiate and solve problems, and make plans for future art activities. Structured and open-ended interviews provided another successful means for evaluating rural gifted and talented students' progress in art as well as their views of themselves, their family backgrounds, and their schooling. Similar journal entries and interviews were used to assess art teachers' views of the success of the Institute's programs for artistically talented students. In order to achieve an appropriate and equitable program, a variety of authentic assessment methods were used in combination to evaluate programming opportunities, curricular modifications, community involvement, and the students' progress and achievements (Zimmerman, 1992; 1994).

The IU Summer Arts Institute provided opportunities for research with artistically talented students from rural backgrounds about perceptions of their early talent, adult and peer encouragement, position in their families, future expectations, interests in creating art, living environments, familiarity with artists, schooling, and art abilities. In 1986 and 1987, we interviewed a random sample of 20 students attending the Institute each of these two summers (Clark & Zimmerman, 1988). Twelve of these students were from Indiana and eight were selected to represent other student groups. Of the Indiana students interviewed, four boys and four girls were from small, rural communities, and two boys and two girls were from large cities. The rural Indiana students remembered outdoor experiences and strong family relationships as influencing their early art development. One boy remembered, "When I was younger, I liked to sketch and go fishing...I was drawing ever since I remember, but the earliest picture I remember when I was four and drew a picture of the woods near my home."

Both boys and girls from rural backgrounds also reported that their favorite subjects to draw were things they observed; places they had been; and animals, landscapes, and human figures. The students from urban areas recalled television, movies, and comic books as primary influences in their early art development. They reported drawing fantasy figures from their imaginations or copying from photographs or magazines.

Most of the rural students reported that they did not have a place to do artwork in their homes and no students from rural communities and only

two students from urban areas reported having art books or other visual resources in their homes. Several girls from rural areas mentioned home and community pressures to marry and raise families and that they were encouraged to practice art only as a hobby. Kleinsasser (1986) also found that academically advanced girls in rural areas are family-oriented and encouraged to marry; have children; settle in their home communities; preserve local culture; and follow traditional, often stereotypic ways of conducting their lives. None of the girls from urban areas referred to home pressures to marry and raise families.

Most of the rural students had no friends who were interested in art; only a few noted that they had one or more friends who shared their art interests. These artistically talented, rural students felt more isolated than students from urban areas, who often reported having groups of friends with whom they shared similar interests. Most of the rural students said that school offered their only access to a social community. One student remarked, "The first semester of school is when I really like it...I live out in the country and bus into school and in the summer I really do not get to see my friends."

As a result of interviews with these students, it also was clear that rural students with high abilities in the visual arts had fewer opportunities than students from urban areas to experience music or art, either at home or in their local communities. Students from rural areas viewed school as a social environment, did not have many friends with similar art interests; whereas students from urban areas described a variety of places where they socialized with friends who had similar art interests.

At the Institute, rural students from Indiana were exposed to students from other countries, including Singapore, Thailand, Taiwan, and Brazil. Many stereotypes they held about people from other places were dispelled and replaced by new understandings of themselves and others. On her evaluation of Institute programs and activities, one student wrote, "I learned that not all the world is as dull as Indiana. There's more out there." Another wrote, "I learned a lot about different people from all over the world [and] I learned a lot about myself too." Parents whose children attended the Institute were sent evaluation forms to complete; one parent responded:

My daughter is a farm girl and she enjoyed socializing an awful lot...there's a lot of kids from different backgrounds at the Institute and it's a good experience for the kids to meet other kids with different life styles. This experience will really prepare her for life.

Art teachers taking endorsement classes also kept journals about their experiences. One teacher wrote about the impact of the university environment on rural students and about their studying with other students from a variety of backgrounds:

As I think about the students' learning, what an experience these two weeks at the Institute has been... Most of them come from small Indiana towns, spend their lives with people like themselves, and for this short intense period of time they met new and different people. A whole new world opened for them. Possibilities have been glimpsed that they might never have had the opportunity to know.

At the conclusion of the 1993 Institute, teachers who attended a gifted and talented endorsement program connected with the Institute were interviewed in small focus groups about their reactions to the endorsement program and its influence on their teaching (Roach, 1993). One theme that emerged was strong feelings of isolation experienced by art teachers in rural schools. Unlike their urban colleagues, rural art teachers often are the only art teacher in a given school or district and teach a full range of classes without input from other art teachers. One rural teacher claimed "if you don't have people to banter with and pound out ideas, then you lose a lot of resources...I don't have anyone at home in my isolated setting to share ideas." Most urban art teachers, however, did not identify with the feelings of isolation described by rural art teachers and reported that they were in contact with other art teachers and had easy access to local museums and other resources.

Another theme that emerged from the focus groups was the need for isolated art teachers to network with other teachers and share ideas and teaching materials. Rural art teachers valued, as one member said, "getting information and resources into the heads of those of us who need it the most, in order to benefit the students we teach." Another art teacher from a rural community described the emphasis on building a community of teachers and being exposed to many teaching materials, as:

A re-awakening. I gained new ideas about teaching resources that I plan to implement in my classroom. Although I had high-ability art students, I was not prepared to teach them. Now I am! I will not only be a better teacher of gifted, but of regular students as well.

Community Involvement

In our own experiences in working with and conducting research about artistically talented students from rural backgrounds, we have observed that reports about gifted education are filled with references to advantages urban and suburban parents offer their children (i.e., Gallagher, 1985; Van Tassel-Baska, 1998). Due to many factors, high-ability art students from rural areas rarely are offered the quality and amount of cultural opportunities available to their peers in urban and suburban schools. Conversely, opportunities that rural parents do provide often are not valued in schools

or may conflict with local school agendas. Families living in rural communities, however, possess rich and unique cultural characteristics that should be taken into account in developing effective curriculum options, programming opportunities, and assessment procedures (Zimmerman, 1990).

A number of studies point to the need for community involvement in successful programs for rural students with high interest and abilities in the visual arts. Programs for gifted and talented students in academic and arts programs in small, rural Alaskan elementary schools were described by Lally (1986). Through a survey of school superintendents, she found that although Native children comprised over 50% of the schools' populations, only 19.5% were placed in gifted and talented programs. Although 40% of school districts provided special identification measures for Native children, programs incorporating aspects of Native cultures were incorporated into only 26% of the district's curricula. Lally found that successful gifted and talented programs for visual arts students in rural areas of Alaska combined both traditional, academically oriented curricula and nontraditional offerings related to leadership, arts, Native culture, and linguistics. Community mentors, interested teachers, and use of outside resources, such as fine arts camps, helped achieve equitable program diversity.

Cleveland (1980) investigated development of a successful program that used community members as adjunct teachers for rural, gifted and talented secondary students. Findings indicated that community volunteers could be used effectively as personnel and integrated into rural arts education programs for secondary students. An outcome of this study was improved communication and cooperation between the school and the local community, and student progress in the arts was accelerated.

Research also has been conducted in Israel about the involvement of local community members in educational programs for gifted and talented students. In a "Discovery Program," selected rural and other underserved students are identified and prepared to be accepted into the Israel Arts and Sciences Academy, a national, residential high school for very highly gifted and talented students (Amran, 1991). Several Discovery Program procedures were found to be successful in accommodating to the needs of rural and underserved gifted and talented students, including meeting with an official from each community to solicit and guarantee his or her prolonged support; holding a series of meetings with school principals, local teachers, and parents of highly able students to create an understanding of the program's goals and activities; and employing local persons as administrators and teachers who understand local needs and local community values and are more successful in promoting positive educational outcomes than are outsiders. Although these three studies were directed toward specific rural populations, conclusions about these programs may have implications for rural students in other contexts than those in the Midwestern United States.

Parents of students from rural backgrounds place great value on the heritages and cultural histories of their families. Schools, however, rarely

incorporate these values when planning or researching programs for students from such groups (Barkan & Bernal, 1991; Melesky, 1985; Montgomery, 1989; Tonemah, 1990). Parents and community members should be involved actively in helping develop identification procedures and visual arts programs that build upon local cultural values and resources and histories within their local communities. These local values and resources should be taken into consideration when research is conducted about the effectiveness of programming opportunities and assessment procedures are being developed for students from rural backgrounds.

Conclusions

There is a need to understand the special needs of all art students including those who are artistically talented and live in rural areas. The challenge to visual arts teachers who teach artistically talented students in rural areas is to find creative ways of bringing cultural resources into their classrooms so that their students who may live many miles distant from urban cultural resources may be exposed to these resources. Another challenge is to bring art teachers, who teach in isolated, rural areas, in contact with other art teachers through local and state staff development services and new technologies, such as distance education and video conferences, as well as making contemporary resources available to them through grants and local education funding. This interchange of information, differentiated curricular, and teaching strategies relevant to teaching artistically talented students in rural areas will benefit not only students and teachers, but local communities as well.

Students with high interests and abilities in the visual arts need to be with others with similar interests and abilities; at the same time they need to interact with peers who are from different cultural, economic, and ethnic backgrounds in the United States and abroad. To achieve this kind of diversity, summer programs and other educational opportunities should be created and made financially feasible for artistically talented students from rural areas. It also is suggested that a variety of authentic measures be used to collect information from students, teachers, parents, and others so that identification procedures, differentiated curricular, and program options can be designed to both meet the needs of artistically talented students and at the same time provide enrichment opportunities for entire school populations.

Finally, community involvement should be a high priority in rural art programs for high-ability art students. In such programs, parents, local artists, and other concerned citizens should be actively involved in all aspects of programs designed for rural, artistically talented students. Such community involvement often leads to positive communications between local school administrators, teachers, and parents who understand community values and mores.

Project ARTS

Several of the needs of rural students who have interests and abilities in the arts were addressed in our federally funded Javits Gifted and Talented Students Education Program Grant entitled Project ARTS (Arts for Rural Teachers and Students). This project was a three-state consortium with administrative responsibilities at Indiana University and satellite sites in South Carolina and New Mexico. Public schools serving rural, underserved, ethnically diverse, visual and performing arts, talented students were cooperating participants. Through research, this consortium developed, modified, demonstrated, and implemented identification methods, curriculum modifications, and evaluation procedures building on local arts resources and cultural traditions appropriate to the needs of rural, talented arts students from Gullah African American, American Indian, Hispanic American, Appalachian, and European American backgrounds. Local parents and community members took active roles in program development, implementation, and evaluation of Project ARTS. Inservice training materials were created to help teachers and administrators, as well as parents, identify, educate, and evaluate students from the targeted populations and be better informed about serving their educational needs (Clark, Marché, & Zimmerman, 1997). It is anticipated that Project ARTS will provide a base from which model programs and resources may be developed for other communities with similar populations of rural students with high interests and abilities in the visual and performing arts.

References

Amram, R. (1991). Things in action: The Discovery Program exploration camps. *Roeper Review, 13*(2), 82.

Arends, J. H. (1987). *Building on excellence: Regional priorities for the improvement of rural, small schools.* A report to the National Rural, Small Schools Task Force by the Regional Educational Laboratories. (ERIC Document Reproduction Service No. ED 289 643)

Bachtel, A. E. (1988). A study of current selection and identification processes and schooling for K-12 artistically gifted and talented students. (Doctoral dissertation, University of Southern California, 1988). *Dissertation Abstracts International, 49,* AH-3597

Baldwin Separate School District. (1982). *A gifted model designed for gifted students in a small, rural high school: Post-evaluation design 1981-1982.* (ERIC Document Reproduction Service No. ED 233 847)

Barkan, J. H., & Bernal, E. M. (1991). Gifted education for bilingual and limited English proficiency students. *Gifted Child Quarterly, 35,* 144-147.

Bolster, S. J. (1990, March). *Collaboration on curriculum.* Paper presented at the Rural Education Symposium of the American Council on Rural Special Education and the National Rural and Small Schools Consortium, Tucson, AZ.

Brown, K. E. (1982). Development and evaluation of a program for culturally diverse talented children. *Dissertation Abstracts International, 44*/01A. (Publication No. AAC8311042)

Carroll, K., Clark, G., & Zimmerman, E. (1990). *Issues of egalitarianism and elitism in teaching artistically talented students.* Panel presentation at the National Art Education Association, Special Interest Seminar, Kansas City, MO.

Clark, G., Marché, T., & Zimmerman, E. (1997). *Project ARTS: Identification, curriculum, and evaluation handbook.* Grant R206A20220, USDOE, J.J. Javits Gifted and Talented Grants Program.

Clark, G., & Zimmerman, E. (1988). Views of self, family background, and school: Interviews with artistically talented students. *Gifted Child Quarterly, 32*(4), 340-346.

Clark, G. A., & Zimmerman, E. (1992). *Issues and practices related to identification of gifted and talented students in the visual arts.* Storrs, CT: The National Research Center on the Gifted and Talented.

Clark, G., & Zimmerman, E. (1994a). *Programming opportunities for students talented in the visual arts.* Storrs, CT: The National Research Center on the Gifted and Talented.

Clark, G., & Zimmerman, E. (1994b). What do we know about artistically talented students and their teachers? *Journal of Art & Education Design Education, 13*(3), 275-286.

Clark, G., & Zimmerman, E. (1997). The influence of theoretical frameworks on Clark and Zimmerman's research about art talent development. *The Journal of Aesthetic Education 31*(4), 49-63.

Clark, G., & Zimmerman, E. (1995). You can't just scribble: Art talent development. *The Educational Forum, 59,* 400-408.

Clark, G., & Zimmerman, E. (1998). Nurturing arts in programs for gifted and talented students. *Phi Delta Kappan, 79*(10), 747-751.

Cleveland, L. C. (1980). The use of community volunteers in a rural secondary school gifted and talented program. (Doctoral dissertation, Florida State University). *Dissertation Abstracts International, 41,* 10A.

Dobbs, S. M. (1992). *The DBAE handbook: An overview of discipline-based education.* Santa Monica, CA: The J. Paul Getty Trust.

Fowler, C. (1988). *Can we rescue the arts for America's children? Coming to our senses 10 years later.* New York: ACA Books.

Gallagher, J. J. (1985). *Teaching the gifted child* (3rd ed.). Newton, MA: Allyn and Bacon.

Hembree, L. (1990). Arts arising: A rural summer arts program. *Gifted Child Today, 13*(1), 43-44.

Kleinsasser, A. M. (1986). Equity in education for gifted rural girls. *Rural Special Education Quarterly, 8*(4), 27-30.

Lally, E. M. (1986). A survey of gifted program administration in rural Alaska (Doctoral dissertation, University of the Pacific, 1986). *Dissertation Abstracts International, 47,* 10A.

Leonhard, C. (1991). *Status of arts education in American public schools.* Urbana, IL: Council for Research in Music Education.

Melesky, T. J. (1985). Identifying and providing for the Hispanic gifted child. *NBAE: The Journal for the National Association of Bilingual Education, 9,* 43-56.

Montgomery, D. (1989). Identification of giftedness among American Indian people. In C. J. Maker & S. W. Schiever (Eds.), *Critical issues in gifted education: Defensible programs for cultural and ethnic minorities* (pp. 79-90). Austin, TX: Pro-Ed.

Nachitgal, P. N. (1992). Rural schools: Obsolete...or harbinger of the future? *Educational Horizons, 70,* 66-70.

National Art Education Association. (n.d.). *Quality art education goals for schools*. Reston, VA: Author.

National Endowment for the Arts. (1988, May). *Toward civilization: Overview from a report on arts education* (S/N 036-00-0051). Washington, DC: U.S. Government Printing Office.

Nelson, K. C., & Janzen, P. (1990). Diane: Dilemma of the artistically talented in rural America. *Gifted Child Quarterly, 31*(1), 12-15.

Regional Laboratory for Educational Improvement of the Northeast and Islands. (1989). *Ideas that work in small schools (grades 7-12)*. (ERIC Document Reproduction Service No. ED 310 905).

Roach, K. (1993). *Focus group with IU Summer Arts Institute teacher participants*. Unpublished manuscript.

Spicker, H. H., Southern, W. T., & Davis, B. I. (1987). The rural gifted child. *Gifted Child Quarterly, 31*, 155-157.

Stake, R., Bresler, L., & Mabry, L. (1991). *Custom and cherishing: The arts elementary schools*. Urbana, IL: Council for Research in Music Education.

Tonemah, S. A. (1990). *American Indian teacher training program. American Indian research and development*. Paper presented at the National Indian Education Association, San Diego, CA.

Van Tassel-Baska, J. (1998). *Excellence in educating gifted and talented learners*. Denver, CO: Love Publishing.

Zimmerman, E. (1990). Preparing to teach art to secondary students from all cultural backgrounds. In B. Little (Ed.), *Secondary art education: An anthology of issues* (pp. 185-199). Reston, VA: National Art Education Association.

Zimmerman, E. (1992). Assessing students' progress and achievements in art. *Art Education, 45*(6), 14-24.

Zimmerman, E. (1994). How should students' progress and achievements in art be assessed? A case for assessment that is responsive to diverse students' needs. *Visual Arts Research, 20*(1), 29-35.

Zimmerman, E. (1995). Factors influencing the art education of artistically talented girls. *The Journal of Secondary Gifted Education, 6*(2), 103-112.

Zimmerman, E. (1997). I don't want to sit in the corner cutting out valentines: Leadership roles for teachers of talented art students. *Gifted Child Quarterly, 41*(1), 33-41.

Footnote

[1]Authors' names are listed alphabetically; each contributed equally to this chapter.

Chapter 9

Narrative Accounts of Experience, Context, Meaning, and Purpose

Steve Thunder-McGuire

None of us are to be found in sets of tasks or lists of attributes; we can be known only in the unfolding of our unique stories within the context of everyday events. (Paley, 1990, p. xii)

Over the course of 3 years I have worked as a visiting artist with children experiencing various physical and developmental disabilities at The University of Iowa Hospital Schools. I became increasingly familiar with idiosyncratic approaches children used to make art. As I acquired a fuller, more complete view of particular children's interpretive strategies, I also began to follow the children back into their art classrooms to work with them and their teachers. When I began to share with teachers [my] interpretations of individuals' art participation, I recognized that we were composing biographies of students. From this I began to consider more thoroughly and philosophically, a strategy for compiling into one story—the content of the IEP, anecdotes, observations, and a portfolio—narrative accounts of individuals' participation.

I would like to share with you my question: What comprises the practice of meaningful assessment? Confronted with the challenge to interpret the critical variables in the art education of a student experiencing physical and developmental disabilities, it is easy to see the ambiguity of the student's actions. The purpose of meaningful assessment then is to discover the intent and purpose of a student's participation in art—to make sense of what the student does. To this end meaningful assessment can become an opportunity to create, with the student, an art curriculum that emphasizes his or her abilities.

The term *authentic* is consistently used by educators to describe "teacher-constructed" assessment in which "the content assessed represents the content taught" (Elliott, 1995, p. 4). While norm referenced testing is often used to determine special education services, art teachers, like special education teachers, find in it generalizations and abstractions, data that fails by itself to provide necessary information required to work with concrete and particular circumstances and complexities. The meaningfulness of

composing narrative accounts, in part, comes from the element of authenticity.

Authentic assessment, while it is only now beginning to be used in special education (Elliott, 1995), is not entirely new to art educators. The use of products or performances to determine learning is what, conceptually, the use of portfolios in evaluations envisions (Hausman, 1992). That is, assessment is directed at the application of knowledge—what students know and how they know it—while creating something.

Let me relate an anecdote to ground why, as art teachers, we necessarily interpret a student's intentions and purposes.

For about 3 years Chris, a 10-year-old boy experiencing cerebral palsy, has been communicating his interests with others through images he selects and has taped to his hands. The images vary from collector cards to stickers. Chris is very limited physically, as he is quadriplegic and has no fine or gross motor development. He is nonverbal and communicates with eye gaze. His movements are too spastic for him to type or point to a communication board. More recently, Chris has begun to find pictures in magazines, the newspaper, or on boxes. Once taped to his hand, they remain there for most of the day. Chris has learned that people will ask him about what he has "taped."

"Story" and "play" are what come to people's minds when they are trying to explain what Chris is doing in art class. This is what Elliana, Chris's classmate, has learned. Chris sings to Elliana the most exciting notes of their play with the action figures on his tray. They are all about the jumps of a Power Ranger as he leaps over the Power Ranger Elliana holds. Chris has an almost constant scream of excitement, so when Elliana can't figure what Chris is thinking, as he moves his action figure, she just makes up something she thinks he may be thinking. "Now that's a high jump, Christopher" she says. Chris can't disagree and smiles. "Draw Power Rangers with me," Chris tells Elliana, by looking at the pencil and crayon box. Elliana puts a crayon in his hand and begins to draw a Power Ranger mask. It is a sticker of a Power Ranger mask Chris has taped to his hand.

To be sure, this anecdote centers on an interesting question. Where Chris is concerned, the support of the presentational quality of his visual images matters very much. What kinds of things can Chris's teachers have knowledge of if they approach the images on his hands as invitations for interpretation, as poems? It is an absorbing question and by no means a rare drama—a child's stubbornly idiosyncratic artmaking approach so captures our attention that we are inclined to try and understand it. Simply, to pay the closest heed to observation and anecdote matters tremendously for the art teacher and student.

Interpreting Meaningful Human Action

Gleason (1993) proposes a theoretical guide for interpreting "...what persons with severe or multiple developmental disabilities do in context" (p. 157). He suggests that "there are clues for discerning patterns of participation. They are context, experience, purpose and meaning" (p. 164), existential, pedagogical and ontological domains familiar, actually, to art educators. For Gleason, explanation of what an individual does "involves deciphering patterns expressed through their human systems." These are "patterns of interference, patterns of participation and patterns in ambiguity" (p. 163). These patterns are interpreted in terms of "shifts in the relationships among form, function and content" (p. 163). That is, it remains difficult to understand what a person does without considering how disabilities reveal themselves as differences in physical characteristics. Differences in physical characteristics of form can affect our recognition of the person's ability—the function of what is being done. In turn, understanding the meaning of what the person is doing, is challenging.

Gleason's goal of discovering an individual's capabilities is consistent overall with an educational philosophy I have in mind. Formula and recipe approaches are not stressed, since they are inconsistent with both "meaningful art" (Zurmuehlen, 1990), education that is grounded in "idiosyncratic meaning," "intentional symbolization," "artistic causality" (Beittel, 1973, pp. 1-3), and special education which is "ecologically founded" (Blandy, 1989, p. 9). Blandy (1989) writes, "teaching which is ecological is fundamentally opposed to a teaching approach...which arbitrarily and artificially sets an individual apart from peers, culture, society and environment" (p. 9).

Gleason (1993) in his theoretical discussion asks us to reflect on what he sees as the alienating force of an overreliance on "educational understanding that proceeds from a...premise...to determine developmental characteristics as states, stages, and skills of the individual as the basis for intervention" (p. 158). The dominance of the clinical orientation to assessment leads to misplaced concreteness, which in turn results not in ambiguity, but abstraction, and possibly corresponding "goals which attempt to compensate for behaviors and characteristics associated with a diagnosed disability" (Blandy, 1989, p. 8). You can imagine this happening when you are working with a student and realize the content of the student's Individualized Education Program (IEP) does not accurately match what the student does in art. A student's participation in art, his or her presence, can be lost to abstraction. For example, rather than recognize clear abilities, like Chris's interpretive strategy, the goal may actually be to rectify a perceived problem—not being able to control a pencil or crayon. Misplaced concreteness—focus on isolated behavior and not meaning, purpose and context—can produce goals in art that actually diminish the value of an individual's idiosyncratic interpretative strategy. When we mistake an

abstraction for the individual's actions, then the reality of the action is concealed from us. Such an experience as Chris's in his fictive play with Elliana can be lost to generalizations that a teacher brings to the process, all too sure that what is observed is clearly based on conceptions of other individuals' artmaking. Though Gleason does not use the word, I believe that he is suggesting we explore presence in the individual's artmaking. When I took stock of the centrality of images in the meaning of Chris's play with other children, I was able to overcome the possible error of identifying only the familiar activity of playing with action figures.

The imperative of developing assessment that makes sense of what a person does by considering meaning and context is now complemented by a growing body of inquiry focused on multiple forms of literacy, including "Rethinking Literacy" (Eisner, 1991), "The Literacy Debate and the Public School: Going Beyond the Functional" (Greene, 1991), and *Multiple Intelligences* (Gardner, 1993). Eisner (1991) suggests that we design "education programs that enable children to play to their strengths, to pursue and exploit those meaning systems for which they have special aptitudes and interest" (p. 127). Perhaps the most important contribution an art teacher makes in the special education situation is identifying an individual's idiosyncratic mode of inquiry and interpretative strategies for configuring meaning. Therefore, "Teachers must learn the techniques of creative problem solving and classroom research" (Guay, 1993).

The composition of a narrative account of a student has a substantial philosophical grounding. Philosophically, such a conception evolves from concepts grounded in phenomenology and hermeneutics. For Gadamer (1975), understanding is characterized by mutual belonging. The truth of understanding, which Gadamer spoke of, rests within the subject, human action, telling us something about that which concerns us, and for our part, recognition of that something. But the theoretical and philosophical work of Paul Ricoeur (1984; 1986; 1988) is the most substantive source to which I look.

Matching Guay's call for learning techniques of classroom research that could identify a special education student's idiosyncratic mode of inquiry, is contemporary narrative interpretation of "meaningful human action" (Ricoeur, 1984, p. 197). According to Gleason, "Making sense of what is implicit in what [individuals] are doing is an avenue for discovering the capabilities of the person." Ricoeur lends a particular philosophical grounding to authentic assessment since his focus is the interpretation of meaningful human action. Ricoeur's view is that, because the whole of human action means more than the sum total of events, we need to emplot it, to compose narratives. MacIntyre (1981) maintained: "It is because we all live out narratives in our lives and because we understand our own lives in terms of the narrative we live out, that the form of narrative is appropriate for understanding the actions of others" (p. 211).

When I use the term *narrative account*, I refer to narrative interpretation, the act of narrating history. Like any good historian, a teacher composes assessment from a sense of vision that originates in attention to the fullness of details. The ordering operation of historical interpretation at work in composing narrative accounts involves "the synthetic function of 'grasping together' common to story making 'along with the reflective function'" of historical composition, judging explanations of what took place (Ricoeur, 1984, p. 156).

An Illustration of Narrative Account

Recently I was working with Chris, and he had on the tray of his wheelchair a book about airplanes. I turned the pages slowly. This seemed to require Chris to scan the drawn images on each page and pick one page of definite interest, which I knew by his looking directly at my eyes and then looking directly back to the picture. Until I went through the whole book with him, performing this exercise of page turning, I did not understand as fully as Chris wanted me to understand, why he chose this book. It is important to Chris that I not only perform page turning, but be intent on uncovering his interests. There is nothing more lively than discovering, in detail, Chris's idea. Chris literally screamed with enthusiasm when, after a few questions, I realized why he was so interested in *this* book. Chris was particularly taken with an image of a jet fighter pilot thrust back in his seat, looking, with his full flight gear, very much like an insect. Having this book was not enough for Chris, though. He was upset that I would not cut out the picture and tape it to his hand. Chris did not resort to demanding, but he solemnly waited for me to resolve this dilemma. He has a way to manage any conversation, even silent ones, with his eyes.

"Chris, I will photocopy the picture," I said. Copyright laws prohibited the copy center from making a color photocopy, so I copied it on my own black-and-white machine. It was obvious that Chris could better imagine himself flying when he saw that drawing. Simply, the image demanded Chris's fictive play.

Chris worked through questions, play, and request for drawings that resulted from this one image. Yet I found myself not able to explain what he was doing, precisely. Yes, Chris was sending messages, conveying meaning. But was he involved in an aesthetic activity?

I reflected on what Chris was *doing*. When I contemplated it in its own terms I remembered what Ryan, a third-grade boy, explained to me once:

On the weekends I have battles with my G.I. Joes—2-hour battles, 8-hour battles, every once in a while a 24-hour battle. What I do is set up my G.I. Joes around the room like they are in the middle of a war—a combat zone. Sometimes I will leave them set up all week long just like I left them and then on the weekend finish where things left off.

All week long, I think about how to position different figures and how things could turn out. So, in my book I wrote down what was going on.

An inventory of features from Chris's strategy as well as Ryan's bear a remarkable similarity: the application of fictive play, "being as something." This is what I, as an art teacher, recognize. Accomplishing fictive play, which is utmost to many children's artmaking, is precisely the stuff of Chris's strategy for accomplishing images, although it is packaged differently.

Teacher's Narrative Account

Composing a biography of a student involves the reading of portfolios; interpreting what parents, other teachers, and therapists tell; observational information; and the initial reading of the student's IEP. Certainly, as I have suggested, what Chris does is an invitation for me and his art teacher to reflect on the presence of his doing. Possibly art teachers are especially attuned to paradoxes of interpreting the meaning, context, and purpose of what an individual is doing. In the fullest sense of assessment, several sources of information are mediated over time and configured into a whole. Teachers, through assessment, collect and review photographs, drawings, writing, anecdotes, and so forth, which follow emergent strands of meaning. We sense that anecdotes such as the one about Chris, as well as those of parents and other teachers, and the student's portfolio will give us more than a graphic description. When we say that we have an art class that includes students with an array of abilities and approaches for artmaking, we need to have a drama in mind in which meanings, processes, environments, and people are interacting. Picturing such a drama should lead to narrative accounts. Wells (1986) in *The Meaning Makers* suggests that "Making sense of an experience is to a very great extent being able to construct a plausible story about it" (p. 196). Narrative accounts of students' participation can focus on the form, function, and content of what the individual does, with the goal of understanding the meaning, context, experience, and purpose.

Instructors who are working with special education students compose narrative accounts of an individual's participation that tell the story of what happened in class. (How was the individual engaged interactively with others, processes, materials, and specific conditions? Teachers and students come quickly to mind as the primary characters in the story, but of course conditions supply context and include such matters as friendships, directions, questions, disagreements, materials, and skills.) Another factor is the physical environment. Consider the meaning of the individual's experience as it relates to them. (Here, teachers consider the meaning of terms that might be contributing to the drama of assessment and, in turn, describing what the student "does." For instance, any discussion of Chris's artmaking, or that of other children experiencing physical and developmental disabili-

ties, must begin with some basic settling of terms. *Artmaking* and *inclusion*, as cover terms, are so broad that they both need, almost always, to be defined for each individual and occasion on which they are used. Just as a single definition of artmaking would be insufficient to include how Chris, with his works of interpretation, is involved in the art classroom, so is scrutiny from within the confines of a single conception of inclusion.) Relate the discontinuity/continuity the teacher perceives, between the class and information gleaned from the individual's portfolio, anecdotes, and preceding classes, as well as the unfolding story. (Rhodes and Nathenson-Majia, 1992, suggest we consider the processes students put to work as available sources for assessment.)

Without composing narrative accounts, I would be left with a chronicle of the individual's work, not necessarily a presentation of meaning. The biography of a student emerges through understanding and appreciating a history of presence—through the composition of plots. My accounts rest upon careful attention to the complexity inherent in the myriad routes individuals may have journeyed as they've worked.

Narrative accounts contain plots that explain events or an individual's actions. A teacher's composition of narrative accounts draws from the power to connect the past, present, and future through meaningful explanation. Explanation in history is the reconstruction of routes of human action. My narratives reconstruct the particular meanings, experiences, context, and purposes that make up the contingent history of an individual's participation in art class, giving reasons why an individual responds in a specific way.

The rational explanations that emerge as reasons in teachers' narratives originate within the students' comments and actions. Ricoeur (1984) wrote,

> To explain an individual's action in terms of reasons is to provide "a reconstruction of the agents calculation of means to be adopted toward his chosen end in light of the circumstances in which he found himself" (p. 122 [Dray's] emphasis). In other words, to explain such actions "we need to know what considerations convinced him that he should act as he did." (p. 129)

In order to show what happened, a teacher's concern becomes not merely the motivations for why a student did certain things, that is, *behavior*. As a teacher, I need to be concerned with *outcomes* also. I must be attentive to the whole sphere of an action. My "rational explanation" depends, for its intelligibility, upon putting together motivations and outcomes of actions. Composing narrative accounts involves plotting the relations between actions and then the direction of their unfolding, so that what is revealed is essentially a meaningful experience of what was done.

The IEP, Portfolio, and Others' Observations

Interviews with pertinent people, the IEP, and the portfolio are integral parts of narrative accounts. What otherwise might appear to be disparate elements of teaching—such as the IEP, a parent's description, adaptive equipment, the portfolio, and the presence of an aide in the art room—are brought together in a biography that has been given direction and continuity from narrative interpretation.

My narrative accounts often push me to review the IEP and ask, "What does this information mean for the student in my art class?" and "What can I do with this information?" There are substantive reasons why it is essential that the art teacher review a student's IEP. It is a developmental appraisal of a student's level of participation and ability in activities and environments in art class. The IEP is one touchstone for communicating a student's school story. From the inevitable dialectical questioning that comes from reading the student's IEP and imagining it in terms of the art curriculum comes the possibility that I will imagine a variety of potential ways to proceed. Pike and Salend (1995) suggested special education teachers "analyze a narrative record of observations over a period of time to determine a student's...responses to specific instructional strategies" of the IEP (p. 15). Because there are specific goals and objectives as well as timelines for reviewing the student's participation in a variety of environments, an art teacher's narrative accounts can become an important consideration in program adaptation.

It is worth considering the reality that parents' and caregivers' descriptions are richer than most descriptions of behaviors and skills in the student's IEP. I have found it important to include parents' answers to questions in my narrative accounts. I ask parents to share their explanation of student participation which I describe. And ask yourself: What does this individual experiencing idiosyncratic physical and developmental disabilities do with a variety of particular tools and materials?

Portfolio assessment is perhaps the most well-known strategy by which art teachers examine the art learning process, as well as the products of learning. Hausman in his editorial, "On the Use of Portfolios in Evaluation" (1992), identifies portfolio assessment projects widely discussed. He refers readers to articles by Howard Gardner, Dennie Wolf, Drew Gitomer, and Kathryn Howard for a description of Arts PROPEL, a component of which involves "the implementation of...a Portfolio Culture" (Hausman, 1992, p. 5). Art teachers who have used portfolios in evaluation probably recognize the powerful potential of which Hausman (1992) wrote: "The process of portfolio review is dynamic and...the judgments or evaluations rendered are based upon multiple images and forms created over time" (p. 4). Because portfolio assessment focuses on artwork and students' reviews—written and oral—it establishes a clear link between teaching and assessment.

While portfolio assessment can be used with all art students, it is particularly meaningful to individuals with a range of abilities, whose participation in art class, like Chris', is different. For example, photographs of art-making, not simply art objects, can be included in the portfolio. By photographing events of artmaking on a regular basis, these students' varied participation can be documented for review with the student and reflection in teachers' narrative accounts.

Narrative accounts that include portfolio reviews have made me appreciate more fully the challenge of contrasting what a student does with what I may be trying to help him or her accomplish. When I review a portfolio, developed collaboratively with the individual over time, I try to consider the context, purpose, and meaning underpinning art production. The interpretive referencing that takes place while talking with a student about his or her work converges on what the student meant to be doing and how it was done. In reviewing a portfolio, you may become aware of the contradiction between your understanding of students' experience in art class and their experience [outside art class]. Being able to then recognize discontinuity between what the individual is really doing and your previous ideas about their ability is an essential interpretive step.

Summary

I view narrative accounts as ongoing configuration of the art curriculum as it is experienced by the student. Certainly, teachers put together information, anecdotes, and observations of students because they want to know how to be better [prepared] teachers for individuals. We found we had to faithfully render a picture of what Chris experiences and means. This allowed the complexity of Chris's participation to guide our teaching.

Narrative accounts are intended to clarify the meaning of the individual's participation and to encourage the teacher to reflect upon the concrete details of the student's education—details that otherwise might pass unnoticed. Most of the time, information gleaned from observation and anecdote does not articulate how best to proceed with a student who experiences physical and developmental disabilities. The information may be "hidden," so your challenge is to compose a more complete biography of the student.

References

Beittel, K. R. (1973). *Alternatives for art education research.* Dubuque, IA: William C. Brown.

Blandy, D. (1989). Ecological and normalizing approaches to disabled students and art education. *Art Education, 42*(3), 7-11.

Eisner, E. W. (1991, Spring). Rethinking literacy. *Educational Horizons, 69*(3), 120-128.

Elliott, S. N. (1995). *Creating meaningful performance assessments: Fundamental concepts.* Reston, VA: The Council for Exceptional Children.

Gadamer, H. G. (1975). *Truth and method.* New York: Crossroad.

Gardner, H. (1993). *Multiple intelligences: The theory in practice.* New York: Basic Books.

Gleason, J. J. (1993). The creation of meaning: What persons with severe or profound multiple developmental disabilities do in context. *Australia and New Zealand Journal of Developmental Disabilities, 18*(3), 157-167.

Greene, M. (1991, Spring). The literacy debate and the public school: Going beyond the functional. *Educational Horizons, 69*(3), 129-134, 164-168.

Guay, D. M. (1993). Normalization in art with extra challenged students. A problem solving framework. *Art Education, 46*(1), 58-63.

Hausman, J. (1992). On the use of portfolios in evaluation. *Art Education, 45*(1), 4-5.

MacIntyre, A. (1981). *After virtue.* Notre Dame, IN: University of Notre Dame Press.

Paley, V. (1990). *The boy who would be a helicopter.* Cambridge, MA: Harvard University Press.

Pike, S., & Salend, S. J. (1995, Fall). Authentic assessment strategies, alternatives to norm-referenced testing. *TEACHING Exceptional Children, 27*(1), 15-20.

Rhodes, L. K., & Nathenson-Majia, S. (1992). Anecdotal records: A powerful tool for ongoing literary assessment. *The Reading Teacher, 45*(7), 502-509.

Ricoeur, P. (1984). *Time and narrative,* volume I. (Trans. K. McLaughlin & D. Pellauer). Chicago: University of Chicago Press.

Ricoeur, P. (1986). *Time and narrative,* volume II. (Trans. K. McLaughlin & D. Pellauer). Chicago: University of Chicago Press.

Ricoeur, P. (1988). *Time and narrative,* volume III. (Trans. K. McLaughlin & D. Pellauer). Chicago: University of Chicago Press.

Wells, G. (1986). *The meaning makers.* Portsmouth, NH: Heinemann.

Zurmuehlen, M. (1990). *Studio art: Praxis, symbol, presence.* Reston, VA: National Art Education Association.

Chapter 10

Art as a Visual Language that Supports Verbal Development

Paula Eubanks

The acquisition of language is central to the education of all young children. Language is the key to learning everything else. For children who cannot hear,[1] language acquisition is *the* primary goal (Paul & Jackson, 1993). Children with specific language disorders or impairments share this priority, because their language learning has been disrupted. The usual avenues of communication are compromised but art offers an alternative avenue, as a visual language. If art is viewed as a language then the problem of language acquisition is somewhat reduced to one of translation from one language to another.

Art as Language

Is art a language? The answer to the question may depend on the perspective of the person to whom it is addressed. Lois Bloom, a scholar in the field of language development, defines language as "a code whereby ideas about the world are expressed through a conventional system of arbitrary signals for communication" (Lahey, 1988, p. 2). Nelson Goodman, a philosopher who explored extensively the nature and function of symbol systems in music, dance, the literary arts, and the visual arts, defines language as a symbol system that conveys complex ideas (Goodman, 1976). These two definitions of language share common elements: signals or symbols with conventional meanings; a code or system that organizes the set of symbols; and the use of this system for communication. Comparisons between the visual language and verbal language often refer to elements the two languages have in common. Phonemes are similar to the elements of art, which are synthesized according to the syntax of the principles of design, in order to create semantics, the meaning interpreted by the viewer (Cromer, 1966; Feldman, 1976).

Language Development Perspectives

Another view of common elements is based on a language development perspective. Verbal language can be viewed as having two components, *recep-*

tive and *expressive* (Bzoch & League, 1971). Receptive language refers to the understanding of words used by others, the decoding of verbal symbols. In the visual language, viewers read and interpret the visual symbols encoded in works of art. The art critic's job is to translate visual language into words that explicate the art for others. Expressive language refers to communicating ideas by speaking or writing, in effect, the creation of coded verbal symbols. The expressive component of the visual language is the creation of visual symbol systems, the making of marks or objects that communicate ideas. If the critic's job is to read the visual language, the artist's job is to speak it fluently and eloquently.

Differences between the visual and verbal languages are based on the extent to which they are codified. Broudy (1972) views visual language as less codified than verbal language: "The arts present us with images of feeling for which there is no dictionary save that of the totality of human experience" (Broudy, 1972, p. 78). Some codification takes place, at least according to art historians. Arnason (1986), modern art historian and critic, refers to various "isms" or styles having a vocabulary and syntax. On this subject of style, Wolf (1977) points out that the codification of verbal language may change over the centuries but, compared to the visual language, is relatively stable. This issue of codification is the basis for Forrest's (1984) view that art is not a language. Communication in the visual language cannot be translated into another language as directly as English can be translated into Italian, for instance. No principles, outside the visual language itself, exist for the verification of meaning conveyed by those visual symbols. While art has some rules, there is no system of correct application, no structure by which one can judge whether or not a work of art is right or wrong.

Returning to Bloom's definition of a language, art may lack enough agreed upon conventions to be considered a conventional system of signals, and accepted as a language universally. However, this shortcoming does not prevent artists from viewing art as a language, one that is superior to words. Kepes (1944) describes visual language as more holistic than spoken language and more efficient as a disseminator of knowledge than most other means of communication. Arnheim (1969) considers the visual language superior because it comes closer to the original stimulus—verbal language being linear, sequential, and one dimensional, by comparison. Reading a picture is like entering a room in which many conversations are occurring; it offers more sequential options than reading words because a picture can be read starting from many different places, and from more than one point of view at a time (Feldman, 1976).

Art educators describe art as the first language of children (Heberholz & Hansen, 1994; National Art Education Association, 1988). Indeed, looking at the receptive component of the visual language, understanding imagery does precede understanding verbal processes developmentally. When verbal skills are acquired, then development in these two areas is concurrent and

interactive (Paivio, 1971). We learn to read visual language, without formal instruction, earlier and more spontaneously than verbal language. Children with modest verbal reading ability can read complex visual images, yet are often presented with only simple, childish ones, "visual pablum" (Feldman, 1981, p. 657). Children understand words before they can say them (Owens, 1988). Similarly with visual language, young children learn to recognize and identify visual images by age 1 1/2 or 2 years (Bruner, 1983) though they generally do not begin to make meaningful marks before age 3 or 4 years (Dyson, 1991; Lowenfeld & Brittain, 1987).

Visual Representation and Drawing

Looking at the expressive component of the visual language, drawing is a step from the internal visual representation of ideas and feelings to the external visual representation of those ideas and feelings (Golomb, 1992; Goodnow, 1977; Krampen, 1991). Drawing development is predictable and regular (Goodnow, 1977). The graphic symbol systems that develop have a structure similar to language and therefore, graphic symbol theory is often presented as analogous to language (Strommen, 1988). The social and cultural aspects of drawing development are also similar to language in that children learn to draw from each other, developing a system of symbols that is not entirely personal but grows out of the shared symbol system of the group (Wilson, 1985; Wilson & Wilson, 1982; Wilson & Wilson, 1984). Individuals adopt, combine, and extend these graphic configurations which are culturally specific: "as conventional, regular, and predictable as the words of a given language" (Wilson, 1985, p. 92). Children's drawings from different cultures share common units of visual form called *graphemes*, which, like phonemes, are put together according to a set of rules, a visual syntax, to form meaningful drawings (Krampen, 1991). These graphemes are universal, like the universal deep structure of grammar (Chomsky, 1968). All the similarities between art and language point toward the perspective that art is a language, a system of symbols used for communication. As such, art may play an important role in the development of verbal language.

Art as a Visual Language

The relationship between art, the visual language, and verbal language development is a strong one. Young children's visual expressions can be an important part of their developing symbolic repertoire (Dyson, 1991). Drawing is another way for children to make meaning, and is often interwoven with verbal expressions which "romance" the drawings (Golomb, 1992). Or, pictures and words can share equal footing; they can be partners in making meaning (Hubbard, 1989). Drawing and other visual means of thinking can foster the development of written language, because it provides

an opportunity to rehearse, develop, and organize ideas prior to writing (Caldwell & Moore, 1991; Sinatra, Beaudry, Guasstell, & Stahl-Gemake, 1988). Art criticism has also been shown to be helpful in teaching students to learn to read because deciphering the code in works of art is preparation for decoding the printed word (Feldman & Woods, 1981). With special needs students, art provides motivation for the difficult job of generating language (Schiller, 1994).

The role of children's drawings as a tool for the formation of symbols would seem to take on special significance for D/HH and SLI/D children, but, surprisingly, relatively little has been written (two dissertations and 15 articles to date). Published studies explore new ways to teach concepts, through art, without using language (Silver, 1978), and new ways to assess the abilities of D/HH children (Silver, 1983); teaching basic concepts through an experimental, highly visual, art curriculum (Greene, 1981); and developing creative abilities in D/HH children through art activities (Laughton, 1988).

A recent study by this author (Eubanks, 1995) explored the use of art, as a visual language, to foster verbal development in a private, oral school for D/HH children. In this setting, with small classes (3-8 students) the master's level classroom teachers are at the empirical forefront of language development, using every means possible, including art. The qualitative study is limited to one setting and cannot be generalized, but it does inform us about the ways that art is used to foster language development.

Mary, an exemplary classroom teacher, made extensive use of children's drawings to teach language, develop vocabulary, correct syntax, and check student understanding. Drawing served to detect the gaps in understanding when students illustrated index cards to demonstrate their understanding of new vocabulary words. The class worked on defining the word *pretend*—to think of things not real. The first round of drawings included the illustration of a real event. Susanna drew a person dropping a cup of worms, a recent classroom catastrophe. Mary intervened, suggesting that Susanna pretend something else is in the cup or that the worms turn into something unreal such as fish.

Students were asked to create and illustrate a series of partitives as a culminating activity for what Mary believed was a thorough understanding of a new concept. Alice drew waves like water and wrote "a cup of box." This dual message signaled that Alice did not understand about partitives. After more explanation, she better understood the concept, drawing "a box of rings" illustrated by two boxes, each containing one ring, but this needed syntactic fine-tuning to correct singular/plural relationships.

Sometimes concepts are incompletely understood, as Todd illustrated in his sentence "He caught a pet in a net." His drawing included dome-like forms along the baseboard. He explained that those dome shapes were pet homes and the pets were rats. This provided Mary an opportunity to expand Todd's concept of pet as any animal in the house.

Sometimes drawings reveal misconceptions about the structure of language. Madeline read a story about a search for a round, thin, button with two holes. Her drawing of the successful end of the search included three buttons, one round, one thin, and one with two holes, indicating her misconception that descriptors come one per noun.

David provides an excellent example of how art can be used to work out ideas. David's mother reports that whenever he is upset, he goes to his room to make drawings that reflect his feelings. His drawing of Miss America (Heather Whitestone) coming down the runway, is a story he isn't yet able to write or tell without the drawing to which he can refer. He indicates enthusiastic clapping with action lines and emotion with facial expressions. Thought balloons with hearts inside tell that one of the judges has fallen in love with Miss America and that she likes him too. David has both a hearing loss and specific language impairments, making the use of verbal symbols doubly difficult. He uses visual symbols to work out his thoughts and as an alternate avenue of communication.

David has also learned to read the visual language. The complex connections he made concerning the art of 17th-century naturalist/artist William Catesby are remarkable. Catesby embedded a lot of information in his images, purposefully combining plants and animals to express environmental relationships. Seeing is knowing, and these works of art were used to teach for understanding. More subtle are the visual relationships between forms which David ferreted out, on his own, with ease and delight. As the discussion progressed, and his contributions were acknowledged, he stuck his chest out, held his head high, and proudly affirmed the teacher's observations with a firm and perky "I knew that!" Reading these works of art engages and acknowledges his intelligence, balancing the difficulties of the school day, spent grappling with illusive words.

These classroom events inform the teaching of art to the population for which language development is the prime directive. Art criticism, the receptive component of the visual language, has much to offer, beyond the advantages afforded to all children (Cole & Schaefer, 1990). The concepts embedded in works of art will affect the depth of students' learning by presenting ideas that would be impossible to communicate verbally. If the outcome goal for those students is to become independent thinkers, examining works of art might help to achieve that goal. They will learn how to rely on visual clues for information and understanding. Works of art bring objects and ideas into the classroom so that verbal language can be mapped onto them and are more exciting than the "visual pablum" illustrations that often accompany educational materials.

There is a place for art criticism in the *art room*, but the benefits of art criticism may be maximized in the *classroom*. Classroom teachers, who have the most experience soliciting language, can form a productive partnership with the art specialist, who has the training to identify and locate relevant works of art. Providing visual arts resources to classroom teachers expands

the role of the art teacher, making more thorough use of specialized art education.

Talking about works of art from other cultures may prepare D/HH and SLI/D students for mainstreaming. The intellectual growth that accompanies development of aesthetic appreciation moves children from an egocentric point of view to a broader appreciation of the views of others and other cultural orientations (Parsons, 1987). Moving from the sheltered environment of a special school, or classroom, into the mainstream will require a similar broadening of perspectives.

The art specialist can also play a vital role in developing a strong expressive component of the visual language. The training that most classroom teachers receive in art methods is usually inadequate, especially considering the time they spend directing activities that include drawing. Mary used drawing in 70-75% of her curriculum, yet she did not feel confident either in her own drawing skills or in her ability to teach drawing. She did offer students opportunities to practice drawing and to learn from each other. She also developed their perceptual awareness by calling their attention to details.

Conclusions

The potential impact of drawing on the development of symbol formation argues for a program of instruction in art that emphasizes reporting personal experiences and personal expression of ideas. The students' repertoire of symbols might be expanded by drawing instruction related to representation of the human figure. For example, instruction, opportunities, and encouragement in altering the human figure schema to represent movement would allow expression of a wider range of actions, a bigger visual vocabulary of verbs. Instruction in the representation of space expands the page, creating more room for these actions to take place. These students' vocabulary of emotion descriptors is often limited, though they understand and react to a broad range of emotions. Increased perceptual awareness of facial expressions and practice reproducing them may lead to a broader expression of feelings and an increase in vocabulary related to emotion. When drawing and writing are often combined, the scale of the drawings is usually small. In this case, colored pencils and fine-tipped markers may be the better drawing tools than the ubiquitous crayons to encourage elaboration.

Drawings provide a visual representation of the students' ideas onto which language can be mapped and an opportunity for students to request new vocabulary relevant to their interests. Classroom teachers, art specialists, and parents need to be sensitive to this opportunity for language development, giving students time to talk about their drawings.

Productive partnerships between art specialists and classroom teachers can maximize the potential for developing art as a means of communication, a cognitive pathway. Art is a visual language, with receptive and

expressive components, in which ideas are both spoken and heard. This perspective can lead to an understanding that art can become a valuable partner in language development. Art can move from the fringes of the curriculum toward the core of learning for all young children, especially children for whom learning language is difficult.

References

Arnason, H. (1986). *History of modern art*. Englewood Cliffs, NJ: Prentice Hall Inc./Harry Abrams, Inc.

Arnheim, R. (1969). *Visual thinking*. Berkeley: University of California Press.

Broudy, H. (1972). *Enlightened cherishing*. Urbana: University of Illinois Press.

Bruner, J. (1983). *Child's talk: Learning to use language*. New York: Norton.

Bzoch, K., & League, R. (1971). *Assessing language skills in infancy: A handbook for the multidimensional analysis of emergent language*. Baltimore: University Park Press.

Caldwell, H., & Moore, B. (1991). The art of writing: Drawing as preparation for narrative writing in the primary grades. *Studies in Art Education, 32*(4), 207-219.

Chomsky, N. (1968). *Language and mind*. New York: Harcourt Brace Jovanovich.

Cole, E., & Schaefer, C. (1990). Can young children be art critics? *Young Children, 45*(2), 33-37.

Cromer, J. (1966). *History, theory, and practice of art criticism in art education*. Reston, VA: National Art Education Association.

Dyson, A. (1990). Symbol makers, symbol weavers: How children link play, pictures, and print. *Young Children, 45*(2), 50-57.

Ellett, J., & Eubanks, P. (in progress). Teaching children to depict motion.

Eubanks, P. (1995). *Art as a visual language in support of verbal development in young children who are deaf or hard-of-hearing*. Unpublished doctoral dissertation, University of Georgia, Athens.

Feldman, E. (1976). Visual literacy. *Journal of Aesthetic Education, 10*(3/4), 195-200.

Feldman, E. (1981). Art is for reading: Pictures make a difference. *Teachers College Record, 82*(4), 649-66.

Feldman, E., & Woods, D. (1981). Art criticism and reading. *Journal of Aesthetic Education, 15*(4), 75-95.

Forrest, E. (1984). Art education and the language of art. *Studies in Art Education, 26*(1), 27-33.

Garner, J. (1995). *More politically correct bedtime stories: Once upon a more enlightened time*. New York: Macmillan.

Golomb, C. (1992). *The child's creation of a pictorial world*. Berkeley: University of California Press.

Goodman, N. (1976). *Languages of art*. Indianapolis, IN: Hackett Publishing Co.

Goodnow, J. (1977). *Children drawing*. Cambridge, MA: Harvard University Press.

Greene, J. (1981). *An experimental study of developmental gains by hearing-impaired children through art*. Unpublished doctoral dissertation, North Carolina State University, Raleigh.

Heberholz, B., & Hansen, L. (1994). *Early childhood art*. Madison, WI: Brown and Benchmark Publishers.

Hubbard, R. (1989). *Authors of pictures, draftsmen of words.* Portsmouth, NH: Heinemann.

Kepes, G. (1944). *Language of vision.* Chicago: Paul Theobald.

Krampen, M. (1991). *Children's drawings, iconic code of the environment.* New York/London: Plenum Press.

Lahey, M. (1988). *Language disorders and language development.* New York: Macmillan.

Laughton, J. (1988). Strategies for developing creative abilities of hearing-impaired children. *American Annals of the Deaf, 133*(4), 258-63.

Lowenfeld, V., & Brittain, W. (1987). *Creative and mental growth.* New York: Macmillan.

National Art Education Association. (1988). *Art is the first language* [poster]. Reston, VA: National Art Education Association.

Owens, R. (1988). *Language development.* New York: Macmillan.

Paivio, A. (1971). *Imagery and verbal processes.* New York: Holt, Rinehart, and Winston.

Parsons, M. (1987). *How we understand art.* New York: Cambridge University Press.

Paul, P., & Jackson, D. (1993). *Toward a psychology of deafness—Theoretical and empirical perspectives.*

Schiller, M. (1994). Give students with special needs something to talk about. *Art Education, 27*(9), 12-16.

Silver, R. (1978). *Developing cognitive and creative skills through art.* Baltimore: University Park Press.

Silver, R. (1983, November). *Using art to evaluate and develop cognitive skills: Children with communication disorders and children with learning disabilities.* Paper presented at the American Art Therapy Association meeting, Louisville, KY. (ERIC Document Reproduction Service No. EC 080 793)

Sinatra, R., Beaudry, J., Guastell, F., & Stahl-Gemake, J. (1988). Examining the use of photo essays on students' writing ability. *Reading Psychology, 9*, 399-408.

Strommen, E. (1988). A century of children drawing: The evolution of theory and research concerning the drawings of children. *Visual Arts Research, 14*(2), 13-14.

Wilson, B. (1985). The artistic tower of Babel: Inextricable links between culture and graphic development. *Visual Arts Research, 11*, 91-103.

Wilson, B., & Wilson, M. (1982). The case of the disappearing two-eyed profile: Or how little children influence the drawings of little children. *Visual Arts Research, 8*, 19-31.

Wilson, B., & Wilson, M. (1984). Children's drawings in Egypt: Cultural style acquisition as graphic development. *Visual Arts Research, 10*, 13-25.

Wolf, T. (1977). Reading reconsidered. *Harvard Educational Review, 47*(3), 411-429.

Footnote

[1]The constant evolution of politically correct terminology is a reality in our society. The little mer-person in one of Garner's (1995) politically correct bedtime stories resented being called a mermaid, which she considered a sexist remark. The terminology referring to population on which this chapter focuses is problematic as well. The parameters defining the terms deaf and hard-of-hearing are not universally agreed upon so both must be used. Learning disabilities are now referred as specific language impairments or disorders (Lahey, 1988). The current consensus on terminology requires that the descriptor follow, rather than precede, the person, for example, "child who is deaf or hard of hearing." However, in order to render this study

in the most readable form, "children who are deaf or hard of hearing" will be referred to as D/HH children, and children with specific language impairments or disorders will be referred to as SLI/D children.

Chapter 11

Promoting a Positive Self-Image Through Visual and Verbal Inquiry: Art Appreciation for Students with Multiple Disabilities

Dorothy S. Carpenter and B. Stephen Carpenter, II

> Tell me…I will hear;
> Show me…I will remember;
> Involve me…I will understand
> —*paraphrased from an ancient Chinese proverb*

The development of a positive self-image in all students is important for success. Human development psychologists, such as Abraham Maslow and Carl Rogers, have found that people who have a positive self-image, have "a sense of well-being and self-satisfaction" (Craig, 1992). Self-satisfaction, built through the development of a positive self-image, may better allow students to successfully achieve life goals. We believe that the development of a positive self-image is a crucial part of any educational setting. In the context of special education, the art curriculum is another format in which to "build in a child deep feelings of achievement and self-motivation along with developing a positive self-image" (Spencer, 1992).

This chapter presents a case study of an art program in a special education high school. This art program was never intended to be the subject of a formal study and, therefore, the results are based solely on the reflection of the teacher. In this particular school, a student's success is measured according to (a) the length of time a student can successfully maintain a job at an approved work site; (b) the student's demonstration of confidence, responsibility and independence; and (c) a student's acquisition of appropriate social skills during his or her school years. These criteria are considered the most important for special needs students to possess when making the transition from being a student in a school setting to the role of a worker (Hughey, 1989). The third criterion, that of appropriate social skills, is perhaps the most important for special needs students to develop. Katz (1980) believes that "there is a connection between

a person's creativity, his [sic] self-image as a more adequate person and his [sic] social competency." In the art program discussed in this chapter, students learned to develop appropriate social skills through open discussions of their own opinions and thoughts about works of art, and the thoughts, ideas, and works produced by classmates.

Self-Image

Several educational researchers use the terms self-image, self-concept, self-worth, and self-esteem to describe ways in which students perceive themselves (Kick, 1992). William Glasser's research demonstrated that people can learn "positive feelings of self-worth" (Goble, 1971) in the classroom setting. We use the term *self-image* to describe the ways in which students perceive themselves. The development of a positive self-image would facilitate a student to achieve success. Conversely, a negative self-image would make it more difficult for a student to achieve.

Perception of self-image, either positive or negative, can be observed by a teacher, based on the statements and actions of a learner. In effect, through observed behaviors, a student's self-image may be determined. To clarify, consider these two examples of students who lack a positive self-image.[1] Claire is an attractive, 18-year-old female with mild mental retardation, who has the basic skills necessary to perform social and office tasks in a business setting, but lacks the self-confidence to make simple decisions or to attempt unfamiliar requests on her own. Lew, a very quiet 16-year-old, also with mild mental retardation, is often described as shy. He has seldom uttered a statement or asked a question on his own, either with or without prompting, but occasionally will perform some tasks when given verbal direction. Based on the above definitions, the behavior of these two students indicates a low self-image. Potentially, a low self-image could prevent these two, otherwise capable, students from successfully achieving school and work goals. Would an improved, positive self-image help Claire to make simple decisions or attempt simple tasks on her own without asking for help? Would Lew make a statement or ask a question on his own without prompting if his self-image improved? The context of an art program was conceived to provide these and other students with an additional opportunity to construct a positive self-image.

Rationale for the Class

The study of art provides students with a means by which they can come to understand themselves and the world. Such an understanding of the world and of oneself can be achieved through inquiry in art production, aesthetics, art history and cultural studies, and art criticism. In order for this inquiry to occur, students need to engage in studio, aesthetic, art historical, and art critical inquiry. Unfortunately, special education art programs typically emphasize the production of works of art by students, but lack sufficient inquiry with regard

to aesthetics, art history, and art criticism. It is perhaps rather ironic that it is these three components, particularly aesthetics and criticism, that promote the most obvious opportunities for special needs students to interpret their world and to develop social skills.

Most of the literature on art for students with special needs emphasizes strategies and adaptations necessary for these students to create works of art (Blandy, 1989; Guay, 1994; Rodriguez, 1984). Although research of art practices for special needs students and teacher education has been well addressed (Guay, 1994), unfortunately, we have found little research in art for special education that suggests these students actually participate in any significant aesthetic, art historical, or critical inquiry. This is not to say that these forms of inquiry are not being addressed in special education classrooms. In fact, the Art Educators of New Jersey (1990) added a section to their book on art for special needs students that is devoted to the teaching of art appreciation. This point notwithstanding, we believe that it is not typical for special needs students to be expected to critically investigate or "interpret the meaning of their own works in light of the themes, subjects, ideas and styles of works created by others" (Wilson, 1994). Special needs students can, in fact, engage in visual and verbal inquiry about works of art made by themselves and artists.

A Course of Study in the Visual Arts

A course of study in the visual arts for special needs students that included opportunities for both visual and verbal inquiry was developed which allowed these students to build essential life skills through the study of works of art and, in turn, to develop an improved self-image. This art class was designed to meet the needs of a public, special education school in Rockville, Maryland. The school offered a diverse curriculum with classes in reading, language arts, math, health, science, physical education, drama, music, and vocational training in food service, auto maintenance and industrial arts. The curriculum also included a variety of on-the-job training experiences, both in and out of the school building. Unfortunately, at the time, this diverse curriculum lacked courses in the visual arts. Most instruction in this school was presented in such a highly structured format that the students had little opportunity to be creative or to think critically.

In addition, the school program provided a class for students to learn about their community and how to use the public transportation network, as well as suggestions for leisure time activities. Because leisure time activities are essential for the postgraduation student (Jensen & Mercier, 1989), it was believed that the addition of an art class to this school program would offer additional choices. For example, students who might choose to visit museums would have a better understanding of works of art and those who might take photographs would now have a basic knowledge of how to use the equipment.

This art course, which was added to the existing school program, was based on the content of two college undergraduate introductory art courses taken by

the teacher, and a set of factors she believed to be pertinent to the needs of her students. First, the range of abilities, skills, interests, and social-emotional levels of the school population were considered. The concern was to provide art experiences in such a way as to allow these students to become involved in the process of learning. Second, the variety and availability of artworks and instructional materials influenced the scope of the initial instructional plan because basic art supplies in the school were limited. Third, the primary motivating factor that influenced the decision to construct this course was influenced by the teacher's interest in art. Though not trained as an art educator, the teacher saw the potential outcome of this course as another opportunity for her students to improve their self-image by becoming more aware of themselves, their surroundings, and their community through the study of art.

Class Objectives

The students, aged 11 to 21 years, have mild mental retardation or a specific learning disability, and at least one other educational disability. In other words, these students have multiple disabilities. The mission of this special school is to help these students grow into adulthood and to gain maximum social and cognitive capabilities. The classroom was arranged in such a way as to provide easy access for students in wheelchairs and students with visual impairments to the display centers, reproductions, and other resources.

The course of study was designed to incorporate all learning modalities. It provided a means by which students were able to convey their ideas about their world and themselves through various art media. In order to satisfy the requirements for the course, students were also required to practice life skills such as riding the subway to visit museums; holding conversations with classmates and museum personnel; and learning to use computers, cameras, and video camcorders to complete projects.

The original course of study outlined 20 general objectives based on the Individualized Education Program (IEP) of each student in the initial class as well as the mission statement of the school. Following are the original 20 general course objectives:

1. To promote and to build upon a positive self-image.
2. To promote and to build self-confidence and self-expression.
3. To relate concepts learned in class to job skills.
4. To follow written and verbal directions.
5. To increase an awareness of one's surroundings.
6. To increase perceptual awareness.
7. To provide a reference for self-improvement.
8. To increase decision-making skills.
9. To increase vocabulary.
10. To increase social interaction and acceptable social behaviors.
11. To provide subjects for conversation.
12. To practice language skills.

13. To increase visual and auditory skills.
14. To increase concentration and to lower impulsivity.
15. To provide an opportunity to create an original work of art.
16. To provide an opportunity to visit an art museum.
17. To introduce various art forms, styles, and techniques.
18. To introduce the visual elements of art.
19. To stimulate an interest in the visual arts.
20. To increase cognitive skills.

Because the course of study required students to *look* at works of art and to *listen* to presentations and questions about works of art, artists, and ideas, it was suggested that the class be called "Looking and Listening"—two skills necessary for success in academics and in life. An increased positive self-image would be determined through observation of behaviors that exemplified achievement of one or more of the general objectives modified for each specific unit of instruction. For example, the teacher might observe whether a student completed a project, displayed his or her work, participated in class activities, or offered positive verbal responses or questions about the student's own project or the projects of other students.

Works of Art, Media, and Resources

Three basic factors determined the structure of the course. Students also considered issues related to actual works of art and the materials used to create them. One factor included the visual elements of art, such as line, shape, form, mass, and texture. These terms, which are basic components to most works of art, became the foundation of the vocabulary used throughout the course of study because students could easily comprehend and use these terms when describing a work of art. A second factor was the availability of a diverse selection of works of art, both Western and non-Western. Works and artifacts from the personal collection of the teacher were the primary source of exemplars ranging from small wooden sculptures to articles of clothing to lithographs collected on travels around the world. Finally, because the course was not based on any previous art instructional experience by the teacher, the task of introducing these students to a variety of art media and encouraging critical dialogue was seen as a challenge.

The materials and equipment used were varied. Art materials already available in the school were limited to drawing pencils, drawing charcoal, watercolors, pastels, construction paper, newsprint, tempera paint, brushes, white drawing paper, wood scraps, glue, a video camcorder, a few Polaroid cameras, a computer, clay, a kiln, and a potter's wheel. The focus of the initial units of instruction was developed from this inventory.

The school's library had an abundance of films; posters; and books on art, artists and art-related subjects. Audiovisual equipment was also available. Within easy walking distance from the school were several outdoor public sculptures located on the campus of the local community college. In addition,

works of art on display in the Smithsonian museums in Washington, D.C. were easily reached by subway. Whenever necessary, funds were made available for the teacher to purchase additional support materials and to pay for transportation costs so that students and adults could travel to museum sites in downtown Washington.

Instructional Methodology

The teaching methods used for this class were specifically chosen with these particular students with multiple disabilities in mind. The instructional methodology included, but was not limited to, five strategies: (a) *multi-sensory experiences* that included listening to lectures and seeing, touching and sometimes smelling the works of art; (b) *making connections* between a particular concept and the context of the workplace or personal life of the students; (c) *encouragement of verbal responses to questions* (e.g., "If you were the artist, what would you have done differently?") and praise for appropriate verbal comments; (d) *demonstration of studio techniques and materials* followed by student creation; and (e) *presentation of student work during critical discussion sessions* in order for students to receive positive feedback about their works. These strategies were intended to encourage all students to engage in critical discourse about works of art created by artists, themselves, and other students.

Scope and Sequence

Based on previous teaching experience with these students, the teacher considered several questions in order to develop an appropriate course of study. Among the questions the teacher considered were the following: How to design the course of study so that each student would be able to participate? How to involve the students so that each could achieve success? How much time should be spent studying each art form while maintaining the interest of each student? Would there be enough resources and examples of each art form to initiate sufficient study? Would there be ample supply of materials for the students to create works of art? Consequently, after giving considerable thought to these questions, it was decided that the basic unit outline would focus on one art form per month. In other words, each unit of instruction would be completed through the course of a month's time.

For the first week of each 4-week unit of instruction, an introduction to the art form was presented. Approximately three works of art were studied each day. Students looked at works of art while the teacher provided historical and contextual information about each. For example, the name of the artist, the material used, and the country of origin were given to the students. Students were asked to identify colors, textures, and other visual qualities of the works and were encouraged to provide opinions or to make value judgments about the works of art studied. The teacher then posed questions intended to provide a means by which students could begin to look at works of art in a critical manner.

During the second week, more examples of the art form were shown as the students were encouraged to respond in a more critical manner. Initially, most student responses were accepted by the teacher, regardless of brevity or lack of depth. A common question asked of the students by the teacher, after viewing and becoming familiar with the work, was "If you were the artist, what would you have done differently?" This type of question was intended to engage students in critical analysis of the work based on contextual information that served as a basis for further thought when they would later produce a work of art on their own.

During the third week, each student produced a work of art stylistically and technically influenced by their study of the works of art studied that month. Each day of the third week was seen as a step toward project completion. With the help of the teacher, each student discussed concepts, gathered materials, and designed and completed a work of art. All students were helped to successfully complete each project with the assistance of the teacher, if necessary.

The last week of the unit of instruction allowed each student to present his or her work to the entire class. Each student would describe their work to the class, using the visual elements of art as a guide for initiating critical thought. Further analysis was encouraged by the teacher so that the student would verbalize his or her aesthetic and critical decisions about the creation of the work. Next, each student in the class was encouraged to make a positive comment, directed to the presenter, about the work. This critical exchange was intended to allow students to build upon their self-image in a positive manner, both for the student who created the work and the class participants. On the final day of the unit, a group review was conducted. All students contributed to the review by answering questions about the content of the unit as the teacher wrote the correct responses on the board. Each student recorded these answers on their own piece of paper. One student used her Braille writer during this exercise. The self-image of each student was boosted during this experience because each had all of the correct answers to turn in and receive full credit.

With the school's special population in mind, six initial art forms were chosen because they could be easily experienced by these students in their everyday world. These six art forms were drawing, painting, sculpture, jewelry, ceramics, and graphic design. Drawings are found in most of the material students see every day in magazines, books, greeting cards, and posters. Sculptures are found in their environment, inside buildings, in public spaces, and in their homes. Paintings, either representational or abstract, personalize their workplaces and homes. Jewelry, used for self-adornment for centuries, is part of the everyday dress of most of these students, both in the school and workplace. Ceramics, both functional and sculptural, are found in their homes, workplaces, and recreational locations. Graphic design is used to entice these students into purchasing items, adopting ideas, and making consumer choices.

The pilot year of this class was based on a two-semester format. In this format, the second semester was a repeat of the first. During the first month, students studied sculpture. The following months included study in drawing,

painting, jewelry, ceramics, and graphic design. After the first year, school administrators saw the success of the course because it provided students with a viable way to develop both their self-image and their written and verbal skills, through the study of art. The teacher was then requested to expand the course into a full-year curriculum. As such, three more art forms, film, photography, and architecture were added to the course content the following year. Architecture was added because it was encountered in students' everyday lives in the places they work, live, eat, and learn. Photography and film were also added because they are used by students for entertainment purposes and to record history and leisure activities.

Each of the units focused on one particular art form and included components of studio production, criticism, aesthetic inquiry, and art historical and cultural studies. Students could also apply their social, verbal, reading, writing, and math skills throughout the course of study when necessary. Table 1 shows a sample outline based on the initial year-long course of study.

Table 1
Initial Year-Long Course of Study—"Looking and Listening"

Month	Art Focus/Medium	Content
September	Sculpture Louise Nevelson, local artist Tom Pitzenberger; wood sculpture	Art History/Cultural Studies; introduction to the visual elements of art
October	Drawing Pablo Picasso, Michelangelo, Salvador Dali, Vincent Van Gogh, Leonardo Da Vinci; charcoal, pen/ink, pencil	Criticism; cartoons, comic books, self-portraits, portraits (*Mona Lisa*), still-lifes
November	Painting Salvador Dali, Jacob Lawrence, Auguste Renoir, Mary Cassatt, local artist Hughie Lee Smith; tempera, watercolors	Criticism, Aesthetics, Art History; genre paintings still-lifes
December	Jewelry Hawaiian necklaces, mixed-media necklaces (contemporary and historical/cultural/traditional)	Cultural Artifacts, Aesthetics; following directions for assembly; fine motor skills
January	Ceramics Maria Martinez clay	Sculptural/Functional Works Aesthetics Art History/Archaeology; pinch pots and functional ware animals
February	Graphic Design Composition and Design, Advertisements Computer Graphic Techniques	Aesthetics, Design and Marketing, Popular Culture; collage
March	Architecture David Macauley Frank Lloyd Wright	Art History/Cultural Studies, Aesthetics; "Falling Water" paper and cardboard houses fantasy houses
April	Photography Ansel Adams; Polaroid Camera	Criticism; social skills landscapes, still-lifes, portraits
May	Video/Film Video Camcorder	Public and Social Communication Skills; interviews, documentaries
June	Art Games, Independent Study	Review and Evaluation

Sample Unit Plan: Sculpture in September

Sculpture was chosen to be the first art form presented to the class. Two reasons guided this decision. First, in the initial year of the course, a student who was totally visually impaired was enrolled in the class. It was believed that an art form that demanded a sense of touch would be the best way to introduce this student to the course. Second, the key to the success of this class was to attract and maintain the attention and interest of all students. Therefore, a one-foot tall, cement sculpture of the head of a man, "Warren," was chosen to be the first work of art studied. "Warren" immediately won the attention of the students and became a year-long fixture in the classroom. The following is an outline of the 4-week unit on sculpture that was taught at the beginning of the course.

Week One: The introduction to the class began with an analysis of the weight of the sculpture, dramatized by the teacher as she struggled to pick up the cement head. The weight, contour lines, and texture of the sculpture were discussed. Students were asked questions about the work, such as "What material was used to make the sculpture?" and "Why do you suppose the artist would want to create this?" The visual elements of art were identified, including line, color, texture, mass, and shape as the students viewed, touched, and held "Warren." These terms were written on chart paper, which was taped to the wall, and were referred to when studying each art form. In the case of "Warren," these terms were modified, by adding adjectives and phrases, as the students attempted to describe the work. Students used words like *rough, smooth, heavy, curved,* and *cold.*

Week Two: The class viewed more sculptures, accompanied by a short presentation by the teacher on their creation, place of origin, and possible meaning. Each student was encouraged to offer opinions and to make comments about the works as discussions about each sculpture developed. All appropriate input was accepted and acknowledged while inappropriate responses were redirected. The additional sculptures included a crystal tree about 8 inches tall, a 10-inch sandalwood, carved statuette of the "Elephant God" from India; two cast aluminum nonrepresentational sculptures about 12 inches tall; a small seated ceramic Rastafarian figure from Jamaica; and a small 8 inch bronze bust of an Indonesian woman. Students were asked to identify the medium used to create each sculpture; identify visual elements in each work; and to give opinions, responses, and to ask questions. The sculptures were passed around the class for the students to examine more closely. In addition, contextual information was provided by the students. This information appeared for the students in the form of summarized sections from reference books, films on sculpture, and a newspaper review of the work of a local wood sculptor.

Week Three: Students went out into the community to view and to discuss six outdoor public sculptures located on the campus of the local community college. Five of these sculptures were made of metal, painted and unpainted. One sculpture was made of wood. All works were over 6 feet tall. A visit to the National Museum of Art in Washington, D.C. was arranged, where a lecture

was given by a museum educator specifically designed for this particular special education class. The student who was visually impaired was given white cotton gloves to feel or "see" a white marble Rodin sculpture. On a third day, a guest artist showed slides of his work and talked about his career as a sculptor. Finally, students watched the teacher as she explained and demonstrated the production of a sculpture made of wood scraps, glue, and tempera paint, in the style of Louise Nevelson.

Week Four: The content of the previous 3 weeks of study was reviewed. Information covered in the review included the visual elements of art, the variety of materials used in sculpture creation, the variety of sizes and forms a sculpture might take, and ideas and concerns that influence an artist working in sculpture. The students selected scrap pieces of wood that were collected from the wood shop and designed a sculpture. Their works were assembled with glue and were painted with tempera paint as desired. Students had to make a choice of paint color and could elect either to paint sections of the sculpture or not to paint it at all. Reasoned explanations for their choice of wood pieces and painting decisions were required.

Several art books were available to the students who had finished their sculptures and were not watching others at work. On the third day of the last week, students engaged in a critical discussion of each other's works. This was an opportunity for students to demonstrate acceptable social, verbal, and communication skills. By following the example of the teacher, each student was required to present his or her sculpture to the class. Students began by identifying the visual elements of art seen in their work and gave a short explanation of why certain pieces or colors were used. Students were also required to share the thoughts and intentions that influenced the production of their work. Finally, each of the other students in the class gave at least one positive comment or asked a pertinent question about each presenter's work. During this critical discussion session, the students were reminded that active class participation would be reflected on their report cards. Finally, as a group, the entire class completed a summary of the unit. Students could then take their projects home after they had been displayed in the gallery space of the classroom.

Instances of Critical Analysis

Critical analysis occurred frequently during each of the units of instruction. For example, in the photography unit, aesthetics questions were asked in relationship to the use of cameras in everyday life. Questions such as, "Why do people take photographs?" and "Why do people keep photographs?" were asked to engage students in critical and aesthetic conversations. Questions were also asked to encourage students to think about the implications of photographic technology on the recording and reproduction of images. Students compared and contrasted this form of portraiture to oil painting. A Polaroid camera was used during this unit because it was convenient, available, simple for the students to use, and provided immediate results.

The final unit was designed for independent study. This month-long unit allowed students to make choices as to which works of art or artists they would use as the focus of further exploration. Students could also approach this independent task by beginning with a medium that they had studied during the course of the year. The works and artists chosen by the students were to be those that inspired or caught their interest in some way. Content of the independent study included time for students to select books related to their medium, an opportunity to view films or filmstrips, or to consult other reference materials. These independent study tasks were to provide students with opportunities to further their critical, aesthetic, historical, and creative understanding and awareness.

Implications

A major expected outcome of this class was that students would improve their self-image. It is impossible to know the degree to which the "Looking and Listening" class specifically helped students to do this. Indeed, the specific effect that art education has on the lives of students is an area that is in need of further research (Wilson, 1994). However, there were indications that the learning environment of this art appreciation course did, in fact, encourage the development of a positive self-image for all students who participated. During the course of the year, the teacher was able to observe each student and to record instances and frequency of achieved objectives. Upon reflection, the teacher needed to ask herself, "Have the students met any of the 20 specific class objectives?" It was determined that if the students showed a positive increase or change in any of these objectives or behaviors, then it may be safe to imply that the students acquired an improved self-image.

Although some students needed no encouragement to produce or to present their works, others took several months to feel comfortable doing so. Remember Claire's indecisiveness and Lew's extreme shyness? These two students made remarkable improvement in self-image as a result of having taken the "Looking and Listening" class.

All during Claire's first year in this class, she was constantly repeating negative remarks such as, "I can't do it," "I don't know," and "I've never done this before." Based on the recommendation of the teacher and school counselor, who is responsible for class scheduling, Claire was re-enrolled in the "Looking and Listening" class. In reaffirmation of the teacher's belief in the potential of the class, during Claire's second year, she began to make decisions and to attempt tasks without requesting help from the teacher. She was also heard to make positive remarks such as, "I remember that. I can make my own," as well as choosing her own colors, materials, and tools. She was also able to more easily conceive her own ideas. The teacher believes that these attempts at more independent decision making for Claire indicate an increased positive self-image.

For Lew, the influence of the class on the development of his positive self-image was just as exciting. Three months into the class, he raised his hand to be the first one called on by the teacher to give an opinion during a critical discussion. This was seen as a significant, positive step, especially for him since this was the first time he had exhibited this behavior for the teacher. Afterwards, Lew slowly began to make periodic, simple comments on his own, albeit hesitantly. Finally, toward the end of the year, at the conclusion of the photography unit, Lew asked the teacher, without any prompting and with a big smile, "May I take your picture, please?" Truly, this request is just one instance of many opportunities the class provided for Lew to demonstrate an increase in his positive self-image. At that time, Lew was at an age in which he was considered for out-of-school work experience. Now his chances of becoming a more productive worker have improved with his increased demonstration of self-worth.

Like Claire and Lew, other students also had the opportunity to benefit from interdisciplinary learning in this art class. For example, in the drawing session, the concept of fractions was used indirectly as students demonstrated their ability in following directions. Students followed both verbal and visual directions given by the teacher as they folded a piece of drawing paper in half, then in half again. When they opened the paper, they found four squares and a center point. The concept of fourths was briefly discussed at this time followed by instructions to begin drawing in one of the four sections of the paper, near the center. In all of the units, reading and writing were used, for example, when the students read resource books related to the unit of instruction and when the teacher wrote definitions, artists' names, visual elements of art, and vocabulary terms on the board or chart paper. Concepts in science were at work as students used prisms to view colors in the light spectrum. They also witnessed the mixing of primary colors using drops of food coloring and water to make secondary colors. Students then used watercolors to experiment with and mix their own secondary colors to be used in a painting. Evaporation was discussed as students observed the way in which wet clay dries, hardens, and shrinks. Geography was applied as students located the country of origin of a work of art, using a globe or map, and learned about the cultural history of the artists who created them.

It must be reiterated that the teacher who conceived, developed, and taught this course had no formal training as an art educator. She believed that through the study of art, her students might have the possibility to develop stronger social skills and a keener awareness of their world. Fortunately, there was a variety of works, resources, and people available to help make this class a success. Nevertheless, much planning and gathering of specific examples of artwork was sometimes a challenge for this teacher. However, by locating the resources within her home, the school, and within the community, she found a wealth of materials. Ultimately, the impact of this class on the students, staff, and faculty of the school continues to be felt. As students and teaching support personnel continue to make references to the excitement, positive comments,

and learning experiences in the class, it can be concluded that this course enabled students to achieve positive self-image.

Recommendations and Conclusions

Upon reflection, there are several points that should be discussed in relationship to the content and instructional considerations of the class. One recommendation is to have at least a 45-minute class period. It was determined, after the first year of instruction, that this amount of time would allow most students to successfully complete a project. This time frame would also allow students to experience a complete studio introduction of equipment such as the potter's wheel, the video camera, or demonstrations by guest artists. Another recommendation is to have students repeat the class, as in the case of Claire. Developmentally, students who repeated the class benefited from repetition of familiar activities and concepts and improved memory, increased vocabulary, and developed self-confidence (Craig, 1992).

This class was able to accommodate all ages, as well as most every skill level and disability. However, some adaptations were still necessary, as in the provision of touching and guiding the movement of students who were visually or physically impaired; inclusion of short breaks during class time for the students with Attention Deficit Disorder or Attention Deficit Hyperactivity Disorder; the use of sign language, the use of exaggerated movements to ensure lip reading for students with hearing impairments; spending extra time and attention on students with emotional impairment; and the use of appropriate peer-pairing.

A final warning is offered to teachers attempting to simulate this type of art class for students with multiple disabilities. Some students may express emotional instability through their artwork. In these cases, the teacher may need to consult with other professionals for support. For example, one year, during the painting and drawing units, one student was observed producing projects that were primarily black, and included depictions of a white skull and crossbones. The words *death* and *murder* were either written or implied on much of his work. Upon consultation with the school psychologist, family counseling was suggested.

However, over a 3-year period, this class provided an opportunity to put into practice the teacher's philosophy that building a positive self-image in students with multiple disabilities is possible through instruction in the visual arts. For example, most students in the class took projects home, and many made more than one project. A few students even brought into class works of art from home, or brought in books from their local library. Claire, now 23 years old, is a full-time, successful worker. Lew, now almost 20, is reported to have done well in his out-of-school work experiences. It is believed that the influence of this class on the development of positive self-image can be seen in the success of these two students. The opportunity to promote a positive self-image through visual and verbal inquiry appears to have merit and further attempts toward this goal for all students is strongly needed and encouraged.

References

Art Educators of New Jersey. (1990). *Insights: Art in special education—Educating the handicapped through art.* Reston, VA: National Art Education Association.

Blandy, D. (1989). As I see it: Ecological and normalizing approaches to disabled students and art education. *Art Education, 42*(5), 7-11.

Craig, G. J. (1992). *Human development.* Englewood Cliffs, NJ: Prentice Hall.

Goble, F.G. (1971). *The third force.* New York: Pocket Books.

Guay, D. M. (1994). Students with disabilities in the art classroom: How prepared are we? *Studies in Art Education, 36*(1), 44-56.

Hughey, J. K. (1989). Counseling to facilitate transition. *Journal for Vocational Special Needs Education, 11*, 10-13.

Jensen, S. D., & Mercier, N. (1989). Academic curricular content: Art. In E. Polloway, G. Robinson, J. Patton, & L. Sargent (Eds.), *Best practices in mild mental disabilities.* A collection of chapters solicited by the Iowa Department of Education, Division on Mental Retardation of The Council for Exceptional Children.

Katz, E. (1980, June). *Creativity: The arts and people with disabilities.* Proceedings of an International Conference, Minneapolis, MN.

Kick, F. R. (1992). The self perceptions of self-concept and self-esteem: A theoretical analysis. Master's Thesis. Antioch University.

Rodriguez, S. (1984). *The special artist's handbook: Art activities and adaptive aids for handicapped students.* Englewood Cliffs, NJ: Prentice-Hall.

Spencer, I. (1992). *Recent approaches to art instruction in special education: A review of the literature.* Information Analyses.

Wilson, B. (1994). Reflections on the relationships among art, life, and research. *Studies in Art Education, 35*(4), 197-208.

Footnote

[1]The names of the students presented here are fictitious. These examples are based on two real students.

School Leadership, the Arts, and Special Education

Alice Arnold

"Ultimately the teacher must help the student become a part of a community of interpreters,...a community of inquirers..."
(Bellah, Madsen, Sullivan, Swidler, & Tipton, 1991, p. 174)

If our goal is to assist each child in reaching their potential, then we must continue to examine the models of learning that we embrace. The arts can infuse a new vitality into schools and make learning dynamic.

The arts help students connect old knowledge to new knowledge. They extend the multiple levels of meaning found in rich themes and allow students to reevaluate their beliefs in strong and powerful ways.

Yet, if school reform is to tap the power of the arts to engage diverse learners more fully in the process of education, support beyond the classroom is needed. Ongoing training for special needs students is a necessary component in the transformation to dynamic, inclusive schools (The Council for Exceptional Children, 1993; National Education Association, 1992).

This kind of restructuring takes time, money, expertise, and a strong commitment to change. Arts-based schools can serve as models for this transformation.

School Restructuring

The inclusion of special needs students into the general education art classroom is a challenge for all, but will provide overall benefits to the class as a whole, as well as to learners who are disabled (Lombardi, 1994). Yet, many teachers are ill-prepared to meet the needs of this growing population.

The Individuals with Disabilities Education Act (1990), calls for the placement of students with disabilities into classes with their nondisabled peers, to the fullest extent "appropriate" (McCarthy, 1994, p. 3). Teachers are being asked to teach children with a greater range of disabilities than ever before.

At the same time that classrooms are becoming more diverse, the new *National Standards for Arts Education* (Consortium of National Arts Education Associations, 1994), outlines a set of benchmarks, describing the kinds of learning that should occur at each grade level. This new climate of excellence requires clear criteria for instruction, with an emphasis on mastery of essential skills.

Therefore, school systems are faced with challenges that are new and difficult. A "customized curriculum" (Association for Supervision and Curriculum Development, 1995, p. 3) that addresses the diversity of skills and abilities in each class must be shared between a team of teachers that are highly trained. Gifted and talented students, as well as those with Individualized Education Programs (IEPs), must be considered partners if educational reform is to work. Research has shown that schools that foster an inclusive environment are also schools that are highly engaged in a set of specific reforms to improve learning (First & Curcio, 1993).

The Arts Create Meaning

An Inquiry-Based Curriculum

The arts support an "inquiry curriculum"—one that puts the ideas and beliefs of the student at the heart of the learning process. They allow children to chart a learning course that is uniquely theirs, as they delve into facets of their personality and experience.

In this model, classroom inquiry about the "big questions," (Stewart, 1994) such as the meaning of art, are just as important as questions that lead to a fine resolution of a specific aesthetic concern. Careful questioning, within a framework of art criticism and aesthetics, can provide a background for dialogue involving technique and process.

An inquiry curriculum can use the arts to deepen meaning, and strengthen the affective realm (Bloom, Krathwohl, & Masia, 1964) of content presented. For example, meaning that is found in literature can be "extended" (Harste, 1994, p. 1221) through the artmaking process and can result in more personal understanding for the child (Polanyi, 1958). Harste explains this process: "Children read or listen to a story, and then they are invited to move from language into art to show what the story means to them" (Leland & Harste, 1994, p. 337).

Harste describes an inquiry-based curriculum as one in which the sign systems become research tools...when students ask:

> "How would an artist depict this topic? What would the topic be like if music were the mode of expression?" These and other questions support children in exploring the potential of a topic, as well as propel them into research as they, more often than not, end up interviewing musicians, visiting art museums, and the like. (Leland & Harste, 1994, p. 341)

An inquiry curriculum causes teachers to rethink their roles in schools. If the inquiry process is a part of their own teaching methods, then honest and authentic dialogue is more likely to occur. Within this educational paradigm, informed and insightful questions are more important than correct answers.

The Co-Construction of Knowledge

Good schools combine a focus on inquiry and the co-construction of knowledge, for the development of a dynamic learning milieu. The highly acclaimed Reggio Emilia schools of Italy value this ongoing method in their exploratory, inquiry-based approach to learning, and can serve as an excellent model of this constructivist view (Malaguzzi, 1993).

At Reggio Emilia, teachers maintain an open dialogue, and foster diverse learning outcomes. Ideas and motivations are presented from many perspectives and children form unique solutions to their own problems. Creativity is valued.

In this model of learning teachers are mentors and guides. They are viewed as helpers by the children—much like a kind parent. But the demands on the teachers are great. They are constantly in a process of evaluation and analysis of the kinds of learning that transpire—always adjusting and examining the process.

The Integration of Knowledge

Harry Broudy has explored the relationship of images and language in his treatise, *The Role of Imagery in Learning* (1987). Dr. Broudy believes that images play a large part in the development of the imagination and provide an "imagic store" that students can use to retrieve meaning. He feels that success in both the sciences *and* the arts depend on the power of the imagination and the quality of the arts encounters that students have had. He states "both art and science depend on the imaginative powers of the mind..." (Broudy, 1987, p. 23).

Classrooms that use images to deepen understanding of the ideas being presented help students generate meaning. Visual images, when coupled with words, symbols, sounds, and/or movements, promote concept formation, retention, and comprehension of essential content. Research on student's thought processes indicates that teachers who help students connect images with ideas promote learning and understanding. In the *Handbook of Research on Teaching*, Wittrock (1986) states, "Learning and memory are facilitated when the learners construct images and verbal representations that relate old memories to new information, especially in organized or sequenced ways" (Wittrock, 1986, p. 311).

Recent reports of the power of the visual and performing arts to increase learning provide clear evidence that *all* students benefit from this exposure. Systematic and sequenced arts events motivate students to want to learn

and allow them to perform better on all measures of school success (Loyacono, 1992).

Training and Staff Development

Staff development is needed if schools are to make the transformation to communities that are designed around the needs of the learners (Arnold, 1996). In this day of burgeoning technology and heterogeneous school populations, alternative curricula and school structures must be considered.

Major changes in the way we view learning should include (a) an emphasis on the interdisciplinary nature of knowledge, (b) school structures that acknowledge the theory of multiple intelligences (or multiple ways of understanding the world), and (c) an awareness of the benefits of collaborative/cooperative learning environments that include a dialogue with the larger community. These approaches seem to hold the most hope for quality education in our increasingly complex world. An arts-based curriculum can serve as a catalyst for each of these approaches.

Interdisciplinary Thematic Learning

Interdisciplinary curricula use thematic teaching to put large concepts or ideas at the heart of the educational process (Jacobs, 1989). Themes must be broad enough to maintain interest over a number of weeks. Themes offer students a variety of creative options that give them a sense of control over their learning. Long-range planning is essential with an interdisciplinary approach to learning. Schools that have a carefully articulated curriculum present a set of progressively more complex themes and issues at each grade level and build gradually upon the concepts of earlier years.

For example, a thematic unit might focus on the concept of man's "interdependency." "The rain forest" could be used to focus the unit more sharply. Books, videos, and other resources might be collected that explain and illustrate the rain forest from a variety of perspectives. Art (or reproductions of art), from the rain forest regions of the world, could enhance the students' sense of the cultures and help explain some of the values found in those regions of the world. Traditional disciplines, such as geography, biology, ecology, and literature, provide a lens for students to explore myriad questions.

Storytelling from a good book can become a point of departure for teaching (Arnold, 1996). *The Great Kapok Tree* (Cherry, 1990) might be read to students in an art class, or by the classroom teacher. Students could act out the characters of the story and/or make a large group mural based on their favorite part. The movement of the children as they act out the characters in the story would cause a kinesthetic awareness of the interdependent nature of all creatures in the forest. Students who have few language skills would be able to understand the story better when they are given the opportunity to move through the events that are read to them.

Mural making following storytelling stimulates comprehension of the tale and causes students to select important information. The artistic process becomes an occasion for retelling or reinterpreting the story in forms children can understand. It creates an internalization of the information that is important in *their* lives.

Making art gives students the opportunity to visualize the major concepts that they are studying. When classrooms are orchestrated so that all contributions to a group project are valued, a stronger basis for learning can emerge.

Arts experiences force students to process information at a *feeling* level. The arts tie all the pieces of information together and give the students the time to absorb the content into their cognitive structure (Piaget, 1970). The arts are a catalyst for understanding; they help synthesize knowledge and make learning bold.

Multiple Ways of Knowing

Both the theory of multiple intelligences (Gardner, 1983) and learning styles (Presseisen, Sternberg, Fischer, Knight, & Feuerstein, 1990) have important messages for those who design educational environments. As schools move toward a more comprehensive understanding of the range of human talents, we also begin to value a more diverse set of human capacities. It is clearly the place of the schools to take on the task of nurturing the multiple gifts that students bring to us, and build learning environments in the schools that support an enlarged view of talent and intellect (Walters & Gardner, 1985).

Old models of intellect tapped primarily the logical-mathematical and linguistic capacities of students. Newer views are derived from the many talents that exist in the world beyond schooling and draw upon a greater variety of skills (Resource Center for Redesigning Education, 1996).

Armstrong (1994) has elaborated on the theory of multiple intelligences by showing how they may be adapted for classroom use. Armstrong suggests that teachers ask the following questions when planning a unit of study:

Linguistic: How can I use the spoken or written word?

Logical-mathematical: How can I bring in numbers, calculations, logic, classifications, or critical thinking?

Spatial: How can I use visual aids, visualization, color, art, metaphor, or visual organizers?

Musical: How can I bring in music or environmental sounds, or set key points in a rhythm or melody?

Bodily-Kinesthetic: How can I involve the whole body, or hands-on experiences?

Interpersonal: How can I engage students in peer or cross-age sharing, cooperative learning, or large-group situations?

Interpersonal: How can I evoke personal feeling or memories, or give students choices?

Amstrong (1994) warns, "You won't always find ways of including every intelligence in your curriculum plans" (p. 27). Yet, an awareness of methods for teaching to the multiple intelligences that students have will make classrooms more inviting.

Gardner views all seven of the intelligences as independent from the others, but it is only when students are able to develop a cluster of skills that they become prepared for the world beyond the school. Those gifted in logical-mathematical thought need linguistic skills in order to communicate their knowledge clearly and in ways that can be understood by others. Gardner explains how important a well-honed interpersonal intelligence is for teachers:

> Annie did not allow Helen to put her hand into Annie's plate and take what she wanted, as she had been accustomed to do with her family. It became a test of wills—hand thrust into plate, hand firmly put aside. The family, much upset, left the dining room. Annie locked the door and proceeded to eat her breakfast while Helen lay on the floor kicking and screaming, pushing and pulling at Annie's chair. [After half an hour] Helen went around the table looking for her family. She discovered no one else was there and that bewildered her. Finally, she sat down and began to eat her breakfast, but with her hands. Annie gave her a spoon. Down on the floor it clattered, and the contest of wills began anew. (Walters & Gardner, 1985, p. 10)

Gardner views individuals who are highly gifted in one or more of the seven intelligences as being "at promise" of having their gifts realized as they mature (Walters & Gardner, 1985, p. 16). We must also look for the gifts of those students who are "at risk" of failure, and provide avenues for their ongoing self-discovery and accomplishment.

Diverse Styles of Learning
Learning is more dynamic when it calls into play students' entire perceptual system—sight, hearing, taste, touch, and movement (Gibson, 1966). Learners with special needs will have a set of preferred modalities for their learning. Yet classrooms that stimulate a range of information processing avenues will prove more successful for all learners.

The learning styles that children use to glean information from their environment develop through an interaction of genetics and experience. Using a multi-modal approach to learning seems to hold the most promise for tapping the variety of sensory systems that children favor. It is incumbent upon schools to adapt their teaching strategies to students' preferred learning styles (Dunn, 1995). Children can become aware of their dominant learning style(s) and develop strategies for themselves that assist in their learning. Teachers should be working to expand the number and ways that their students seek and use information—thereby expanding their ways of knowing.

Rita Dunn, author of *Strategies for Educating Diverse Learners* (1995), suggests that direct instruction works best when teachers "relate the content to the children's lives, experiences, interests, fears, or aspirations" (Dunn, 1995, p. 24). She suggests the use of "projects and original creations to develop verbal, tactual, kinesthetic, analytic, and global capacities" (p. 28). She encourages teachers to use the following methods:

With your students, develop guidelines for viewing television, listening to music, reading a story, or watching a film. Permit the youngsters to analyze each activity in terms of agreed standards. Let them do this independently, in pairs, or in a small group. Encourage students to report their decisions through alternative forms of intelligence, such as music, drama, poetry, mathematics, pantomime, drawing, painting, puppetry, or sculpture. (Dunn, 1995, p. 28)

Assessment for multiple intelligences will cause a rethinking of the standardized test as the primary assessment tool. Scott Massey describes the use of process portfolios as a way to assess creative inquiry:

Imagine schools in which student work is itself regarded as a "work of art"—that is, student learning is grounded in creative inquiry, then artfully rendered into Process Portfolios that tell the story of the learner's journey with power and beauty. (Massey, 1995, p. 8)

Teachers who follow these guidelines will broaden not only their notions of intelligence, but their ability to teach and assess learning in novel and innovative ways.

Cooperative Learning: Creating Connections
Many students learn best in small group settings where student ability varies. Slower learners are supported and coached by their more able peers. The arrangement of partners or teams in the classroom can change during the day, week, month, or school year, so that each child is challenged with activities that foster their highest achievement. Again, with the cooperative

learning model, the teacher is viewed more as a facilitator of learning rather than the director.

Cooperative learning can take many forms in the school and community. When artists from the local community spend time with children in schools, an apprenticeship system can be set up. The kind of life-stories that these teachers bring is often very different from the daily routine of schooling and can assist students with moral and aesthetic questions (Freeman, 1991). Artists often provide the kinds of activities that lead to the arousal of emotion and a higher degree of motivation. Dewey describes this kind of experience:

> The final comment is that when excitement about subject matter goes deep, it stirs up a store of attitudes and meanings derived from prior experience. As they are aroused into activity they become conscious thoughts and emotions, emotionalized images. To be set on fire by a thought or scene is to be inspired. (Dewey, 1934, p. 65)

This kind of excitement makes students want to be in school and learn from activities that they help construct.

The technique of creating cooperative learning groups in the classroom has numerous benefits that impact indirectly on instruction. Robert Slavin (1995) lists self-esteem, social acceptance, intergroup relations, time on-task, liking the class and school, liking classmates and feeling liked by classmates, cooperation, altruism, and the ability to take another's perspective as benefits of the cooperative learning approach.

Cooperative learning increases opportunities for dialogue with others and deepens students' knowledge structures. Competition is diminished in these classrooms and a sense of achievement prevails.

Toward an Expanded View of Schooling

We have many indications of a great need to radically change our conceptions of learning and school practice. As society changes, the institutions of schooling must change as well. It will take time, money, and expertise to transform schooling. Leadership from decision makers is a crucial element if we are to learn from the models of success that exist.

There are pockets of excellent schools across the nation. Individuals with strong leadership skills have taken worn-out buildings and turned them into thriving centers of accomplishment. Trust, flexibility, and altruism are the hallmarks of these schools. We find that efforts have been consistent and focused over a period of years. The arts have the power to assist each child in reaching his or her potential. We must find ways to use the arts to transform schools into places where students want to learn.

References

Armstrong, T. (1994). Multiple intelligences: Seven ways to approach curriculum. *Educational Leadership, 52*(3).

Arnold, A. (1996). The connective power of stories in art. In C. Henry (Ed.), *Middle school anthology,* (pp. 21-28). Reston, VA: National Art Education Association.

Arnold, A. (1996). Fostering autonomy through the arts. *Art Education 49*(4), 20-24.

Association for Supervision and Curriculum Development. (1995). Multiyear education: Reaping the benefits of "looping." *Education Update, 37*(8).

Bellah, R. N., Madsen, R., Sullivan, W. M., Swidler, A., & Tipton, S. M. (1991). *The good society.* New York: Alfred A. Knopf.

Bloom, B. S., Krathwohl, D. R., & Masia, B. B. (1964). *Taxonomy of educational objectives: The classification of educational goals. Handbook II: Affective domain.* New York: David McKay Co., Inc.

Broudy, H. S. (1987). *The role of imagery in learning.* Los Angeles: The Getty Center for Education in the Arts.

Cherry, L. (1990). *The great Kapok tree: A tale of the Amazon rain forest.* New York: Harcourt Brace & Company.

Consortium of National Arts Education Associations. (1994). *National standards for arts education: Dance, music, theatre, visual arts: What every young American should know and be able to do in the arts.* Reston, VA: Music Educators National Conference.

The Council for Exceptional Children. (1993). *Including students with disabilities in general education classrooms.* Reston, VA: Author.

Dewey, J. (1934). *Art as experience.* New York: Capricorn Books.

Dunn, R. (1995). *Strategies for educating diverse learners.* (FASTBACK #384). Bloomington, IN: Phi Delta Kappa Educational Foundation.

First, P. F., & Curcio, J. L. (1993). *Implementing the disabilities acts: Implications for educators.* (FASTBACK #360). Bloomington, IN: Phi Delta Kappa Educational Foundation.

Freeman, M. (1991). Rewriting the self: Development as moral practice. In M. B. Tappan & M. J. Packer (Eds.), *Narrative and storytelling: Implications for understanding moral development* (pp. 83-102). San Francisco: Jossey-Bass, Inc.

Gardner, H. (1983). *Frames of mind: The theory of multiple intelligences.* New York: Basic Books.

Gibson, J. J. (1966). *The senses considered as perceptual systems.* Prospect Heights, IL: Waveland Press, Inc.

Harste, J. C. (1994). Literacy as curricular conversations about knowledge, inquiry, and morality. In R. B. Ruddell, M. R. Ruddell, & H. Singer (Eds.), *Theoretical models and processes of reading* (pp. 1220-1242). Newark, DE: International Reading Association.

Jacobs, H. (1989). *Interdisciplinary curriculum: Design and implementation.* Alexandria, VA: Association for Supervision and Curriculum Development.

Leland, C. H., & Harste, J. C. (1994, September). Multiple ways of knowing: Curriculum in a new key. *Language Arts, 71*(5), 337-345.

Lombardi, T. P. (1994). *Responsible inclusion of students with disabilities.* (FASTBACK #373). Bloomington, IN: Phi Delta Kappa Educational Foundation.

Loyacono, L. (1992). *Reinventing the wheel: A design for student achievement in the 21st century*. Washington, DC: National Conference of State Legislatures.

Malaguzzi, L. (1993). History, ideas, and basic philosophy. In C. Edwards, L. Gandini, & G. Forman (Eds.), *The hundred lanfuages of children: The Reggio Emelia approach to early childhood education*. Norwood, NJ: Ablex.

Massey, S. T. (1995). The arts as knowing. *On Common Ground: Strengthening Teaching Through School-University Partnerships, 5*, 5-8.

McCarthy, M. M. (1994). Inclusion and the law: Recent judicial developments. Bloomington, IN: Research Bulletin: *Phi Delta Kappa, 13*.

National Education Association. (1992, May). *The integration of students with special needs into regular classrooms: Policies and practices that work*. Washington, DC: Author.

Piaget, J. (1970). Piaget's theory. In P. Mussen (Ed.), *Carmichael's Manual of child psychology* (vol. 1, pp. 703-730). New York: Wiley.

Polanyi, M. (1958). *Personal knowledge: Toward a post-critical philosophy*. Chicago: University of Chicago Press.

Presseisen, B. Z., Sternberg, R. J., Fischer, K. W., Knight, C. C., & Feuerstein, R. (1990). *Learning and thinking styles: Classroom interactions*. Washington, DC: National Education Association.

Public Law 101-476 (1990). *The individuals with disabilities education act*.

Resource Center for Redesigning Education. (1996). *How are kids smart? Multiple inteligences in the classroom*. (Video Recording, No. 4262). Brandon, VT: Author.

Slavin, R. E. (1995). Cooperative learning and outcomes other than achievement. In R. E. Slavin, *Cooperative learning: Theory, research, and practice* (pp. 49-70). Needham Heights, MA: Allyn & Bacon.

Stewart, M. (1994). Aesthetics and the art curriculum. *The Journal of Aesthetic Education, 28*(3), 77-88.

Walters, J. M., & Gardner, H. (1985). The development and education of intelligences. In F. Link (Ed.), *Essays on the intellect* (pp. 1-21). Washington, DC: Curriculum Development Associates.

Wittrock, M. C. (1986). Students' thought processes. In C. Merlin (Ed.), *Handbook of research on teaching*. New York: Macmillan.

Art Education and Person-Centered Futures Planning: The Dynamic New Wave in Human Services

Claire B. Clements

Eric's Story

Eric's painting hangs in my colleague Mary's office. Each time I visit her, the artwork's red, blue, yellow, and black are reinforced in me. The configuration the colors make stays with me and lingers for quite a while, continuing to work its way back into my present consciousness. A few years later it still causes me to wonder, "What is the origin of this artwork's energy? What about this artist, Eric? How does he do this work?"

Eric is 29 years old. He has cerebral palsy, which prevents him from speaking or controlling his spastic body movements. He has been painting for the last 6 years. [Eric's mother recalls that about 12 years ago Eric's responses to her own paintings were positive and that he knew his colors at the age of 4.] With limited use of his left hand, he makes energetic, abstract, colorful paintings. His art teacher, Manita, uses a homemade easel, which she rests against her hip. Eric's brush is fastened to his middle finger. With it he jabs, makes a mark and then lets the brush fall, creating a streak of paint. His teacher says, "It's his unusual muscular movements, full of continuous contraction and rigidity, which contribute to the quality of the brush stroke." Those who appreciate Eric and know his work say, "His designs are powerful transformation of his feelings and moods onto paper" (St. Mary's Health Care System, 1992).

The Futures Plan—The Road to Eric's Art

The search for a way to facilitate Eric's communication skills was circuitous and arduous. In the search to improve Eric's quality of life and the lives of the rest of Eric's family, Dottie Adams of Community Support Services of Northeast Georgia Mental Health, Mental Retardation, and Substance Abuse served as facilitator and mapped out a Futures Plan. Eric's enjoyment and ability to do art emerged out of the speech therapy sessions that

were part of his Futures Plan. While working on communication skills, Eric's speech therapist read about the use of paints and wanted to see if painting would appeal to Eric. Using art as the vehicle, Eric's unique ability to express and communicate emerged. It has now been 6 years since Eric's Futures Plan was first formed. He has made much progress.

Person-Centered Futures Planning and Art Education

A new movement toward an era of community membership, characterized by an emphasis on functional supports, now enhances community integration, quality of life, and individualization. "Community Membership" is reshaping contemporary views of the basic principles that now drive policies and practices in serving people with disabilities. People with disabilities are no longer living and being served away from the rest of the population, primarily in institutions and in hospitals. Community membership means that the focus is not on making the individual adapt to the environment; rather, its focus is on ways to adapt the environment to the individual. People with disabilities, as members of the community, are picking and choosing what they want for themselves as they go through life (Bradley & Knoll, 1990).

Changing from a systems approach to a person-centered approach—putting the individual first—is the new way of thinking and interacting with people with disabilities in the '90s. This movement puts several rights into action: the right to be informed, the right to choose, and the right to be heard. By exercising their inalienable rights, people with disabilities are spending their lives as an integral part of the rest of society. Person-Centered Futures Planning is about "the journey of walking with people over time in mutual friendship, in contrast to ruling over people because of the mandate of a job description" (Mount, 1995).

Even though this new approach was developed for use with people with disabilities, its wider use is also appropriate for people without disabilities. For example, as people age and grow older, their natural familial and community supports shrink as parents, family members, and friends die and move away. Person-Centered Futures Planning, with its concept of Circles of Support and inclusion into the community, promotes making new friends, establishing new networks, and creating the spirit of community. At the other, earlier end of the age spectrum, and throughout a person's life, as soon as it is recognized that a Person-Centered Futures Plan would be of benefit, it is time to begin the Futures Planning process. In the early years Futures Planning is a way to increase connections and interactions in the community. Thus parents, families, and communities expand as the person with a disability grows older.

The Importance of the Arts to Person-Centered Futures Planning

This way of working with people emphasizes the ongoing process of planning and continually striving to realize results. Person-Centered Futures Planning is a method to provide needed supports for people with disabilities to help ensure their successful membership in the community. The arts are a powerful vehicle when combined with Person-Centered Futures Planning, which has a common focus with the arts: realizing what people can do with their unique abilities, gifts, and talents.

The Person-Centered Futures Planning movement, begun 20 years ago, is catching on in communities across America. The goal of this chapter is to inform art educators in all communities so they will be able to ensure that their arts programs will provide appropriate settings, and therefore will be selected, for utilization by and for people with disabilities. Art educators play an important role in the Person-Centered Futures Planning process, because art education settings are among the best places in the community to serve as a good forum for self-actualization of gifts and talents for people with and without disabilities (Clements, 1998).

Values and Philosophy That Support Person-Centered Planning

The values and philosophy of Person-Centered Planning and building Circles of Support revolve around issues that are often cited by people with disabilities: rejection, loneliness, indigence, and discrimination. Person-Centered Futures Planning works toward changing those negative realities into positive avenues for self-actualization so that each person can be a contributing member of the community. This positive approach involves learning to listen and being responsive to people, as well as searching out and developing each person's strengths and capacities. A vision or plan is developed to help the person utilize his or her gifts and talents. Members of the Circle of Support make up and help to develop a network, an arena in which the person with the disability draws strength to function in society (Mount, 1991). A person with interests in art has the opportunity to be a member of art education programs in the community.

The Facilitator, the Circle of Support, and the Focus Person

The *Facilitator* of a futures plan brings together people who love, work, care for, and have concerns for the person for whom the futures plan is being created. The people who form the *Circle of Support* can come from all areas of the community, such as family members, a place of worship, and various agencies. The *Facilitator* encourages the *Focus Person*—the person with a disability—to envision the future that he or she wants most, thinking of how to best utilize his or her unique gifts and talents. The *Circle of Support* forms a spirit of community around the Focus person and works to make these dreams come true. If it is revealed that the Focus Person has interests in the arts, then the most inclusive, welcoming art program in the community will be selected to help achieve the goals described in the Futures Plan.

Futures Planning Steps

The first of the three basic steps in the Person-Centered Futures Planning process is to gather comprehensive information about the Focus Person to form a personal profile. The next step is to utilize that information to develop a plan with and for the Focus Person. Finally, the committed Circle of Support, or network, helps the Focus Person carry out the Futures Plan (Mount, 1988).

Eric's Futures Plan

When they relocated to a new state, Eric's parents found that the supports they had experienced in the past in caring for their son Eric were no longer available. Without supports it was difficult to care for him at home. The Facilitator spent time with Eric and got to know and establish a relationship with his family. She got to know how the family was living and what was important to them.

The specialness of Eric and his family emerged. Eric's father is a professor at a major university. Both his parents are college graduates; his siblings were in college at the time of his Futures Plan. His mother, Mary, had been an art minor in college. In her parenting role, her efforts were aimed at developing Eric's life to his fullest potential. She was instrumental in forming a grass-roots provider agency called "Georgia Options in Community Living."

Georgia Options helps people with severe disabilities to live in their own homes with supports. The State of Georgia joined in furtherance of this work, and, through Medicaid waivers and a variety of supports, 10 adults with severe disabilities now live, work, and play in the community. Once Georgia Options was an accomplished fact, the University of Georgia's University Affiliated Program for Persons with Developmental Disabilities recruited Mary as a parent of a person with a disability who had first-hand knowledge and good sense about what is needed in the field of disabilities.

Part of the new way of working and thinking about people with disabilities involves the process of getting to know the family well. This enables the Facilitator to get past stereotypes and past professional roles and to begin to develop a personal vision of the Focus Person in light of his or her capabilities. The next step was to develop a capacity description, Eric's "Personal Profile." The Facilitator brought together Eric and his family and a series of meetings were held in Eric's parents' living room. Together, in familiar surroundings, they began to discuss Eric and his abilities and capacities. They created an overview of Eric's life, utilizing the Personal Profile Process (Mount, 1992). The process began as the Facilitator taped large, 2' x 3' sheets of blank paper on the walls, around the room. Each of these papers is what is known in the Futures Planning process as a "map." The mapping process, referred to as "group graphics" (Mount, 1988), uses

a combination of words and symbols to organize information that can be understood through pictures as well as words.

Using many colors of magic markers, as the Facilitator recorded and guided the discussion, the family discussed Eric's background, his home, health, places he goes, people with whom he associates, his skills, choices and rights, images others would have of Eric, and desires or images of the future. Eric's preferences and desires, those things he enjoys most and those things that bore him, were also brought out. Together, the Facilitator, Eric, and his family created a series of maps. The Facilitator then combined the maps into Eric's Personal Profile (Figure 1).

Figure 1—Detail.
Eric's Personal Profile

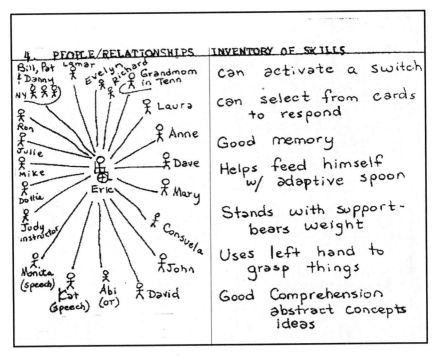

Next they made lists titled "What is Working" and "What Isn't Working." To help in understanding the Futures Planning process and the importance of it in Eric's life, in relation to his identity as it is connected to the art-making process, I have included the pieces that the Facilitator and family put together:

What is Working: More people in his life; more interesting activities; getting out in the community; having aides come into the house;

aides—close to his age who can be friends; routine—place to go every-day; secure home; lift bus; his bed; relationship with Dad; chair lift on stairs—helps; wheelchair working okay; insurance (finally).

What Isn't Working: Aides—come and go—lose them too often; stay-ing at home all day—boredom; restrictions in his life; lack of trans-portation; lack of stability in paid caregivers; Dad traveling, Eric miss-es him; hard on Mom to manage Eric—physically and stamina wise; needs new improved chair; getting respite for the evening or weekend; Eric's yelling gets in the way of activities and bothers family.

In addition to these lists, a three-page description was created all about Eric's day. It documents his day, beginning with the time he wakes up at about 6:15 a.m., is changed and dressed in bed, and is brought downstairs and gets into his wheelchair. The description includes meals, grooming, putting the splint on his hand, and getting ready to go to a day center. We learn that Eric likes activities, and doesn't like things to be canceled. He has a good sense of time and can tell time. Eric attended Hope Haven, from 8:00 a.m.-2:00p.m. (Eric and his family didn't like Hope Haven but at this point in time it was the only option open to Eric. His mother reports that "the Futures Planning helped us dream of a more meaningful day for Eric and actually led to his eventual removal from Hope Haven into a more inte-grated life in the community.") Eric likes to be driven around town to see the sights for as much as an hour and do some errands and, when helpers are aboard, he helps to do these. (This led to his being a volunteer for the Council on Aging). Lying on the floor, he listens to music, does his range of motion exercises, and likes having company. When he stays in his chair he sometimes joins his mother beside the typewriter where she is working. She will give him paper and a marker. Sometimes he will press the keys of the typewriter randomly. He enjoys marking on the paper—an indicator, wor-thy of noting, of Eric's artistic identity (Selections from Eric's Futures Plan, 1990).

Another map was made, entitled "Imagine—Create a picture of what is possible for the persons you know in your community" (Figure 2, Selections from Eric's Futures Plan, 1990). This map is based on Eric's needs and interests. It encapsulates all that the family knows, projects, hopes, and dreams for Eric that would make him happy.

Utilizing the Personal Profile Map, the "What Is and What Is Not Working" list, and the Imagine Map, the Facilitator and the family began Futures Planning strategies for Eric. With guidance and direction from the Facilitator, together they discussed and the Facilitator recorded the follow-ing lists:

The Facilitator explored people for Eric's Circle of Support and began to build community and a network around Eric to effect change in Eric's life.

Figure 2
"Imagine—Create a picture of what is possible for the persons you
know in your community"

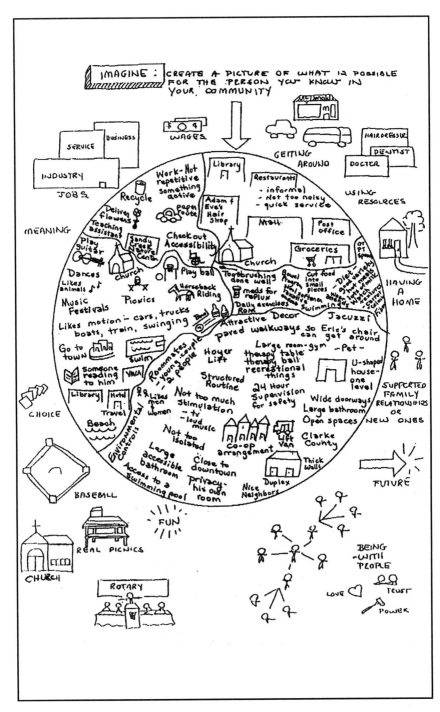

Important for art educators to note is that in the Obstacles, Opportunities, and Strategies listing, "finding the right people who will work with Eric over time" was, in hindsight, germane to Eric's artistic growth. It was the speech therapist with the interest in painting who envisioned and implemented art as a vehicle for expression for Eric. In the Opportunities listing,

OBSTACLES	OPPORTUNITIES	STRATEGIES
Money	Medicaid Waiver —Georgia Options	Dottie: call the Department of Human Resources to see about waiver
Eric's size. Accessibility—house, transportation to the community	Lift bus will start in the county (probably in January)	
Having a lot of expertise with new technology and how it applies to Eric	Michelle and other therapists to work on communication	Ask Michelle to get involved during holidays
Lack of time to try out new equipment...a person who will help Eric learn to use it		Mary: check with Abi and Kat about switches to access the computer
Aides transient	Dottie: help Hope Haven expand his opportunities/activities	Dottie takes some pictures to show Eric's interest in activities
Finding the right people who will work with Eric over time		
Demands of family daily living make it hard to focus and solve issues around Eric's needs		Dottie can start exploring people for Eric's Circle of Support. Start Circle of Support

"therapists to work on communication" in particular also helped to pave the way for Manita to work with Eric toward increasing his communication skills and creating a vehicle for Eric's self expression.

Art Education—A Good Fit for People with Disabilities

Manita, in her painting sessions with Eric, creates a sense of trust within Eric. She gives him her undivided attention. She adapts the painting process by using thick, drip-free paint, and by placing the painting surface within Eric's reach. She guides his hand to the paper, where he will begin making his own marks on the easel she adapted herself which she perches upon her hip. She uses his ability to read by having him choose the colors he uses from cards with double rows of words. She mixes the colors he determines by the reading cards and indicates whether he wants the colors darker, lighter, duller, or brighter. Eric's mother says, "Eric calls the shots when he makes his art." Manita turns Eric's limitations into assets and maximizes the impact of the tension in his muscles so he can create powerful artistic statements. Whether working with individuals or

in groups, creating trust and a sense of security allows student artists to open up and share their thoughts and feelings.

Eric's favorite person to do art with is his speech communications teacher. Although on occasion he has worked with others, usually he has refused to do art with other people. He makes paintings on a variety of surfaces, such as large and small note cards and tote bags. From time to time, people who have either heard or seen Eric's work come to purchase it. Color photocopies of his works have been made and used for a variety of purposes. Explorations have been made toward marketing Eric's paintings. One of the local flower and balloon stores has been approached to include a hand-painted gift card by Eric on their flowers and balloons.

It's time now to do an update on Eric's Futures Plan. His first plan was done shortly after the family relocated to a new state, 6 years ago. Many major accomplishments have been made; for example, Eric is now in his own home, across town from his parents, in a lovely single family home. His wheelchair fits in, out, and about his home. His love of water is capitalized on every day in his own Jacuzzi tub. The people who provide support for Eric have made long-term commitments, and there is minimal turnover. Eric gives to others through volunteering in the community on a steady basis, delivering groceries to two women who are older. Most importantly, he has developed an identity for himself. He uses his creative energies in the unique way he communicates through his art. Sales of Eric's art bring him in contact with new people. When the update of his Futures Plan is done using the same process, there will no doubt be an explosion in his quality of life, in increased and deepened relationships, and in satisfaction gained in daily pursuits. Art was never mentioned in Eric's first Futures Plan. Yet, the desire to enable Eric to communicate, and the sensitivity to his abilities and capacities expressed by one teacher brought it about. Eric's strengths are assembled in his brightly colored expressions using the language of art.

Let's take a hypothetical look at the role of the art educator in Eric's updated Futures Plan:

1. The breadth and depth of Eric's expressions should be increased. Art educators' knowledge gained through education and experience could lead to new materials, techniques, sources of inspiration, motivation, and expression.
2. The valued community role of an exhibiting and marketing artist is within Eric's grasp. Eric's visual proof of breaking through barriers and boundaries to finding his artistic voice is a priceless gift to be shared with the community.
3. Eric could join in community art classes. Although Eric is shy and frequently unwilling to interact with others, his artwork might be the catalyst to bring about a new social plateau.

Community Membership and Art Education in Community Art Classes

The following definitions are included here to assist in looking at art education classes through the eyes of the Facilitator and Circle of Support as they search the community for supportive environments in which to include the Focus Person who wants to be in an art class:

Community membership is the latest paradigm that is being used; it will carry the disabilities field into the next century. It is a comprehensive, individualized, community-based support system that has been evolving for the last three decades. The "Community Membership" paradigm consists of: (a) a commitment to community and family, (b) an emphasis on human relationships, (c) person-centered programming, and (d) real choice and control by people with developmental disabilities (Bradley & Knoll, 1990).

A *community-based program* is a program that already exists and is in operation in the community. It is not segregated by age or by any other classification. It is a desirable place for people with disabilities because it is located in and utilized by the community.

An *inclusive setting* is one in which all adults, including those who have been labeled as having mental or physical disabilities, are accepted and included as equal members and are recognized for what they have to offer (Clements, 1994; Le Pore & Janicki, 1990).

When People with Disabilities Choose to be Part of a Community-Based Art Education Program

The day of building separate arts programs for people with disabilities is over. When people with disabilities choose to be part of a community-based art education program, they are expecting to be included with people without disabilities. Today, people with disabilities that are either developmental (onset before age 21) and/or that occur with natural aging are participating with people of all ages in arts classes in the community. Program characteristics and advantages for people with disabilities in community-based programs follow:

- Locations in the community, right in with the rest of society.
- Opportunities for people with disabilities to participate and interact with people without disabilities. The people we are with the most, we like the most; therefore, community programs provide the conditions to develop relationships with people both with and without disabilities.
- Opportunities for socialization.
- Opportunities for the person with the disability to be the giver, the provider of enrichment.
- Opportunities for the person with the disability to find role models and mentors.
- Chances to develop artistic talents and pursue interests in the arts.

Art Education Provides Benefits on Both an Individual and Group Basis

Art education provides a number of benefits for the whole person, such as:

- Getting to know oneself better through the creative process.
- Wellness and therapeutic benefits of the art-making process itself.
- Education/experimentation/knowledge about elements and principles of art and design, art materials, art history, art criticism, and aesthetics.
- The sense of community, connectedness, and increased strength gained by participation in arts activity designed with principles of normalization.
- The sense of satisfaction and self-validation that comes with self-expression.
- Total absorption in the process of arts-making.
- The sense of belonging attained through interactions with others in the group about the arts.

Barriers to benefits

- Lack of knowledge on the part of those conducting the program about ways to adapt art education to individual needs.
- Lack of disability awareness on the part of participants and/or staff to create an atmosphere that is conducive to inclusion of people with disabilities.
- Cliques or groups within the participants that promote exclusion.
- When working in public facilities and other community settings, art supplies can be lacking, funding can be very sparse; resourcefulness helps.

Bridges to benefits

- Cross training of staff in methods of art education and disabilities.
- Intergenerational involvement, student matching through universities, and school programs.
- Buddy systems, pairing compatible people.
- Climates of responsiveness in art education sessions.
- Communicating with and without words; both are equally important.
- Sharing of real feelings.
- Allowing enough time for incubation of ideas (Torrance, Clements, & Goff, 1989).

For a few years Eric's artwork has been exhibited in *Community Collection: Connecting Georgians Through the Arts*, an annual vehicle for the dissemination of visual and performing arts. In addition, arrangements are being made to show his artworks at the Saint Mary's Gallery. Originated by Claire Clements, *Community Collection* is sponsored by the University Affiliated Program at the University of Georgia and provides a prototype and an arena for simultaneously showcasing and sharing arts made by people with and without disabilities.

Conclusions

Art Educators working in the community need to be poised both to fill potential requests, and to initiate participation in the Futures Planning process. We will need to be able to recognize those indicators of interests, gifts, and talents in art. This can be done by learning about and becoming comfortable with the Futures Planning process and tools: the Personal Profile, Lists of Opportunities, Obstacles and Strategies, and the functions of the Circle of Support. By learning to listen to the cues from the Focus Persons and the people who care about them, we will be able to make significant contributions to a Circle of Support meeting. We will be able to search a Personal Profile like Eric's and uncover those indicators of an artistic spirit. At the time Eric's Futures Plan was done, all that was known about his artistic interests was that he loved books and music and that he enjoyed marking paper.

Recently, holding two cards before Eric, one that said "yes" and one that said "no," Mary leaned down in front of his wheelchair and said, "Eric, do you think you're an artist?" Grinning widely, Eric reached out and grabbed the card with the word "yes."

References

Bradley, V. J., & Knoll, J. (1990). Shifting paradigms in services to people with developmental disabilities. *The Community Service Reporter*, Bulletin No. 90-60.

Clements, C. B. (1994). *The arts/fitness quality of life activities program: Creative ideas for working with older adults in group settings.* Health Professions Press, 6-9.

Clements, C. B. (1998). Art education, community membership, and quality of life. In M. Rugh & D. Fitzner (Eds.), *Crossroads: The challenge of lifelong learning* (pp. 128-138). Reston, VA: National Art Education Association.

Le Pore, & Janicki (1990). The wit to win: How to integrate older persons with developmental disabilities in community aging programs. Albany: New York State Office for the Aging.

Mount, B. (1991). Values and philosophy. In D. Spitalnik et al., *Building person-centered support: Part one—vision and ideals* (pp. A2-A5). Piscataway: The University Affiliated Program of New Jersey: University of Medicine and Dentistry of New Jersey, Robert Wood Johnson Medical School.

Mount, B. (1992). *Person-centered planning: Finding directions for change using personal futures planning: A sourcebook of values, ideals, and methods to encourage person-centered development.* New York: Graphic Futures, Inc.

Mount, B. (1995). *Capacity works: Finding windows for change using personal futures planning.* (A Communitas Publication Monograph). Manchester, CT: The Community Place.

Mount, B., & Zwernik, K. (1988). *It's never too early; it's never too late: A booklet about personal futures planning.* St. Paul, MN: Metropolitan Council.

Northeast Georgia Mental Health, Mental Retardation, and Substance Abuse Community Support. Services, D. Adams, Facilitator. (1990). [Eric's Futures Plan].

St. Mary's Health Care System, Inc. (1992, Fall). Communicating through art. *Health Scene: Journal of Wellness and Good Health Care*, 5-6.

Torrance, E. P., Clements, C., & Goff, K. (1989). Mind-body learning in the elderly. *Educational Forum, 54*, 123-133.